BALTIMORE

TEXT AND CAPTIONS BY MARK WALSTON

TURNER

In July 1913, photographer Frederick Mueller climbed to the top of the Emerson Bromo-Seltzer Tower to take a complete circle view of Baltimore. Designed by Joseph Evans Sperry, the tower, completed in 1911 and at the time the tallest building in the city, was the brainchild of Captain Isaac Emerson, who had organized the adjacent Bromo-Seltzer Company in 1891 to produce his headache remedy. A 51-foot revolving replica of a bottle of the celebrated nostrum originally surmounted the tower.

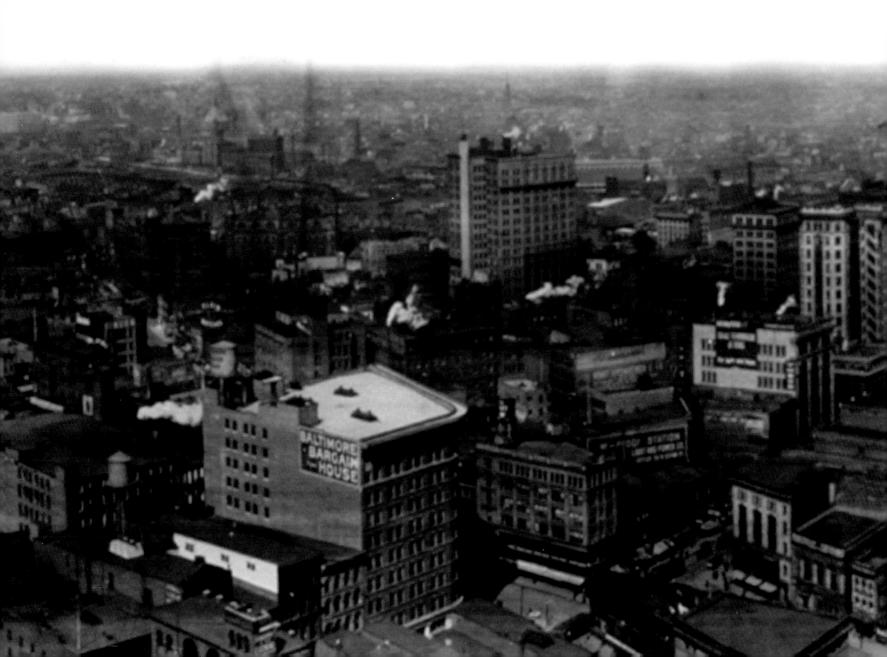

HISTORIC PHOTOS OF BALTIMORE

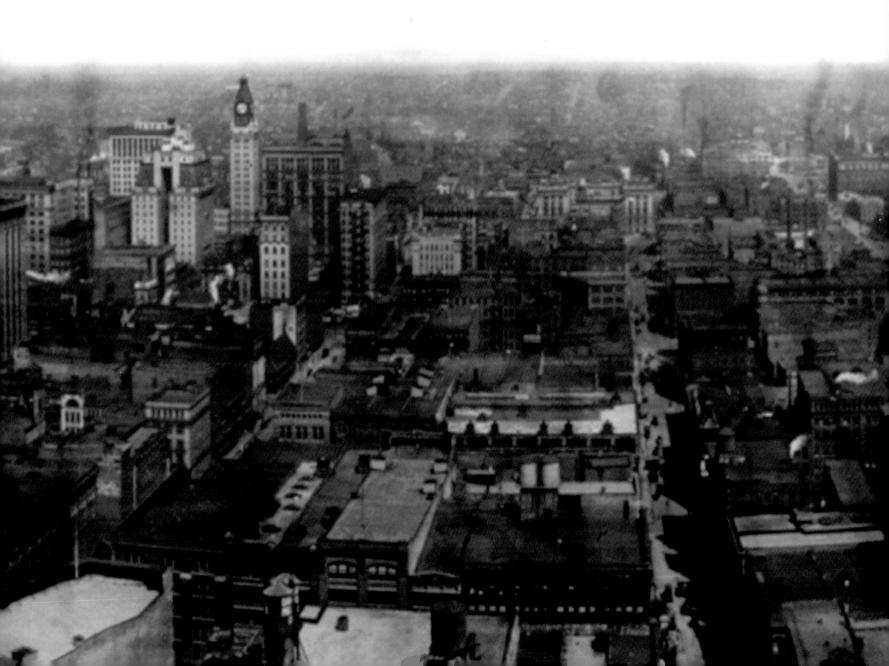

Turner Publishing Company 200 4th Avenue North • Suite 950 Nashville, Tennessee 37219 (615) 255-2665

www.turnerpublishing.com

Historic Photos of Baltimore

Copyright © 2008 Turner Publishing Company

All rights reserved.

This book or any part thereof may not be reproduced or transmitted in any form or by any means, electronic or mechanical, including photocopying, recording, or by any information storage and retrieval system, without permission in writing from the publisher.

Library of Congress Control Number: 2008905530

ISBN-13: 978-1-59652-316-6

Printed in the United States of America

08 09 10 11 12 13 14-0 9 8 7 6 5 4 3 2 1

CONTENTS

ACKNOWLEDGMENTSVII
PREFACEVIII
THE RISINGEST TOWN (1840–1903)
DISASTER CONVERTED (1904–1939)
LIBERTY SHIPS TO HARBORPLACE (1940-1980)
NOTES ON THE PHOTOGRAPHS 201

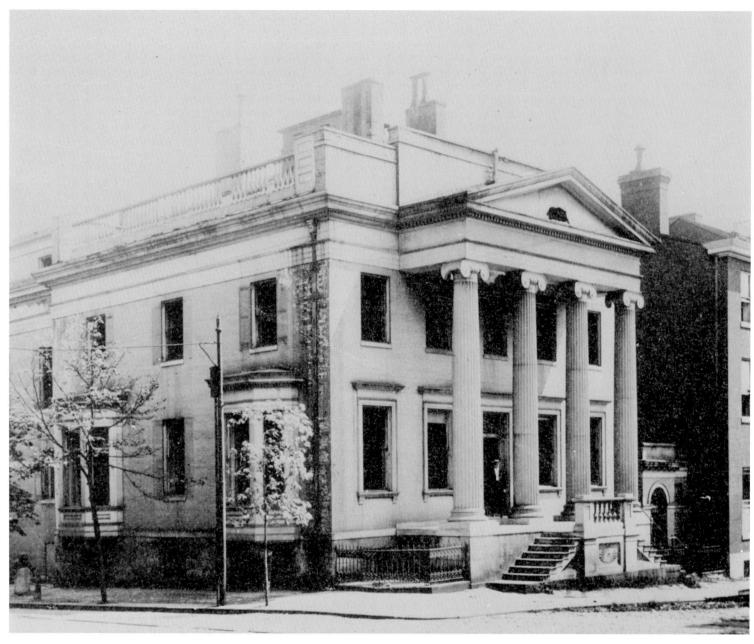

The Baltimore Athenaeum Club, an association of the city's elite formed to promote literary and scientific learning, claimed as its home the residence of William Howard, constructed between 1828 and 1830 at the intersection of Charles and Franklin streets. Howard was not only a noted physician, but also a natural historian, engineer, surveyor, and amateur architect who traveled the world seeking history's great buildings. He hired architect William Small to design his classically inspired residence, with its heavy, pedimented portico supported by four columns.

ACKNOWLEDGMENTS

With the exception of cropping images where needed and touching up imperfections that have accrued over time, no other changes have been made to the photographs in this volume. The caliber and clarity of many photographs are limited by the technology of the day and the ability of the photographer at the time they were made.

This volume, *Historic Photos of Baltimore*, is the result of the cooperation and efforts of many individuals, organizations, and corporations. It is with great thanks that we acknowledge the valuable contribution of the following for their generous support:

Baltimore Camera Club
Baltimore Museum of Industry
Enoch Pratt Free Library, Central Library/State Library Resource Center, Baltimore, Maryland
The Frances Loeb Library, Harvard Graduate School of Design
Library of Congress
The New-York Historical Society

PREFACE

Every day, the average American is exposed to hundreds of photographic images, in newspapers, magazines, books, advertising, web sites—photos both publicly displayed and privately shared among family and friends. Photographs inform us of occurrences around the world. They capture personal moments. They illustrate, identify, educate, entertain, inspire. They show us the distant reaches of the universe and the smallest particles of life.

From its beginning in the 1830s, when the French painter and printmaker Louis-Jacques-Mandé Daguerre first discovered a chemical method to fix an image on a sheet of highly polished, silver-plated copper, photography radically changed how the world saw itself. Now there was a scientific method of showing rather than describing, a means of presenting life as it is, rather than filtering it through painting or drawing. "A mirror with a memory," early admirers called it.

Some may argue how much of a mirror photography truly is, whether it accurately reflects reality or is more a display of the photographer's personal bias—the subjects posed, positioned, manipulated, cropped to suit a particular idea or intention. As a historical record, however, photography provides a resource of inestimable value to anyone attempting to decipher a society at a particular point in time. It may not present a complete picture, but it provides details unobtainable in other references and, when combined with the written historical record, significantly enhances our understanding of the past.

In the beginning, photography was a specialized endeavor, reserved for a handful of artisans with the wherewithal to purchase equipment and supplies and the knowledge of how to produce the images. As a result, daguerreotypes, the earliest form of photography, were reserved for portraiture of the well-off—stiffly posed because of the length of time the subject had to stay still—or for capturing important landscapes or structures in the man-made environment. John Plumbe's 1846 daguerreotype of Baltimore's Battle Monument reflects photography's early emphasis on the significant rather than the mundane. Other methods of processing would appear over the next decades, from glass plates to the tintype, patented in 1858, which substituted a less costly iron plate. Traveling tintype photographers now could conduct business out of the backs

of wagons, taking pictures—for a price. The portability of the process expanded the range of possible subjects, while its relative inexpensiveness widened its accessibility.

Yet, by the 1880s, further improvements in processing would bring about a revolution in photography, and finally put a camera in the hands of the masses. George Eastman would develop a flexible alternative to the cumbersome photographic plates and toxic chemicals then in use: a thin strip of paper to which dry gel had been applied—the first practical film. Then, in 1888, Eastman's Kodak camera appeared, so simple that it did away with the specialized knowledge required to take a photograph. The user just pushed the button and left the complex process of developing the image to others. In 1901, with the appearance of Eastman's inexpensive Kodak Brownie, the era of popular photography began in earnest.

Technical advances during the latter part of the nineteenth century, as well, made it possible for photographers to clearly capture moving objects, allowing a greater spontaneity, producing on-the-spot photos of fast-breaking events. The series of images of Baltimore's Great Fire of 1904, taken just after fire fighters responded to the first alarm and documenting the spread of the fire minute by minute, provide a remarkable record of the catastrophic event.

With a camera in every hand, photography became no longer the province of the few, and the photos taken began to reflect every aspect of life, the common as well as the extraordinary. A steamship docking at a pier, a policeman directing traffic, shoppers at the market, a woman scrubbing the stairs of her row house, all these familiar sights of everyday life in Baltimore were now recorded, preserved in photo albums, available for viewing far into the future.

Additionally, advances in reproductive technologies, in particular the development of the halftone printing process in the 1890s, allowed these photographs to be inexpensively shared through the pages of newspapers, magazines, books, and more, thus expanding their use as a means of telling stories to the wider public. Photojournalist Lewis Hine would turn to photography as a key way of displaying the working conditions of children in the first decades of the twentieth century; his images of Baltimore children toiling in canning factories and picking fruit on area farms would be a major impetus for reform.

The advent of digital cameras further extended photography's reach—history has yet to determine whether the ephemeral nature of pixels on a screen will be preserved in any readable form, if saved at all for future generations to view and ponder. The images presented on the following pages, however, represent the early days when a photograph was a physical object—and by their reproduction in this book present in tangible form a record, however partial, of 125 years of life in Baltimore.

-Mark Walston

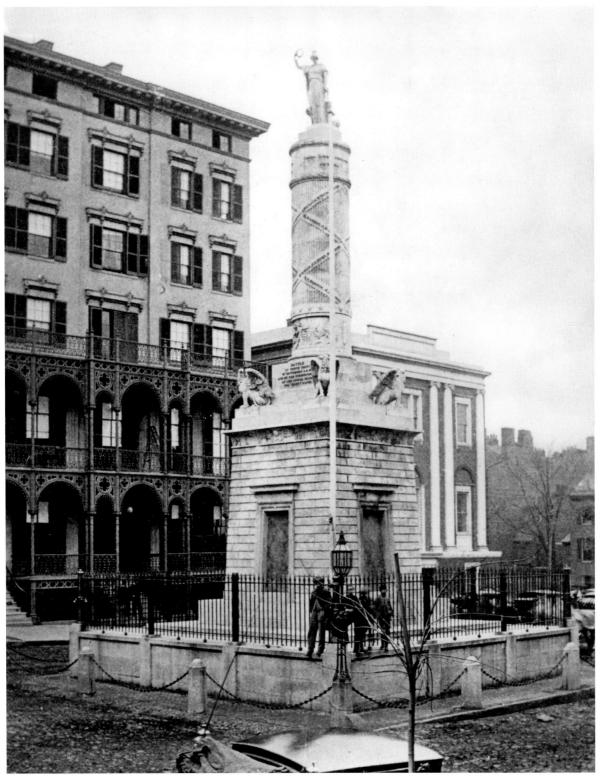

The beginnings of architectural cast iron, which experienced nationwide popularity in the mid-nineteenth century, had strong Baltimore connections, due in part to the existence of a number of ironworks already operating around town. The Gilmore House, built about 1840 and later known as the St. Clair Hotel, decorated Monument Square by its addition of an elaborately ornamental, two-story cast-iron front, seen here in 1894.

THE RISINGEST TOWN

(1840 - 1903)

Advantageous geography gave rise to early Baltimore. The broad basin formed by the confluence of the Patapsco River and the Chesapeake Bay prompted its initial chartering by the Maryland Assembly in 1729, the intention being to create around the natural harbor a new port to serve the region. Equally attractive was the town's location where the rocky Piedmont descended to the Coastal Plain, providing swift-moving waters to power fledgling industries, particularly the city's flour mills.

Growth came rapidly to the port town, and in 1798, as Baltimore's population approached 26,000, President George Washington declared it "the risingest town in America." By 1830, the textile mills sprouting along Jones Falls produced over 80 percent of the nation's cotton duck, while scores of other enterprises turned out an inestimable amount of goods.

Perhaps the most significant occurrence in the city's early history came with the 1828 founding of the Baltimore and Ohio (B&O) Railroad, which provided local industries with a cheap and rapid means of transport. Water-oriented transportation would initially keep pace with the rails, with steamships carrying products and people across the Atlantic by 1865.

Baltimore's progress would be dimmed by the Civil War but not extinguished, for, as the only southern port still under Federal control, it became a major shipping center for the Union army. After the war, improvements in steam power brought a slew of large-scale concerns to the city. Bountiful harvests gave rise to a prosperous canning industry, and by the 1880s, Baltimore had become America's leader in canned fruits and vegetables—and oysters.

Industries such as fertilizer and men's clothing also rose to national prominence, while Baltimore's foundries and machine shops hammered out products in prodigious numbers. Between 1881 and 1895, the number of corporations headquartered in Baltimore leaped from 39 to more than 200. The population grew swiftly, too, from 267,354 in 1870 to 508,957 by 1900.

Private fortunes were made seemingly overnight but were shared in a generous outpouring of philanthropy by men such as William Walters (Walters Art Museum), George Peabody (Peabody Institute), and Enoch Pratt (Enoch Pratt Free Library). Those in town with a high thirst for knowledge would find sustenance in the scholarly offerings of Johns Hopkins University, founded, along with a hospital, in 1876 under the beneficence of its namesake financier.

Baltimore's Battle Monument on Calvert Street, seen here in an 1846 daguerreotype by photographer John Plumbe, honors the brave who perished defending the city from British attack in September 1814. Designed by the French architect Maximilian Godefroy, the 39foot monument, built over a 10-year span from 1815 to 1825, is surmounted by a female figure representing Baltimore, sculpted by the Italian-born artist Antonio Capellano, who had been brought to America to create the patriotically themed carvings on the United States Capitol in Washington. The Battle monument was the nation's first war memorial dedicated to the common soldier, and the first commemorating the War of 1812.

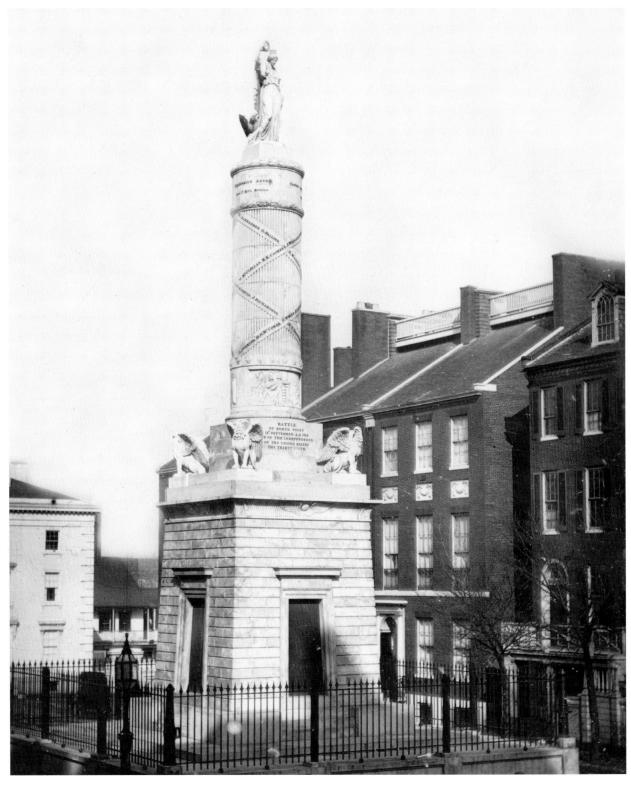

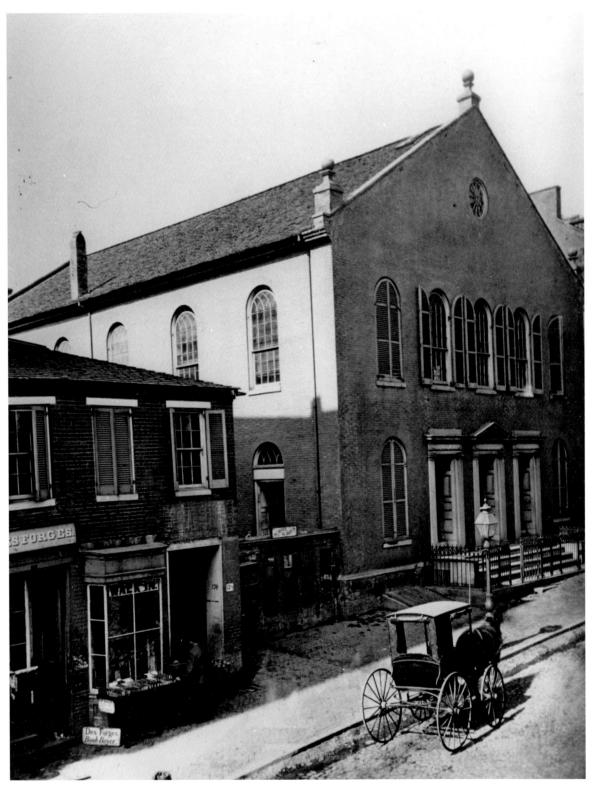

In 1784, a new denomination was born in Baltimore: the Methodist Episcopal Church. Organized in a humble log structure known as the Lovely Lane Meeting House, the congregation by 1797 had grown to the point where a larger meetinghouse was in order, and so a new church was constructed, fronting Light Street. Seen here in an 1860 view—taken before the building's demolition about 1872—the simple, unadorned structure adhered to the desire of those first Methodists to avoid the ostentation that marked many of the city's churches.

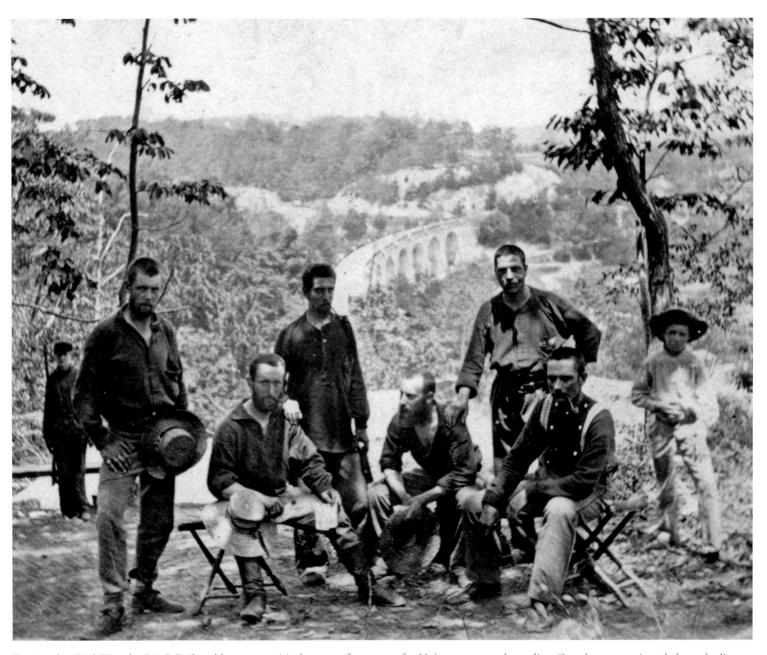

During the Civil War, the B&O Railroad became a critical means of transport for Union troops and supplies. Guards were stationed along the line to protect it from Confederate attack. Here a detachment is tasked with defending the Thomas Viaduct, a 612-foot stone bridge completed in 1835 that carried a branch of the B&O Railroad across the Patapsco River Valley—the longest bridge built in America at the time, and still the world's largest bridge of its kind.

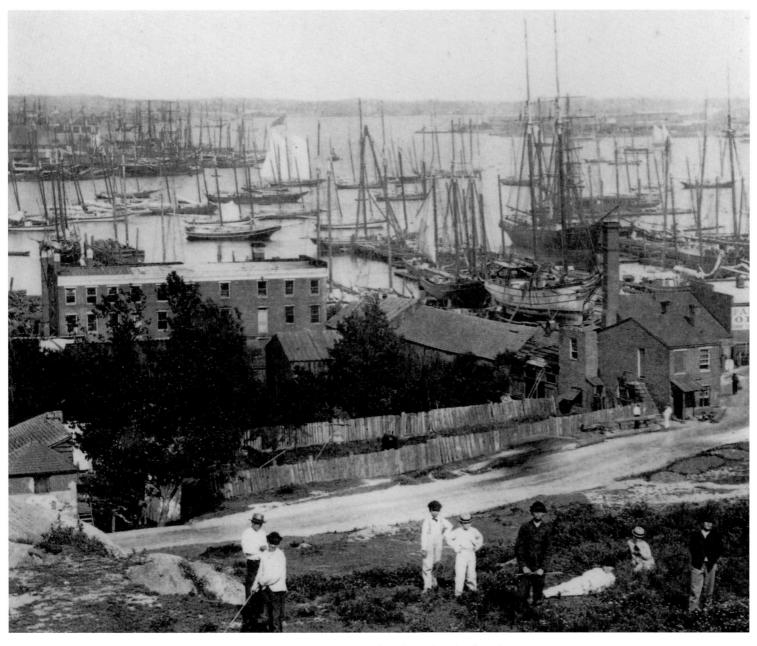

The masts of sailing ships form a forest in the water as vessels lay at anchor along the wharfs and in the harbor, seen here in a Baltimore view taken about 1870 from Federal Hill, south of the city center, looking east toward the Chesapeake Bay.

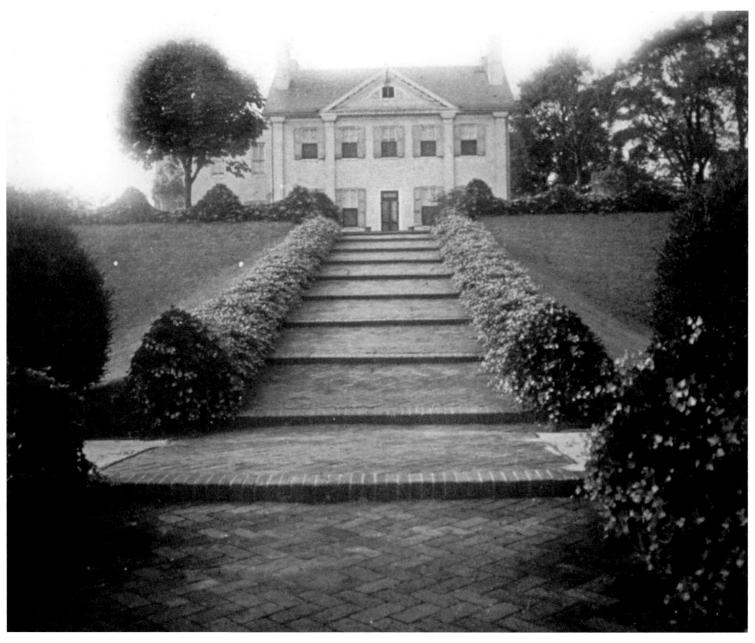

Mount Clare, the Baltimore home of Charles Carroll, known as the "barrister" to distinguish him from his father Charles, the doctor, was begun in 1767 as a grand country residence, complete with exotically landscaped grounds, including an orangery for the propagation of citrus fruit.

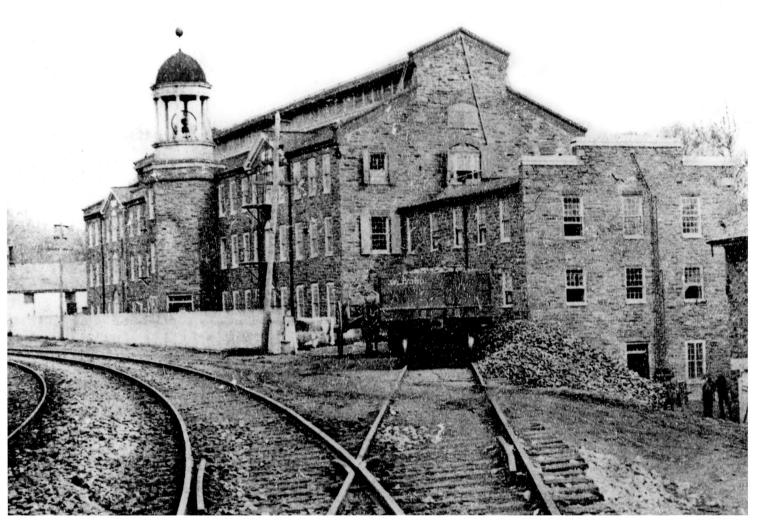

By the mid nineteenth century, Baltimore had become one of the nation's leading centers of textile manufacturing, with dozens of cotton mills springing up around the city, availing themselves of a ready supply of moving water for power. Impressively, Baltimore's mills, including the Mount Vernon–Woodberry mill seen here, accounted for about 80 percent of the world's cotton duck production. A precipitous decline in demand after World War I—and a series of workers' strikes—sent the mills into decline, and by 1925 many had abandoned Baltimore for the lower costs of operating mills farther south.

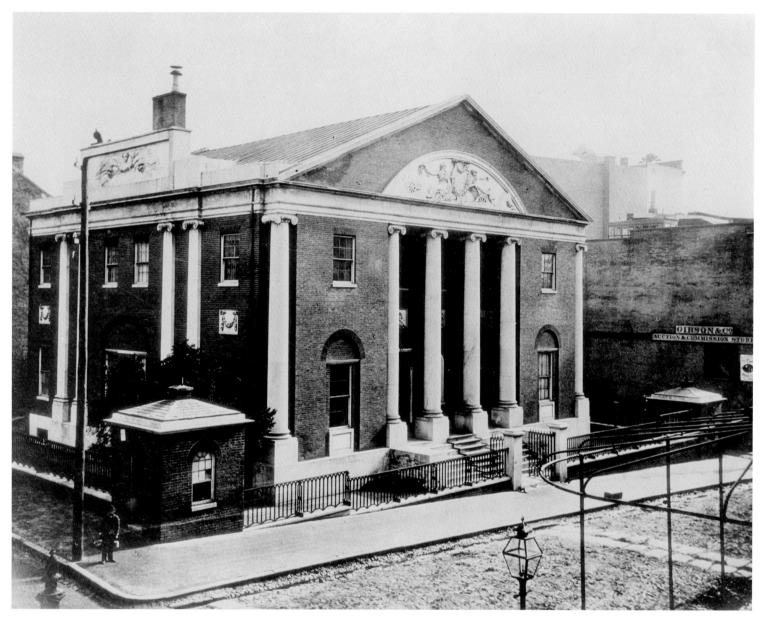

In 1804, the Union Bank of Maryland was organized and chartered, and by 1807 it had built this spacious banking house on the southeast corner of Fayette and Charles streets. Designed by architect Robert Carey Long, Sr., the bank was his first public structure and featured such classical elements as Ionic columns, marble pilasters, and the first figural sculpture to decorate a Baltimore building. The sculpture was carved by the Italian artists Giovanni Andrei and Guiseppi Franzoni, whom Baltimore architect Benjamin Henry Latrobe had brought to America to work on the Capitol in Washington, D.C.

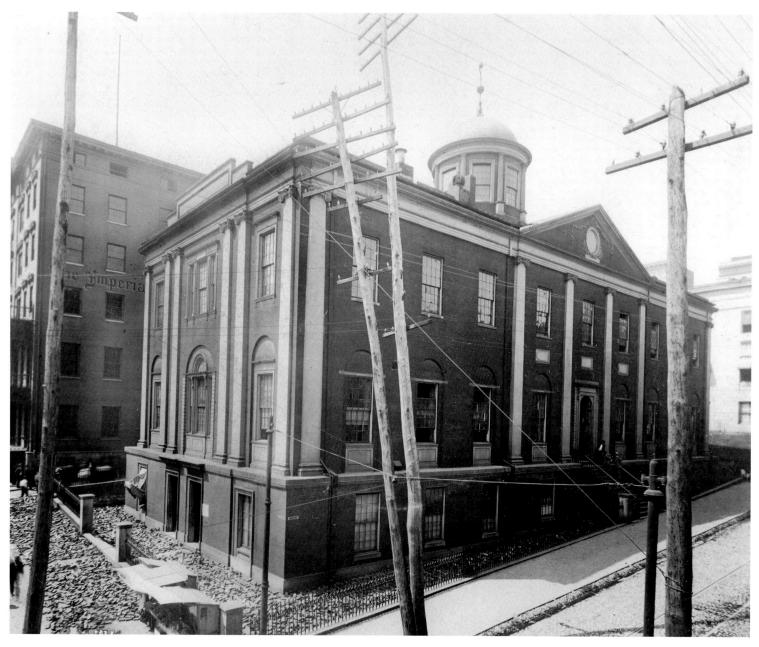

When the hills and valleys of Calvert Street were leveled in 1784 to better accommodate carriage travel through the city, the original Baltimore City Court House—site of the July 1776 reading in Baltimore of the Declaration of Independence—was raised high above street level on huge stone arches that allowed passage underneath. By 1805, the small courthouse could no longer serve the growing population, so the city contracted with Irish-born architect George Milliman to design this impressive structure, seen here in 1885. For years it remained the most important civic building in the city.

In 1858, Baltimore mayor Thomas Swann—inspired by the work then progressing on New York City's Central Park—formed a city park commission, which immediately urged for a municipal park the purchase of Druid Hill, Nicholas Rogers's 500-acre county estate about two miles north of the harbor. Acquired in 1860, the property gradually developed into one of the nation's most picturesque garden parks, dotted with spreading lawns, bucolic glades, and winding paths. Another enticing feature was Druid Hill Lake, begun in 1863 and constructed to function also as a drinking-water reservoir for the city. It was—and remains—the largest earthen-dammed lake in the country. Here, around 1896, a pair of buggies sit at the park entrance.

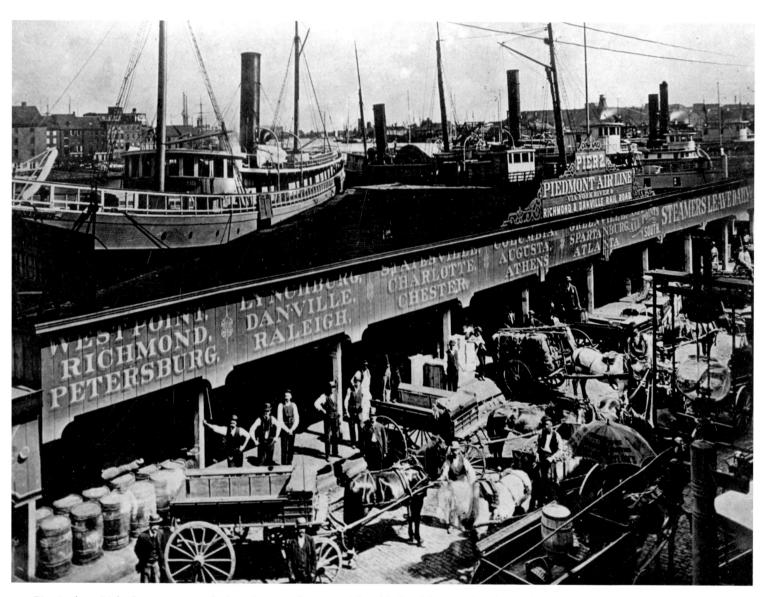

Pier 2, along Light Street, supported a broad range of commercial and industrial enterprises during the nineteenth century, not the least of which was the terminal of Piedmont Airline, which provided steamship connections between northbound and southbound passenger trains, in particular the Richmond and Danville line, a complex system of railroads encompassing 3,000 miles of track that stretched from Virginia to Texas. Railroads crisscrossed the city's waterfront—although, for safety reasons, steam-driven passenger trains were drawn to the piers by strings of horses or mules.

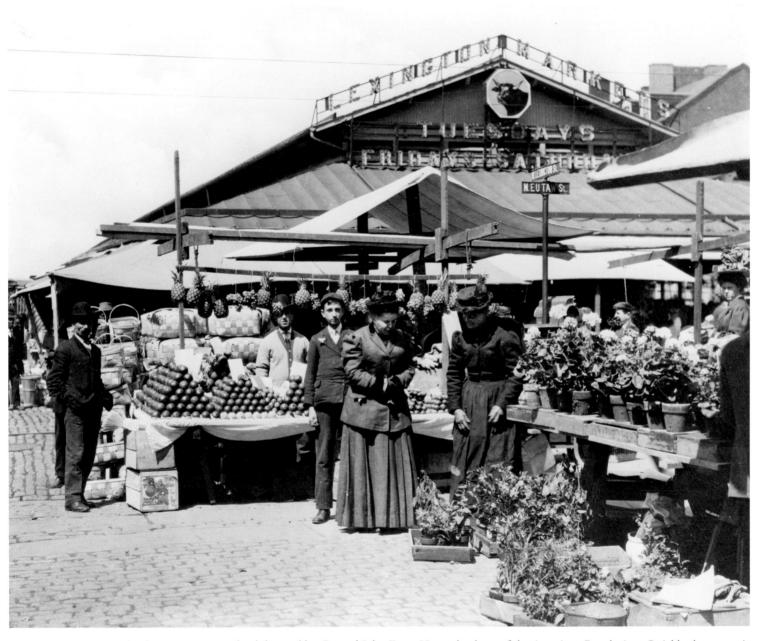

Lexington Market began in 1782 on land donated by General John Eager Howard, a hero of the American Revolution. Quickly the open-air market—patriotically named for the Battle of Lexington—became an important center for local commerce. A convenient place for area farmers to peddle their wares—hams, eggs, butter, vegetables, fruits, flowers, and more—the market also attracted merchants who gathered to barter and purchase grain, hay, farm supplies, and sundry other staples. In 1803, sheds began to be constructed on the site to protect the produce from the elements.

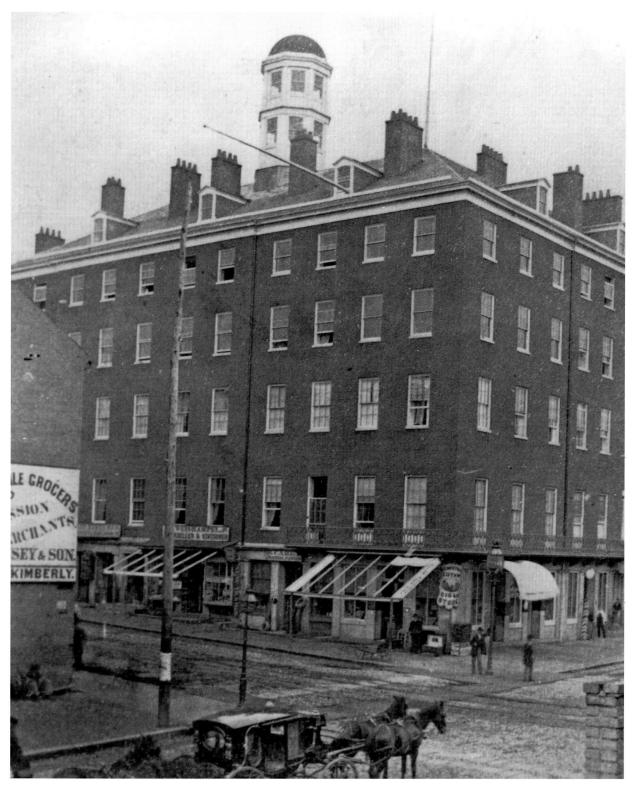

The Eutaw House, seen here at the intersection of Baltimore and Eutaw streets, was one of the city's oldest hotels, built in 1835. The building was severely damaged by fire in 1912 and, two years later, was torn down and replaced by the Hippodrome Theater.

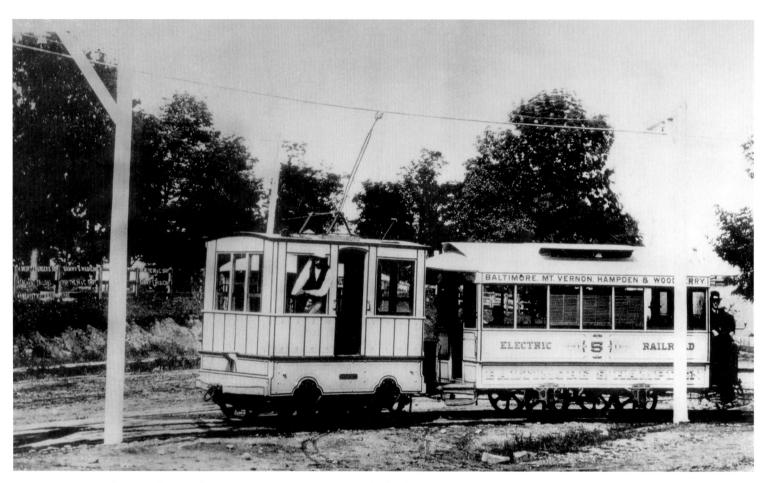

In 1859, horse-drawn trolley cars began running over iron tracks embedded in city streets, carrying travelers from railroad stations to hotels about town. As the years progressed, a web of privately operated lines crisscrossed the city and its environs. Then, in 1885, Leo Daft began experimenting on the Baltimore and Hamden lines using electricity traveling through a third rail to send power to a locomotive pulling a horse car. It was the nation's first commercially operated electric streetcar. Unfortunately, continued incidents of electrocution from the exposed third rail, knocking down horses and mules and the occasional unaware pedestrian, forced the experiment to close, and in 1889 the line converted back to the dependable horse as the main motive power. By the mid-1890s, however, overhead lines proved a safer alternative for a new breed of "electric railways."

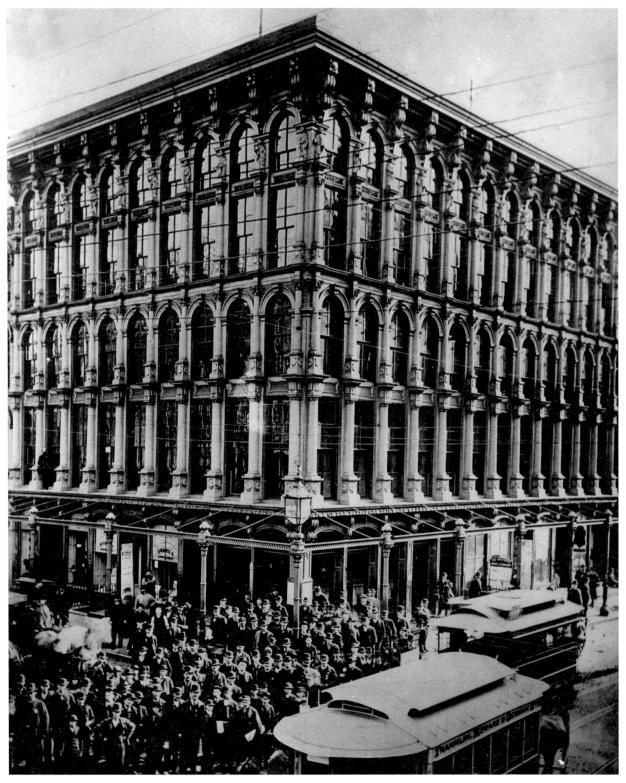

In 1837, Baltimore's growing presence on the national stage caught the attention of a journeyman printer from Rhode Island by the name of Arunah Shepherdson Abell, who decided to relocate to the city to try his hand at establishing a newspaper. Within a dozen years the paper, named the Sun, had grown into the most important publication in the city. In 1850, Abell engaged New York architect R. G. Hatfield to design a building better befitting the paper's status. Notably, the building, completed in 1851 and seen here some years later, featured a cast-iron front, thought at the time to be not only stylishly ornamental but thoroughly fireproof.

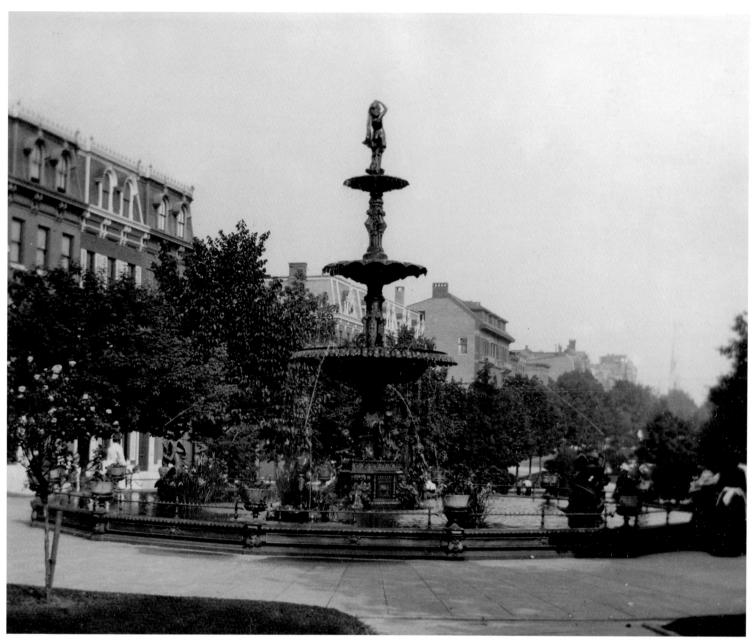

Following the trend of urban parks then springing up in the nation's major cities, Eutaw Place was laid out in 1856 as a trio of grass "places," providing an attractive view for the new blocks of fashionable houses going up along Eutaw Street. In 1880 the decision was made to extend the street with new greenspaces up to North Avenue, creating a broad promenade. Eventually, Eutaw Place would present an amiable mix of sculptural landscaping, winding paths, and formal fountains, such as this one viewed about 1890.

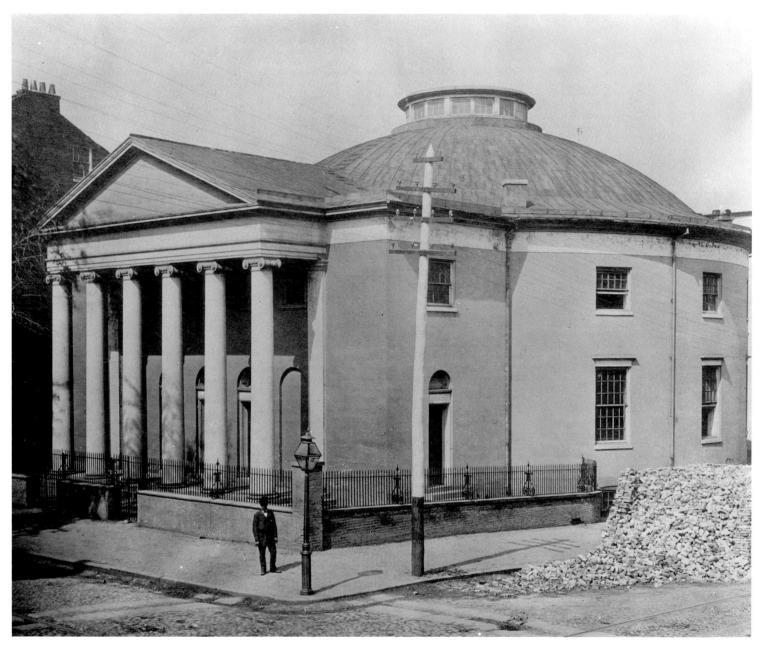

In 1817, Robert Mills, one of early America's most prolific and influential architects, designed the classically derived First Baptist Church. Completed the following year and majestically occupying the corner of South Sharp and Lombard streets, the church's central and most impressive feature was its great, laminated rib dome, inspired by the Pantheon in Rome, which soon garnered the church the affectionate nickname of "Old Round Top."

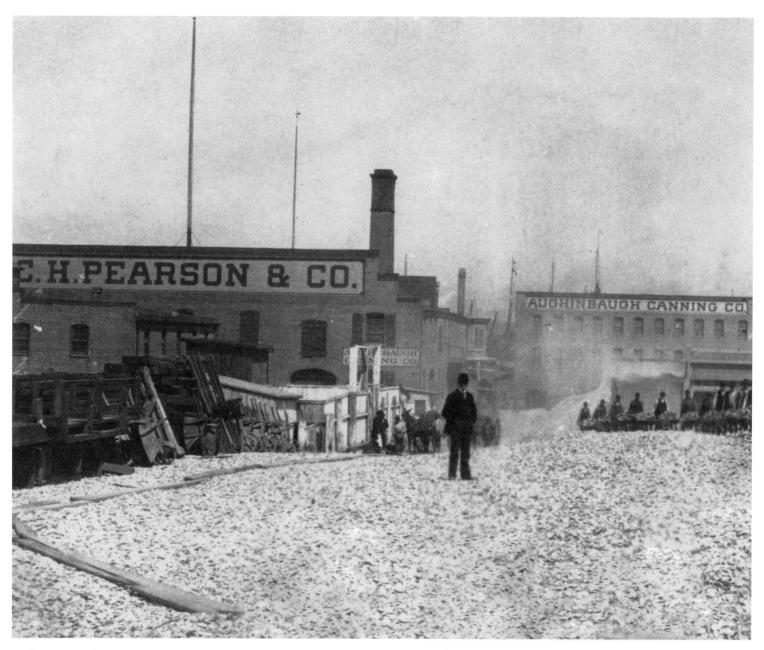

In the nineteenth century, Baltimore developed into the nation's greatest center for canning. The catalyst was the Chesapeake Bay oyster, a local delicacy that, in the 1850s, became a national delight with the emergence of large canning companies throughout the city. Firms such as C. H. Pearson and Company, seen here around 1890, packed the oysters and shipped them to other parts of the country. Every year oyster boats would bring millions of the freshly harvested mollusks to the canning plants, where workers extracted the meat and discarded the shells, which were carted by wheelbarrows out to expansive heaps in the factory yard.

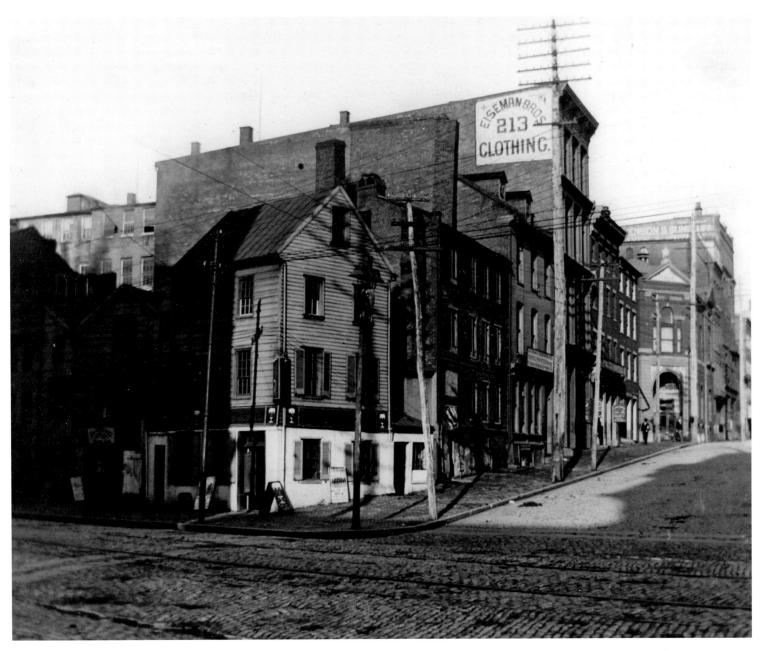

Humble reminders of Baltimore's eighteenth-century beginnings coexisted with the Victorian edifices of the nineteenth century, bringing a certain charm and visual delight to the city streets. Seen in 1894, this slightly askew building at the corner of Liberty and German (later Redwood) streets anchored a row that displayed the city's various architectural periods, from the wooden homes of a colonial village to the brick and iron of a major metropolis.

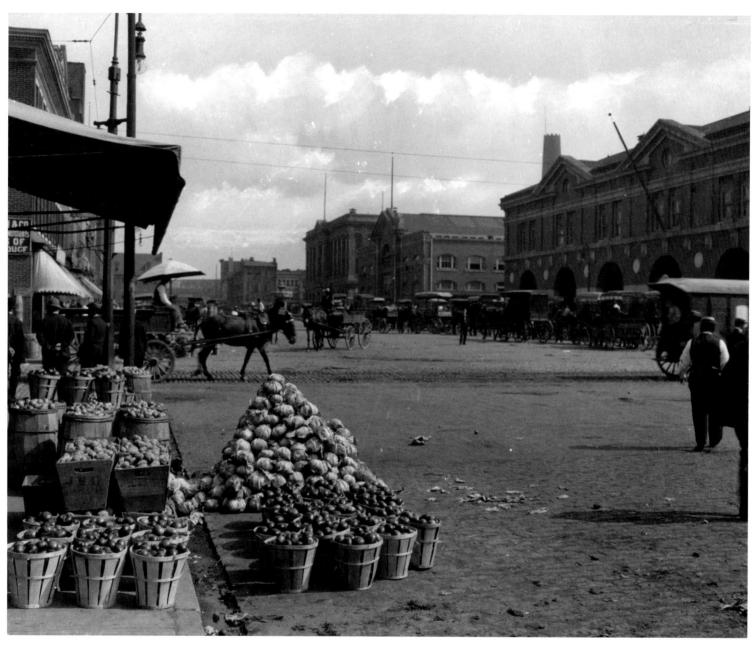

Situated on Harrison Street on the bed of an old swamp, Center Market was established in the mid eighteenth century as one of three major marketplaces in the city. In 1784, construction began on a long, broad-roofed market house supported by brick piers. Over time, the building would be enlarged and improved and, by the late nineteenth century, developed into an expansive building covering two city blocks, where city dwellers could fill their baskets with fresh produce, such as the vegetables and fruits displayed here, carted in daily from area farms.

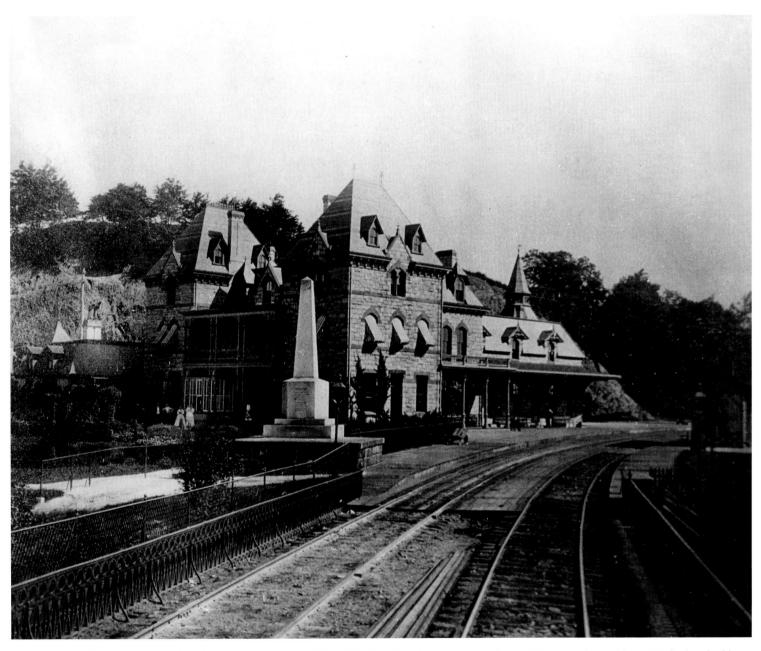

In 1828, ground was broken for the Baltimore and Ohio (B&O) Railroad—the nation's first public railroad—and by 1830 the line had been completed to Ellicott's Mill, some 13 miles away. Originally, horses pulled the cars over the rails but needed rest along the way. The Relay House was established near the halfway mark so the horses could be changed—and passengers could stop for rest and repast. In 1872, a large, Victorian combination passenger station and hotel was built to cater to travelers. Shown here around 1890, the white obelisk beside the building is dedicated to the architects, engineers, and government and railroad officials connected with the building of the nearby Thomas Viaduct, an impressive stone structure that carried the B&O over the Patapsco River.

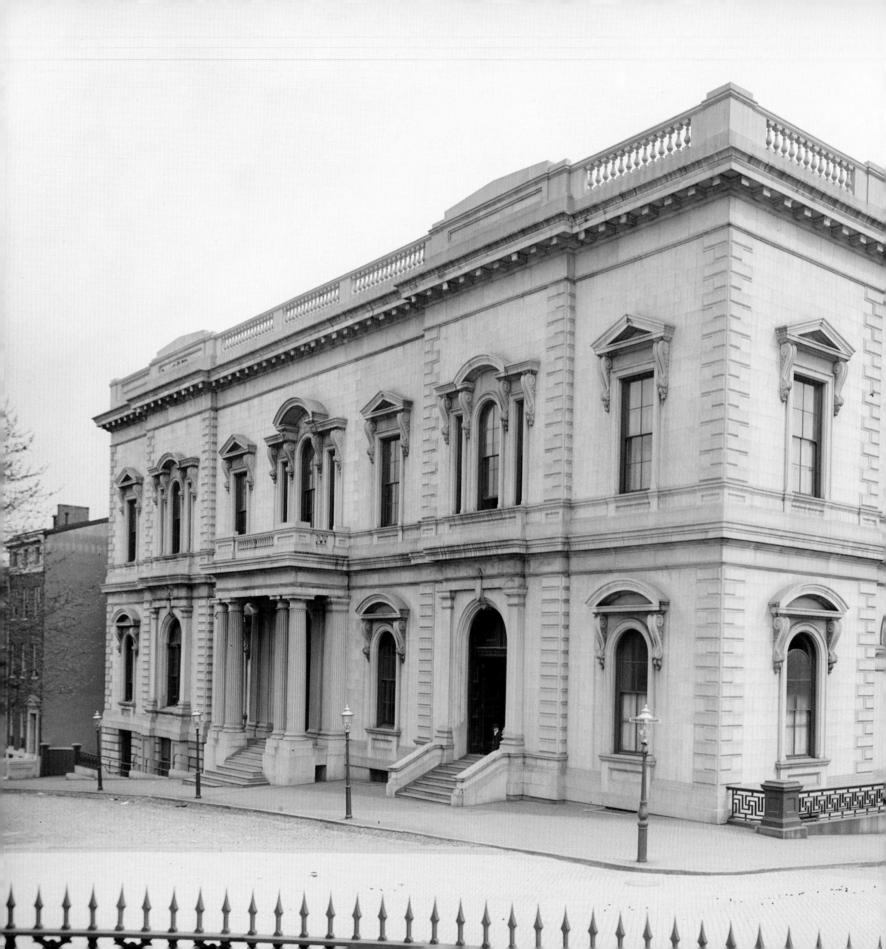

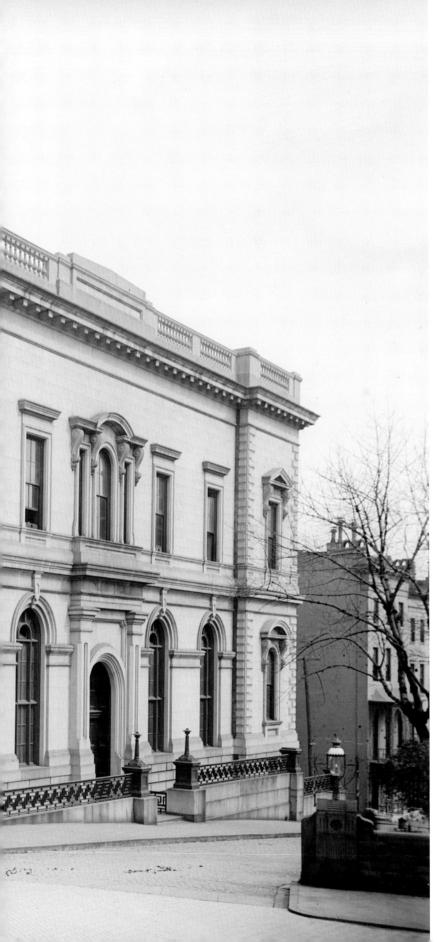

Massachusetts-born George Peabody accumulated a fortune as a merchant in mid-nineteenth-century Baltimore; he then gave thanks to the city with a \$1.4 million gift to found a cultural institution of ambitious scope, to include a school of music, a library for scholars, an art gallery, and rooms for lectures and exhibitions. Designed by the architectural firm of Lind and Murdoch, the building on Mount Vernon Place known as the Peabody Institute was finished in 1861, but its dedication ceremony was postponed until after the Civil War.

On Broadway Avenue in 1865, the Independent Order of Odd Fellows of the United States erected a monument to its founder, Thomas Wildey, who first organized the beneficent self-help organization at the city's Seven Stars Tavern in 1819. More than 50,000 people attended the dedication ceremony, including the general of the Baltimore garrison and prison along with his inmate Jefferson Davis, former president of the Confederacy, both of whom were Odd Fellows. These two boys are standing in front of the monument at about the turn of the century.

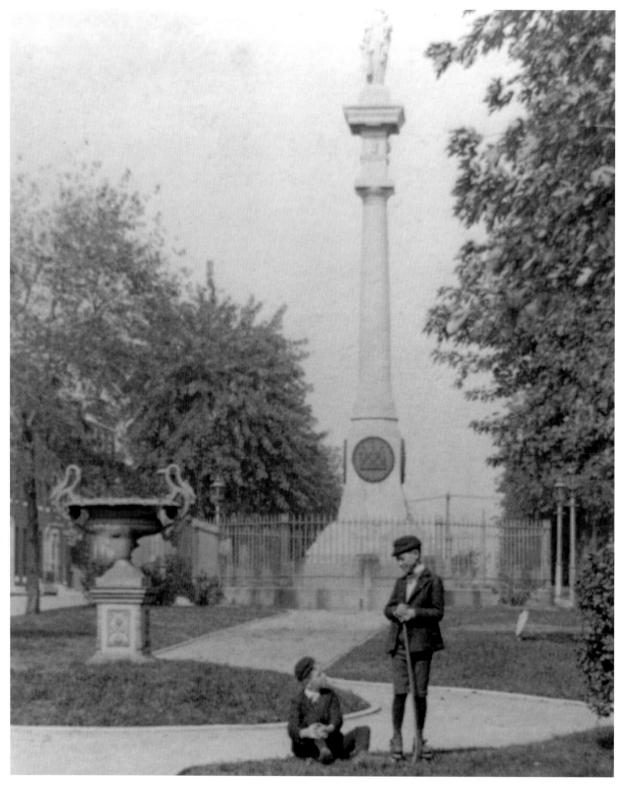

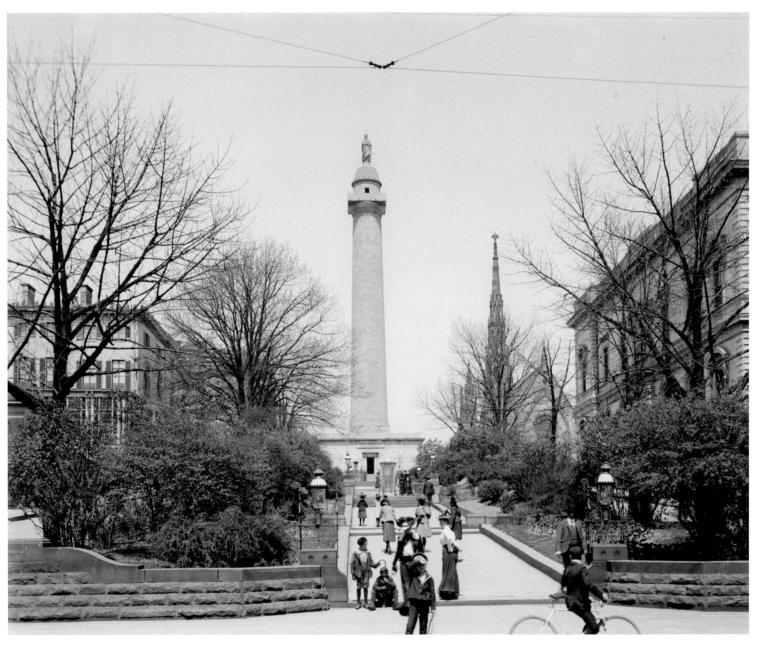

Baltimore's soaring Washington Monument, America's first public monument to George Washington, was designed by the noted South Carolina architect Robert Mills and begun in 1815. The monument's capital would be in position by 1820; still, seven years would pass before Enrico Causici, an Italian sculptor brought to America to work on the United States Capitol, would begin work on the 16-foot high representation of the commander in chief, standing boldly atop, dressed in a Roman toga and captured in the act of resigning his military commission.

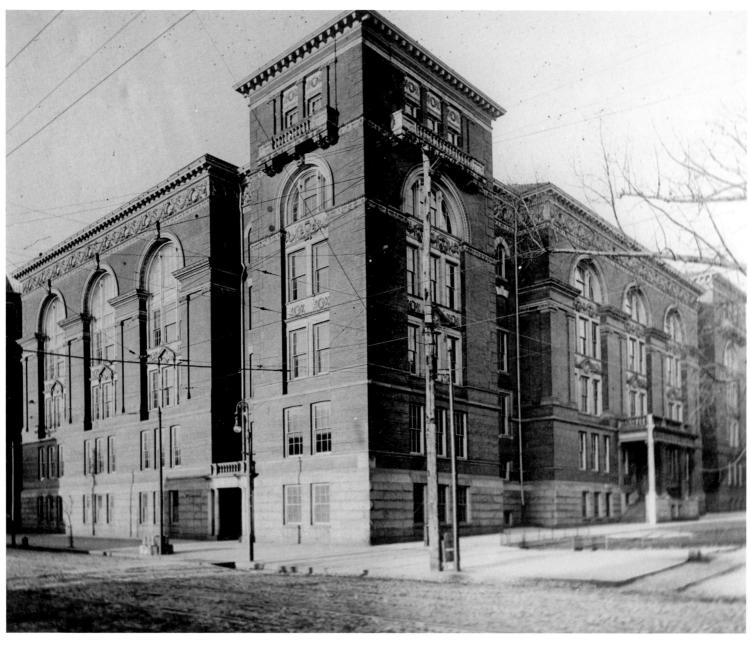

Founded in 1839, Baltimore City College is said to be the third-oldest secondary school in the United States. Located at Howard and Center streets beginning in 1875, the school moved into this building in 1899 after construction of the railroad tunnel under Howard Street undermined the previous building and caused its collapse.

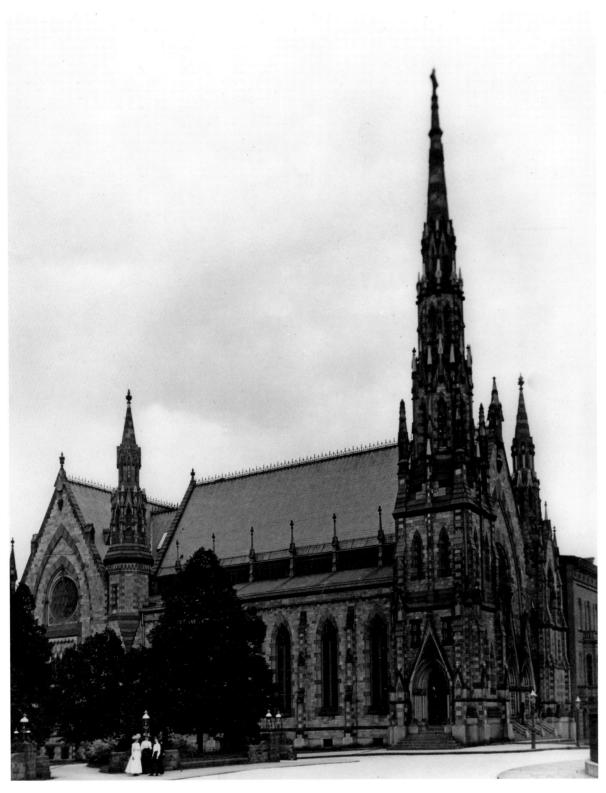

The most striking High Victorian Gothic church built in Baltimore was undoubtedly the First Methodist Episcopal church, located on Mount Vernon Square and seen here about 1900. Completed in 1872 and designed by architect-partners Thomas Dixon and Charles Carson, the church was intended to be a "Cathedral of Methodism."

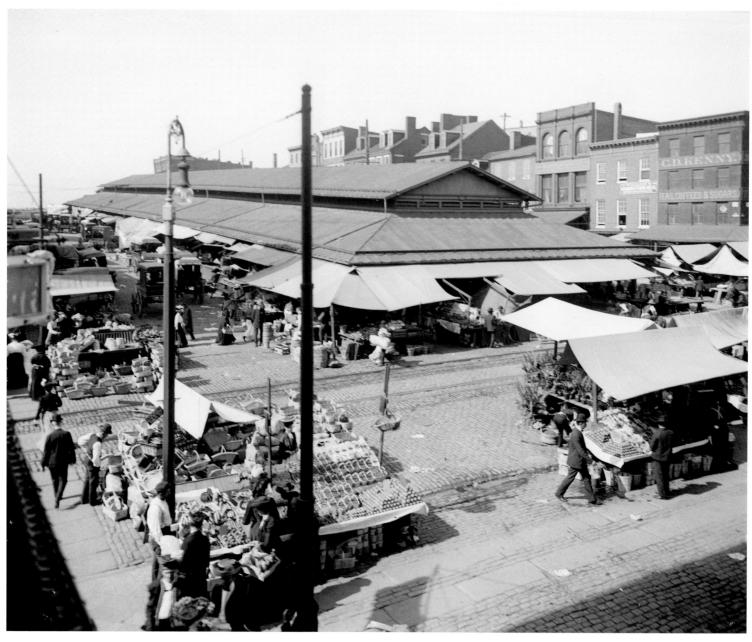

Lexington Market in 1900 remained a vital part of community life, attracting an array of farmers, butchers, importers, bakers, merchants, and craftsmen, all plying their wares. The market was originally opened only on Tuesday, Friday, and Saturday, from 2:00 A.M. to noon.

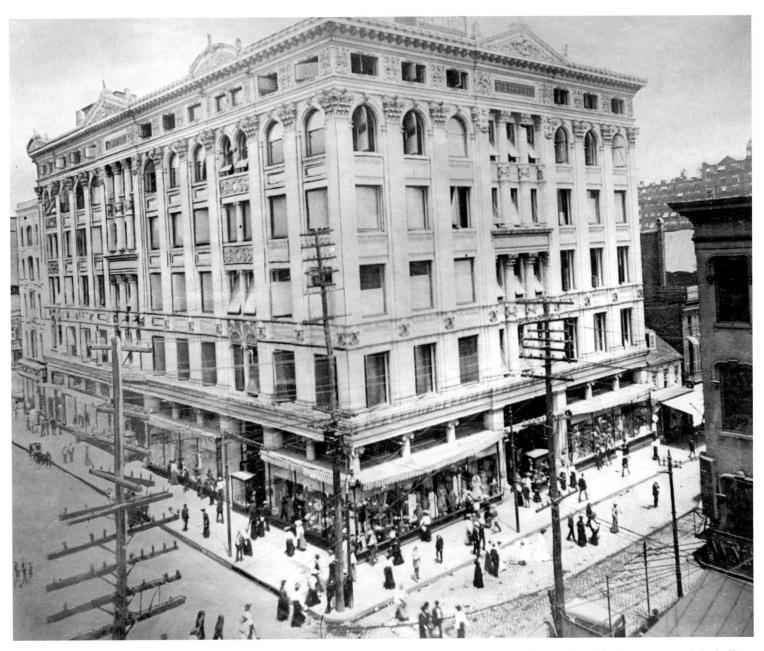

Shoppers found a plethora of offerings at Stewart and Company's department store, at the corner of Howard and Lexington streets. The hulking stone building acquired its name in 1901, when merchant Louis Stewart purchased what was then the home of Posner's Department Store, designed by the noted architect Charles Cassell in 1899.

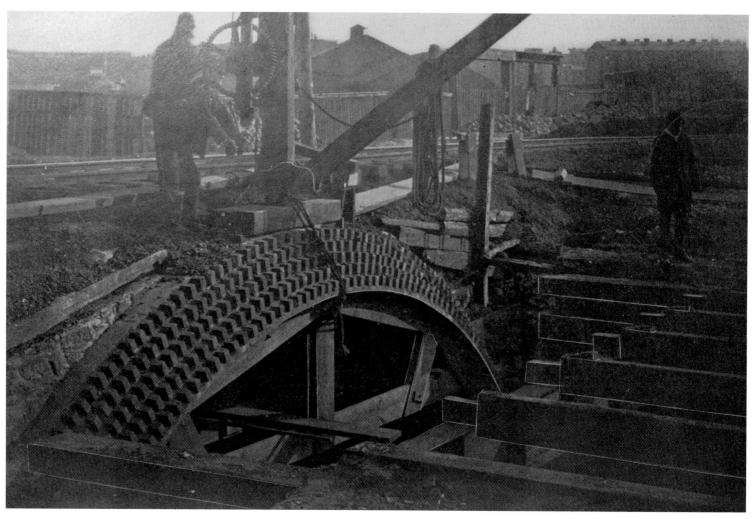

Under construction here in December 1901, the Boston Street Bridge, of brick arch design, replaced a metal girder bridge by which Boston Street had crossed over the Harris Creek sewer's outlet. A municipal project itself, the sewer was nearly 20 years old at the time the new bridge was built.

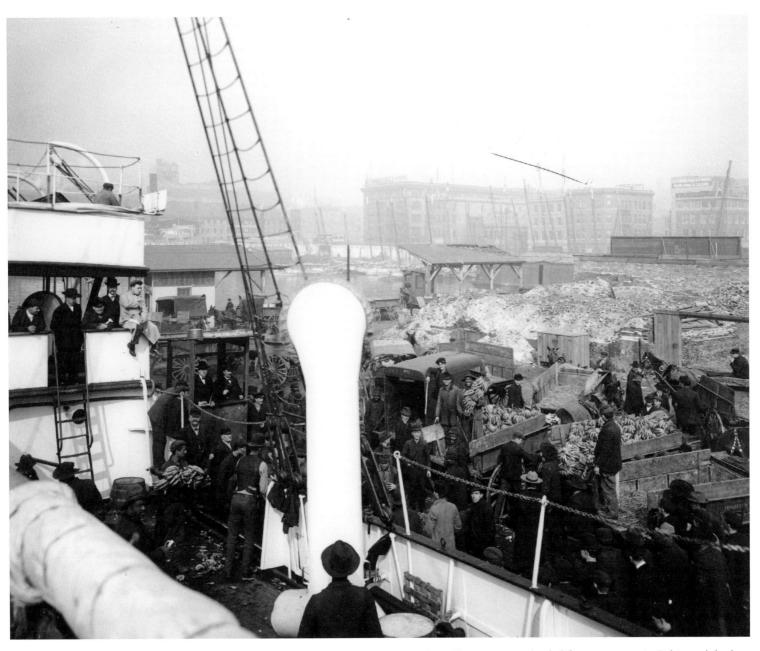

Fresh bunches of bananas are unloaded from a steamer in Baltimore's harbor.

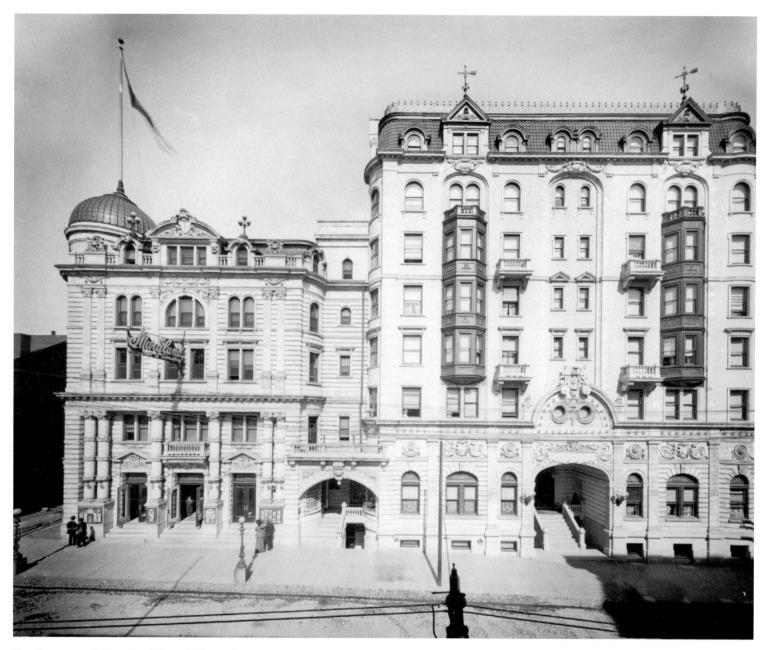

On the corner of West Franklin and Howard streets, entrepreneur James L. Kernan—a park commissioner and member of the city's jail board—built his Hotel Kernan and the adjacent Maryland Theater, opened in 1903. A popular music venue, the theater was home to the city's first jazz band, led by John Ridgely.

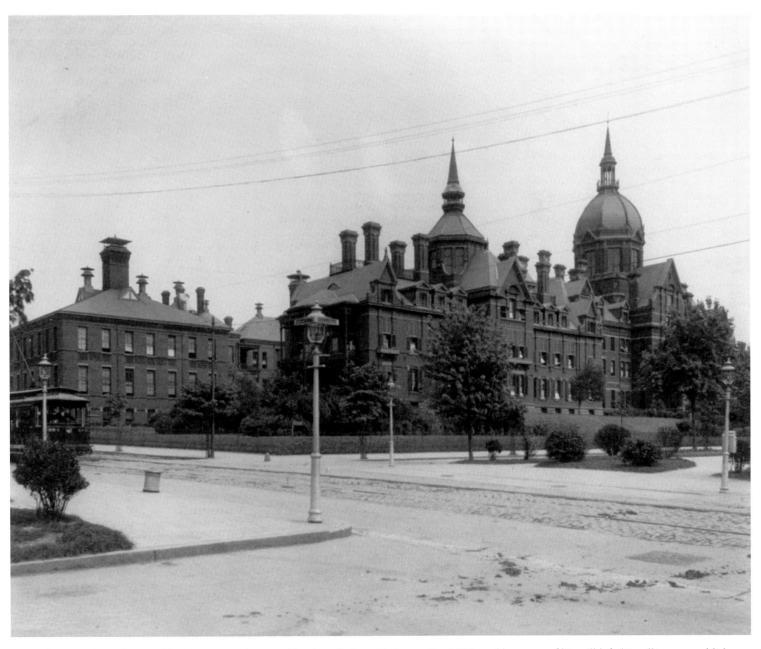

Johns Hopkins, the noted Baltimore merchant and banker, died on Christmas Eve 1873, and by terms of his will left \$7 million to establish two institutions: Johns Hopkins University and Johns Hopkins Hospital, the latter seen here about 1903. John Rudolph Niernsee was appointed architectural consultant for the hospital in 1876 and drew plans based on a revolutionary idea developed by the Army physician John Shaw Billings, which called for a scheme of 20 or more separate buildings to reduce the danger of spreading infectious disease. Work on the main administration building began in 1877, following a design from the Boston architectural firm of Cabot and Chandler, and would proceed for 12 years.

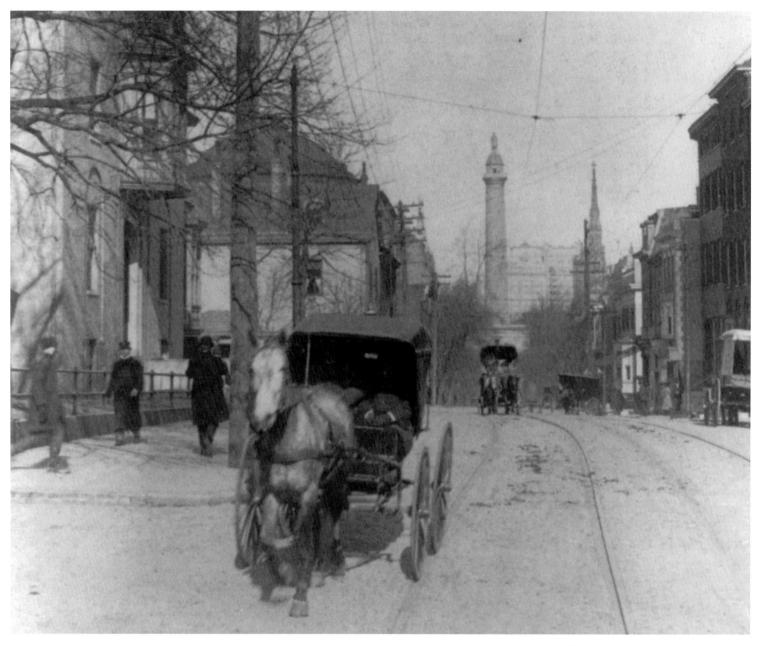

Born in Baltimore in 1834 and raised partly in his parents' native Ireland, James Gibbons returned to the place of his birth in 1877, where he was appointed coadjutor archbishop and then archbishop of Baltimore. In 1886 he became the second man from the United States to be invested as a cardinal. His home, in the left foreground, stood on North Charles Street a few blocks south of the Washington Monument.

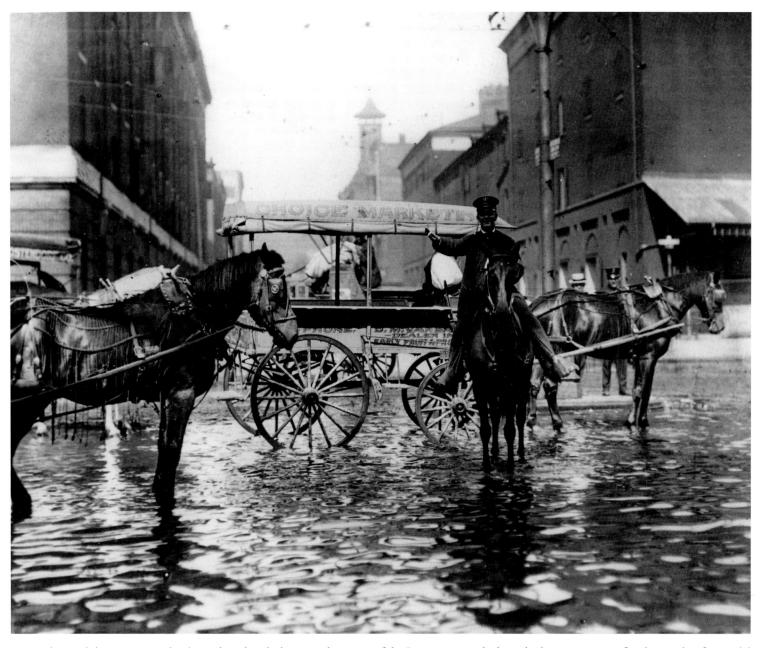

Baltimore's location at sea level, combined with the myriad streams of the Patapsco watershed, made the city prone to flooding, either from tidal surges or torrential downpours. Here at turn-of-the-century Light Street, near the city docks, a policeman guides carts and horses through the standing water.

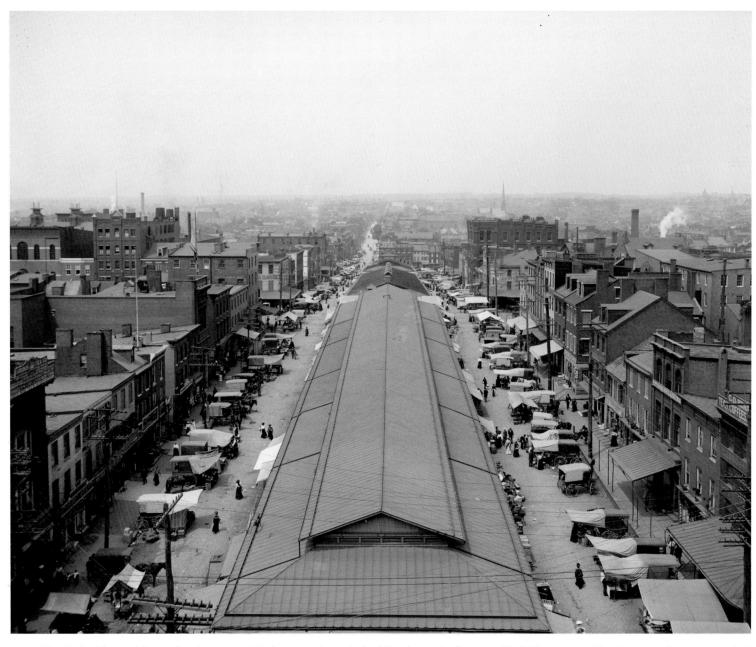

The city's oldest public market, Lexington Market, experienced a building boom in the post–Civil War years and by the turn of the century had grown into a sweeping, single-story structure of enormous length, surrounded by brick residential and commercial buildings.

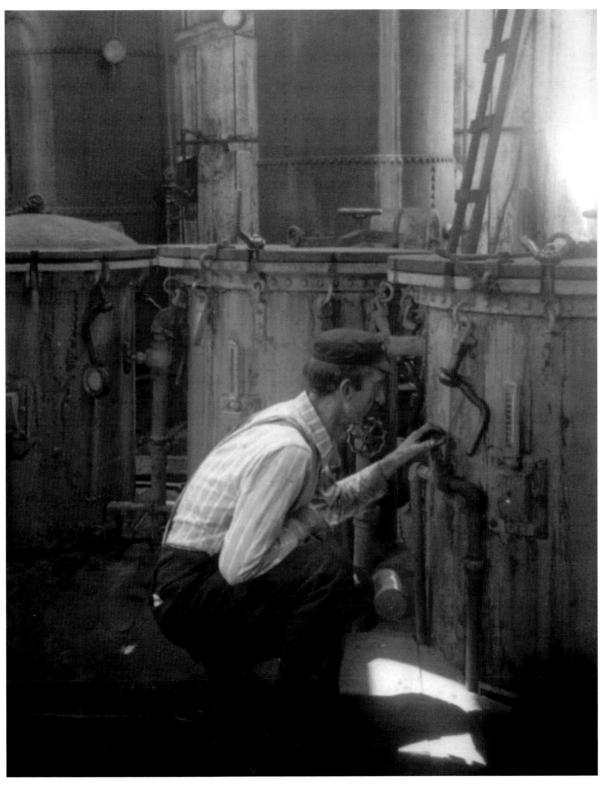

A cannery worker in early twentieth century Baltimore inspects one of the many processing kettles used to treat oysters before canning.

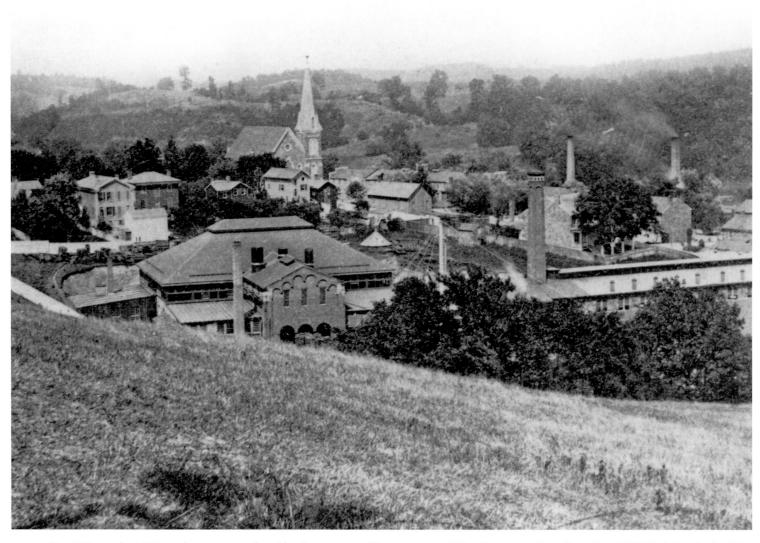

By 1870, nearly 3,000 workers were employed by the various milling concerns at Woodberry, seen here from Druid Hill Park. Entire families, including children, worked 12-hour days; in return, patriarchal owners built housing, schools, churches, libraries, and savings and loans associations for their workers.

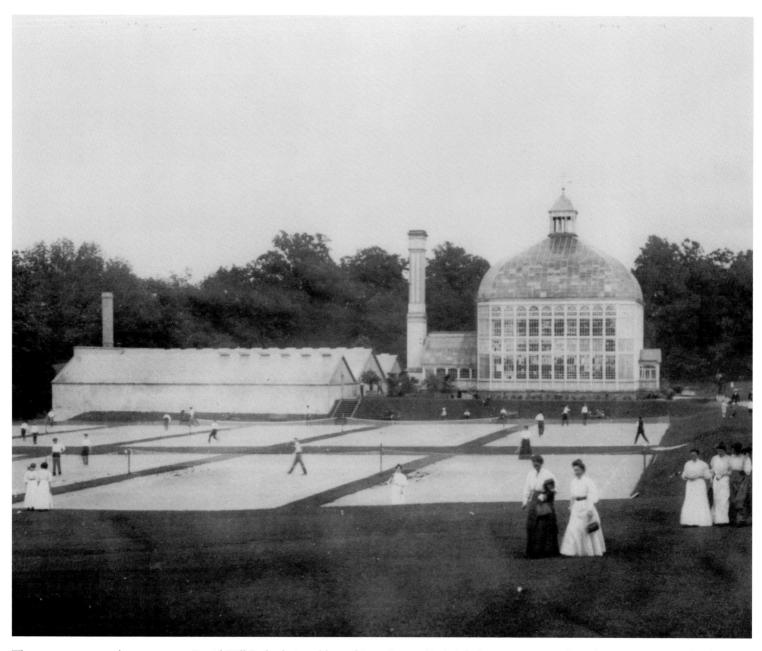

The conservatory at the entrance to Druid Hill Park, designed by architect George Frederick, began in 1888 as the Palm House, a uniquely shaped glass building that housed a botanical garden offering park visitors the pleasure of moving among exotic flora. Adjacent stood the park's lawn-tennis grounds.

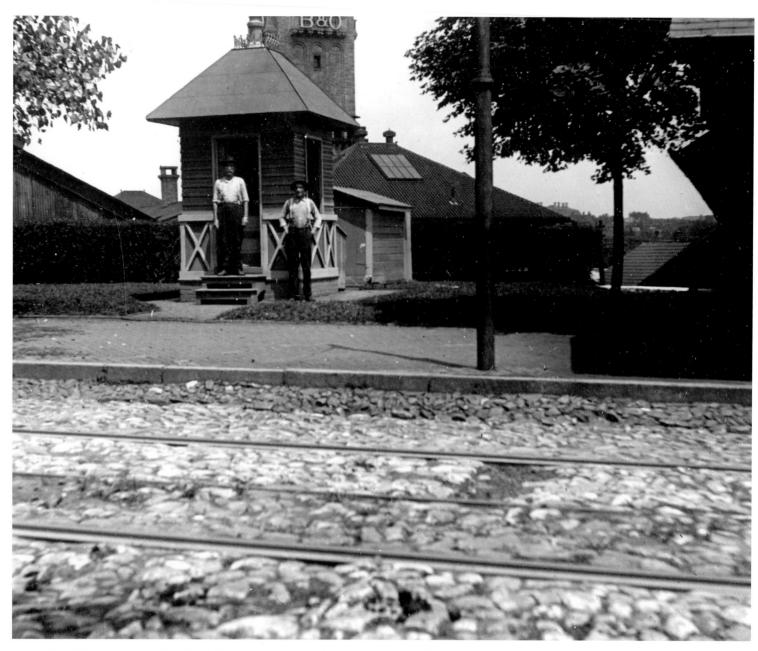

Mount Royal Station, designed by the Baltimore architectural duo of E. Francis Baldwin and Josias Pennington and opened in 1896, served the nation's first electric locomotive main line, established by the B&O in 1895 and known as the Baltimore Belt Railroad. The line was electrified to resolve safety issues created by smoke that billowed out of the steam locomotives as they passed through the 1.25-mile-long tunnel situated under a residential section on Howard Street—the smoke not only obscuring tunnel signals but considered a serious health hazard to neighbors. Rising in the background is the station's 150-foot clock tower, its heavy granite walls belying the rich ornamentation of the station's interior.

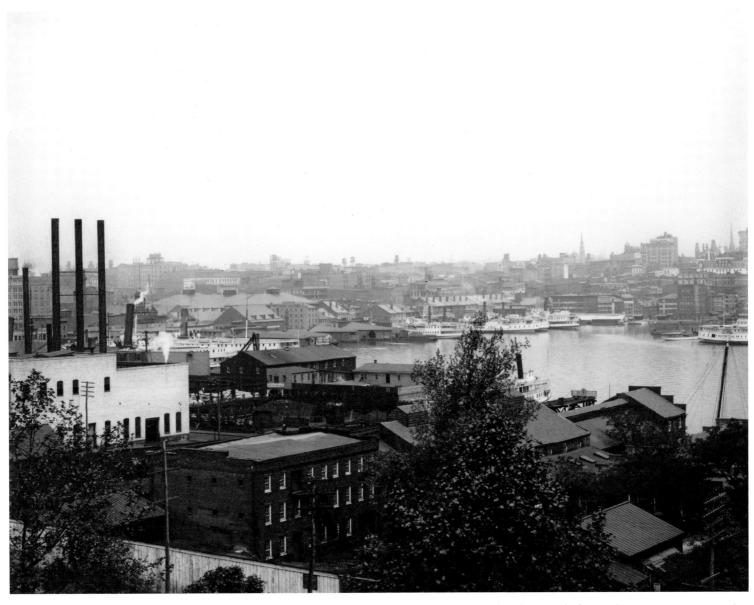

Prominent in this view from Federal Hill, about 1903, are the smokestacks rising from the United Railways and Electric Company power generating plant begun in 1895 and located at Pier 4. The plant held huge coal-fired engines that produced the electricity for the city's streetcar system.

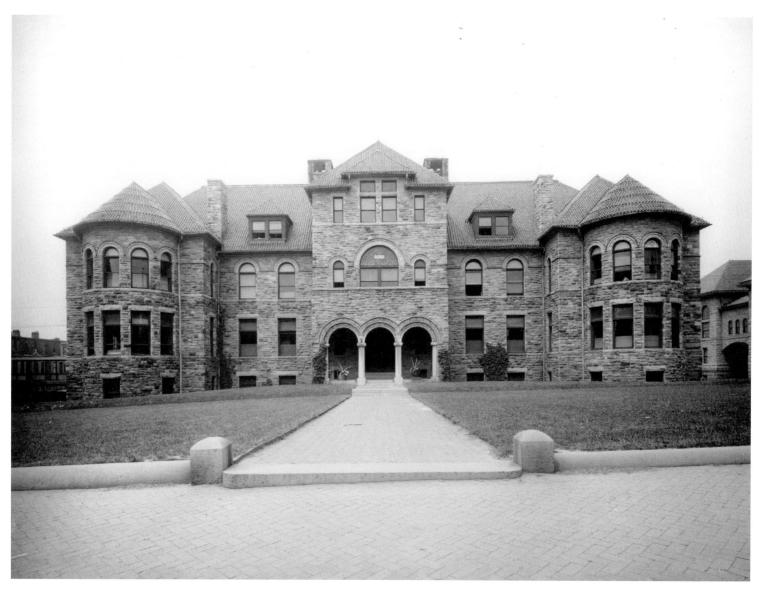

Seen here about 1903, Goucher Hall, designed by Charles Carson in a heavy Romanesque style, was constructed in 1887 as the central building for the Women's College of Baltimore, the Methodist school begun two years earlier by ministers Dr. John Goucher and John B. Van Meter. In 1910 the school was renamed Goucher College in honor of its founder.

DISASTER CONVERTED

(1904 - 1939)

Sunday morning, February 7, 1904, the peel of church bells over Baltimore gave way to the clang of alarms as fire engines raced through the city streets toward a widening pillar of black smoke rising from the heart of downtown. A fire had blown the roof off Hurst and Company's dry goods store. With frightening speed the conflagration, aided by a high southwest wind, spread to adjacent buildings, sweeping down the block, rapidly eating its way through the city. By the time it was over, more than 80 blocks in the heart of the business district had been consumed, more than 175 acres scorched, more than 2,500 buildings destroyed. Miraculously, not one life was lost.

Quickly, merchants, politicians, civic leaders, and citizens—the wealthy and the laboring classes alike—set to the task of rebuilding the city, and in the process brought an even greater vitality to the downtown area. As the Baltimore American reported in 1906, "one of the great disasters of modern time has been converted into a blessing." Improvements were initiated on city streets, along trolley lines, down at the harbor, and below ground; the new sewer system was considered one of the most modern of its time. Sturdy new structures of brick and steel and stone created a modern skyline.

The city's five railroad stations hosted hundreds of passenger and freight trains, while its 13 steamship companies plied a coastal and overseas trade. Financial interests were handled by 21 national and nine local banks, while 13 trust companies controlled a large portion of industry. National corporations such as the pioneering aeronautical firm of Glenn L. Martin were establishing Baltimore bulkheads. By 1920, expanding jobs helped push the population to 733,826.

Then, in October 1929, the bubble burst; the economy, stretched to the limits by rampant speculation, came crashing down and the Great Depression ensued. The effects hit Baltimore hard. On September 31, 1931, the Baltimore Trust Company closed its 32-story skyscraper; by 1933, the governor of Maryland closed all banks in an attempt to prevent mass withdrawals. For the next six years, Baltimore spiraled deeper into despair. During the latter half of the 1930s, federal resources would attempt to keep Baltimore afloat—funding engineering projects, constructing new government buildings—but ultimately, it would be the outbreak of war that would pull the city from its economic morass.

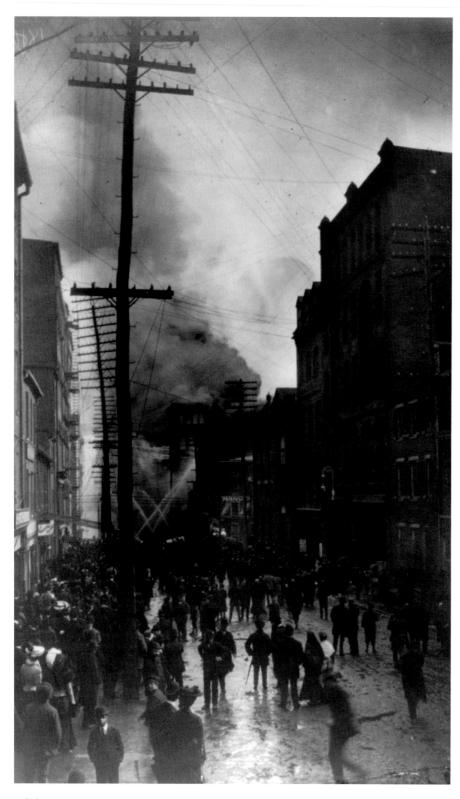

The Great Fire broke out Sunday morning, February 7, 1904, at Hurst and Company's dry goods store at the corner of Liberty and German (now Redwood) streets. Seen here is the Hurst building just 15 minutes after the first alarm.

Fire fighters couldn't contain the 1904 Hurst fire—seen here 25 minutes after the first alarm—and it began to sweep down the block, rapidly eating its way toward Charles Street. Soon fire fighters turned to dynamiting buildings in the fire's path, hoping to halt its horrible progress, but to no avail.

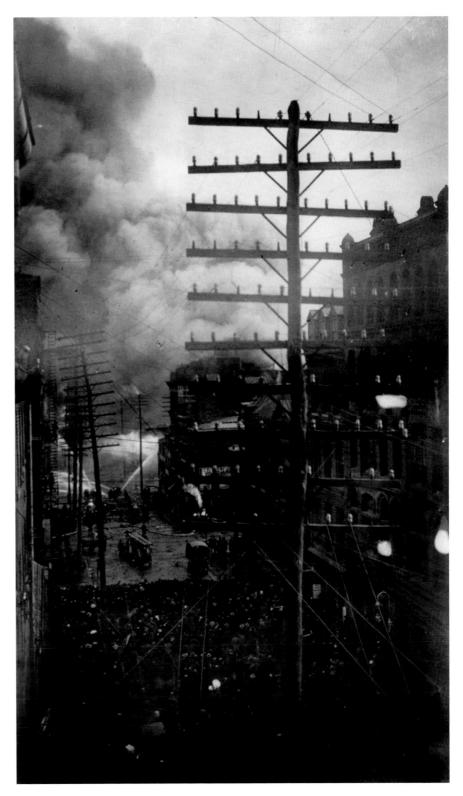

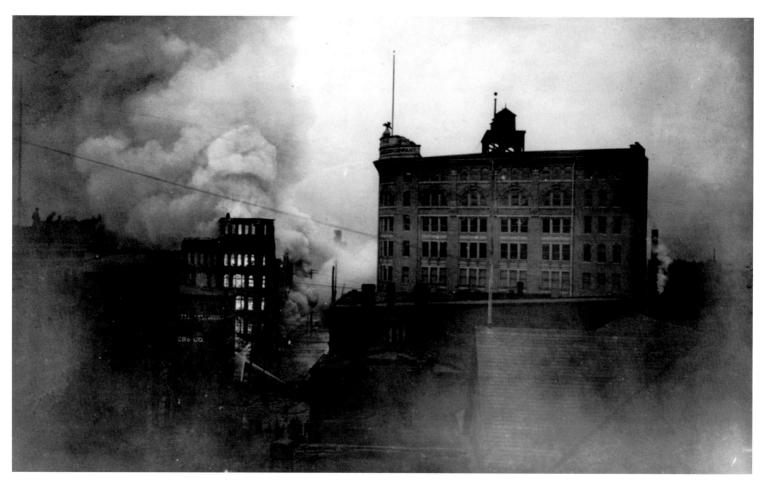

Here flames prepare to engulf the Guggenheimer and Wells building as, within hours of the first alarm, the city's business district becomes an inferno. By Sunday afternoon the flames were climbing the sides of the supposedly fireproof skyscrapers along Fayette Street, shooting sparks hundreds of feet into the air, igniting surrounding structures. The *Sun* newspaper's venerable iron building, believed to be imperishable, was completely destroyed in the 1904 fire.

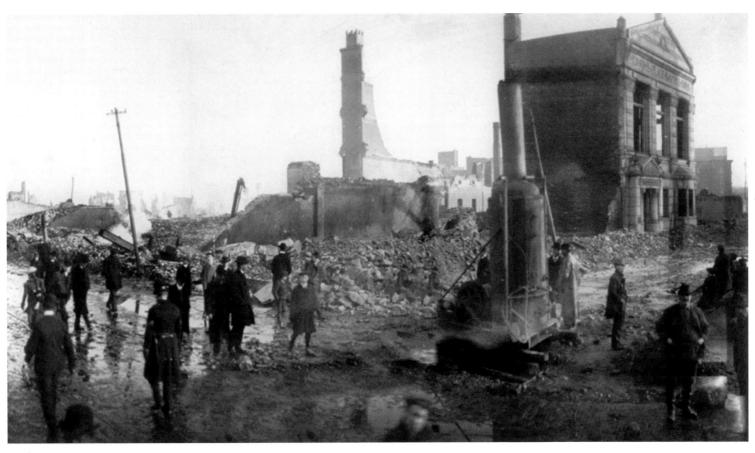

All through the night and into Monday morning, the blaze burned on, the flames leaping from building to building, west of Jones Falls and then, with a shift in the wind, south to the waterfront. Only the facade of the Hopkins Place Savings Bank remained standing.

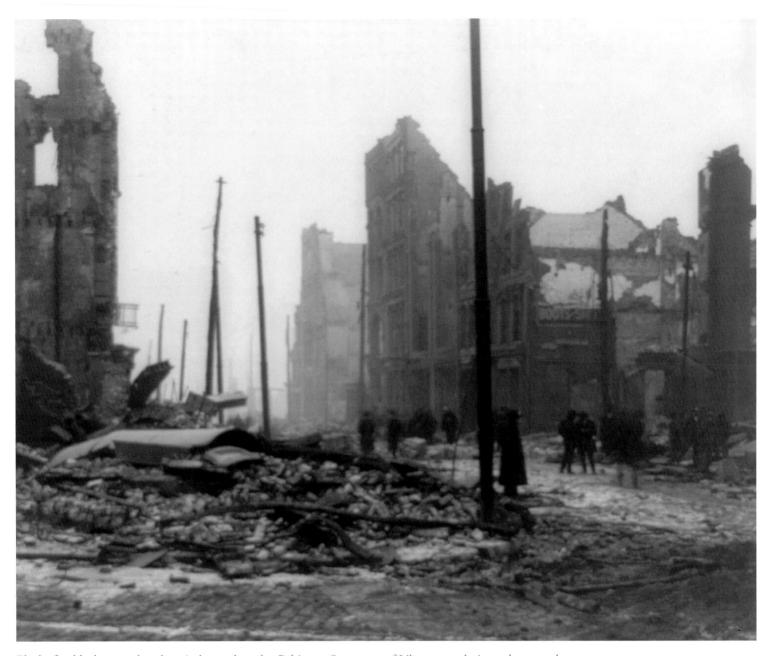

Block after block was reduced to cinders and smoke. Baltimore Street, east of Liberty, was decimated, as seen here.

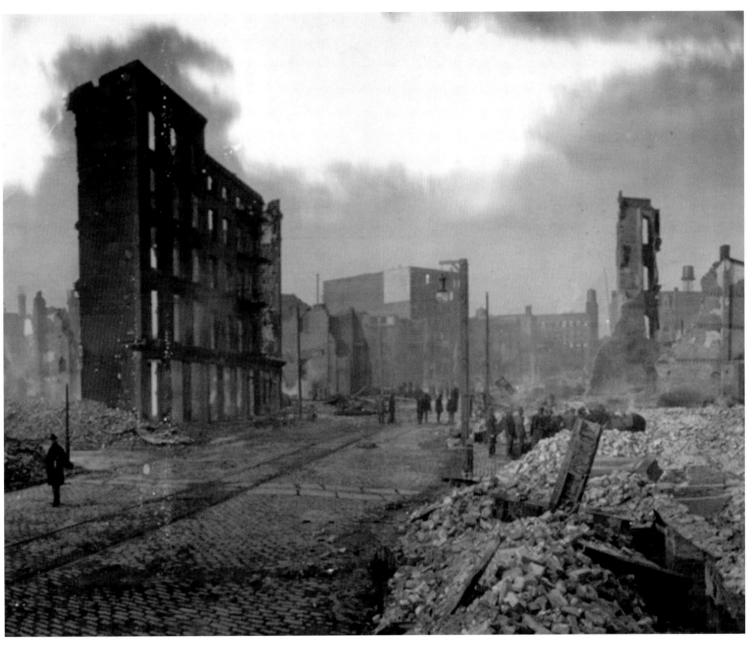

This area around Hanover Street was incinerated.

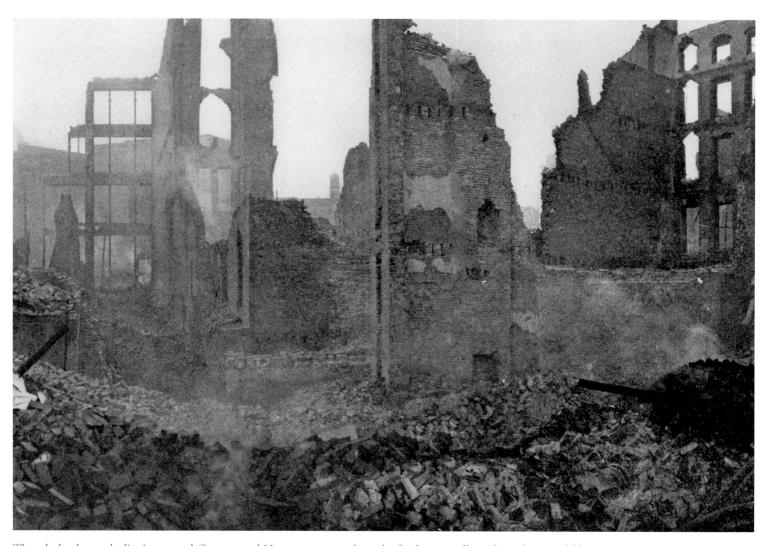

The wholesale-goods district around German and Hanover streets, where the fire began, collapsed into burnt rubble.

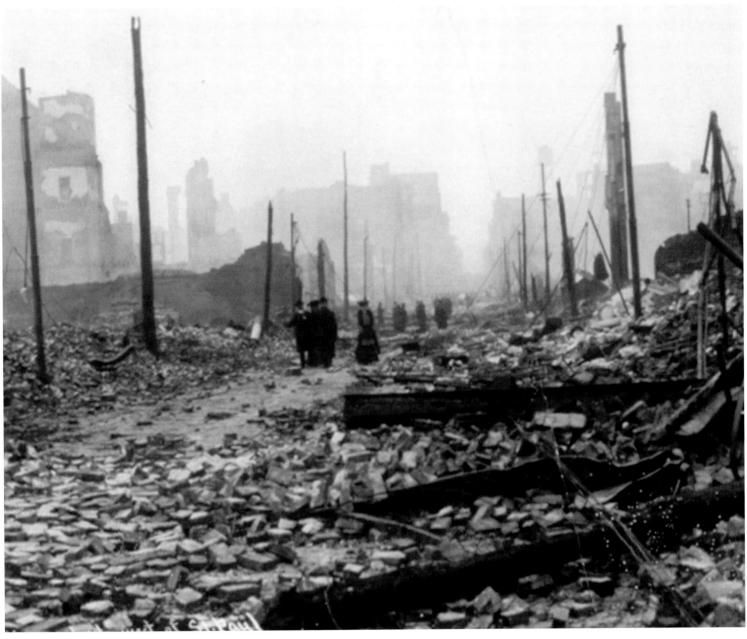

Baltimore Street, west of St. Paul, lay in ruins. Finally, by late Monday afternoon, February 8, an army of fire fighters from Baltimore, Washington, Wilmington, Philadelphia, and as far away as New York City had trapped the flames down at the piers, and with the valiant assistance of the fireboat Cataract, which pumped plumes of water up from the harbor, the Great Fire was finally conquered.

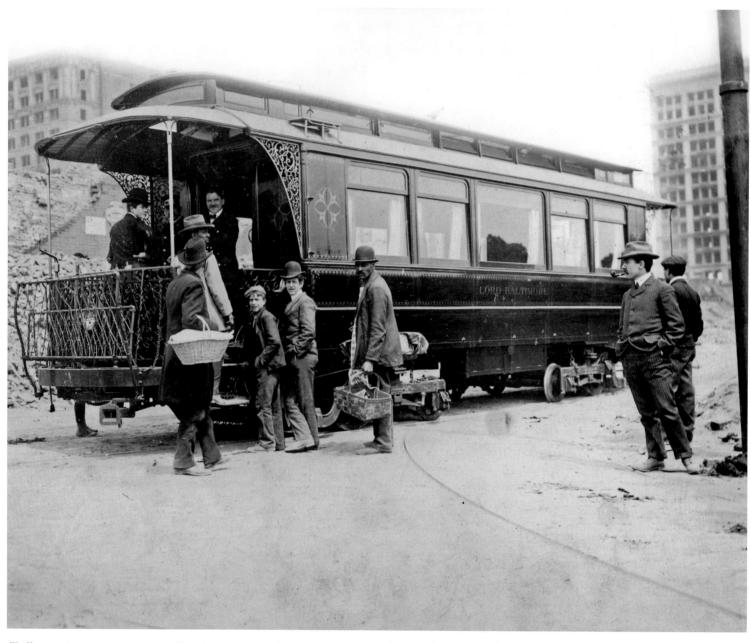

Trolley service was soon restored after the Great Fire, the cars running through the eerie remains. The quick restoration of the streetcars, like the *Lord Baltimore* seen here, did much to bind the city back together and get it working once more.

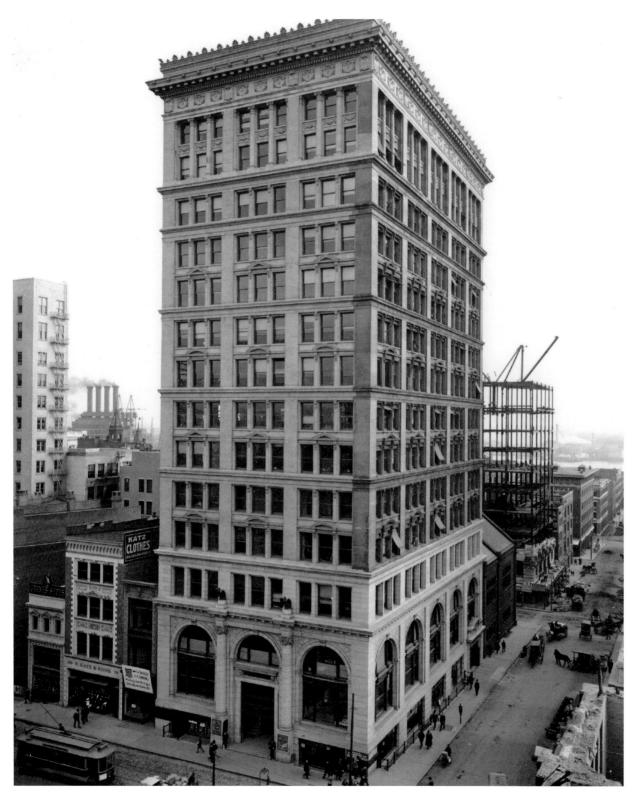

Designed by the famed Chicago architect Daniel H. Burnham in 1899 and completed in 1901, the Continental Trust Building, at the corner of Baltimore and Calvert streets, briefly stood as the tallest building south of New York. The building's steel-cage framework saved it from total destruction in the Great Fire of 1904; still, the severely damaged building was essentially reconstructed through the following year and is seen here about 1906. Dashiell Hammett, the celebrated American author, worked in the building from 1915 to 1918 as an operative for the Baltimore branch of Pinkerton's National Detective Agency.

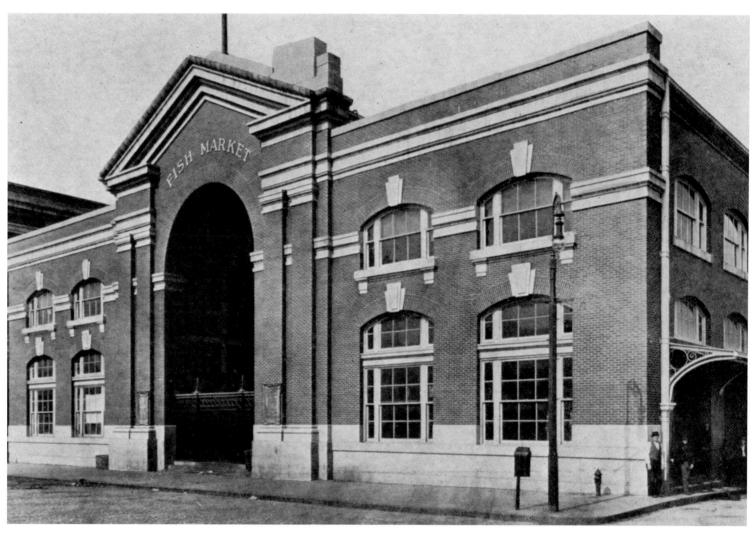

The Baltimore Fish Market, adjacent to the sprawling Center Market, dates to the eighteenth century and operated as the city's official wholesale seafood marketplace. The impressive brick building seen here was built after 1904, when the original structure was destroyed in the Great Fire.

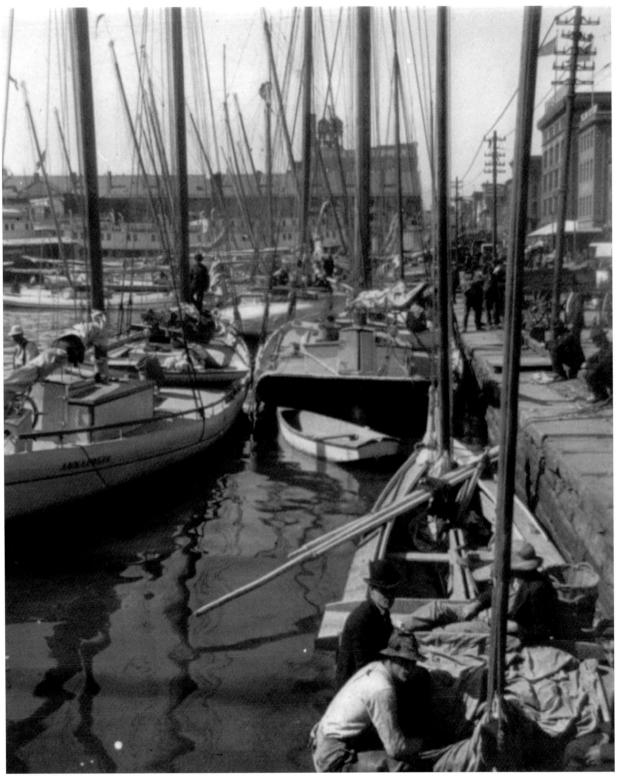

Oyster boats crowd the wharf on Pratt Street around 1905. The distinctive skipjacks were the boats of choice, often built by house carpenters or the watermen themselves. The name comes from the Chesapeake bluefish, which at times seems to skip along the water's surface. In 1910, 2,000 of these boats worked the bay.

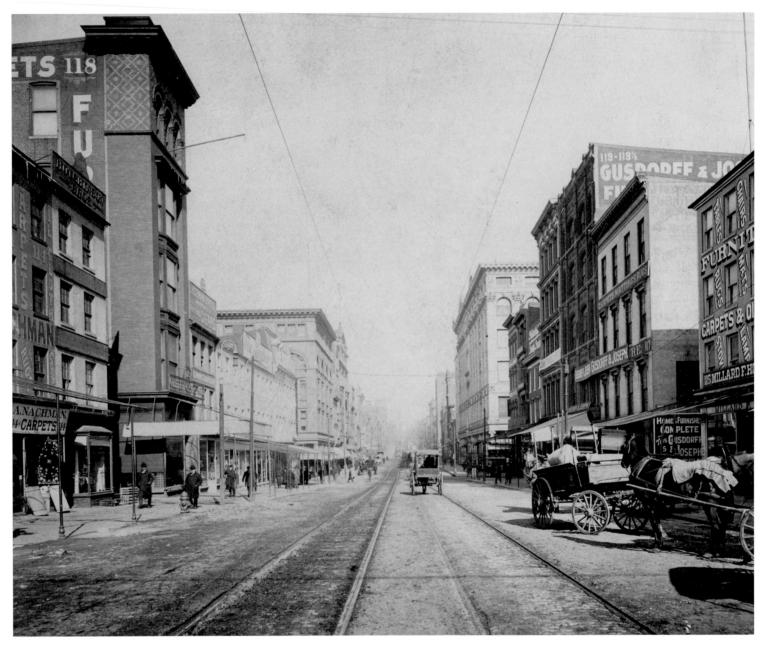

North Howard Street in 1905 was the furnishings center of town; all manner of shops lined the streets, touting an endless array of items prime for interior design, from floor coverings to the latest styles of mass-produced furniture.

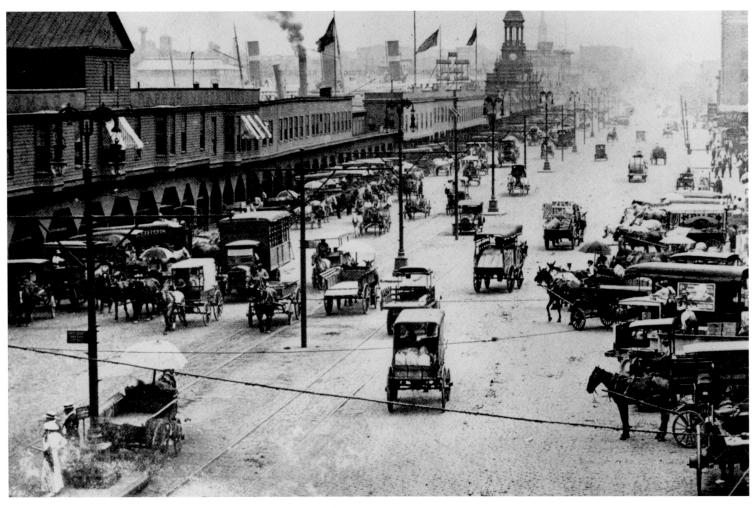

Life along the wharves in the early twentieth century remained bustling, although now on Light Street horse-drawn wagons intermingled with gasdriven trucks, vans, and Model T Fords, all carrying goods and passengers to and from the harbor.

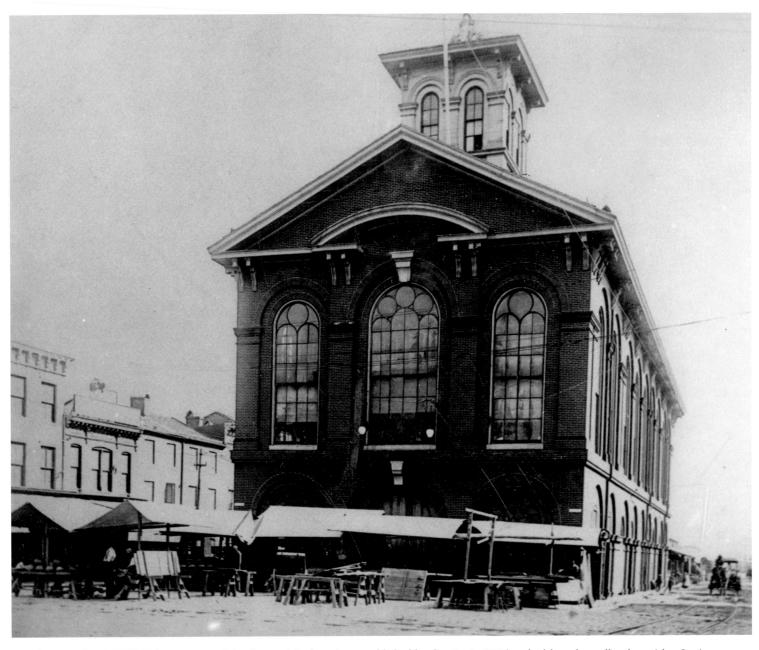

Broadway Market in Fell's Point was one of the three original markets established by the city in 1784 and, although smaller than either Lexington or Center Market, did a trade brisk enough to warrant the construction of a handsome, brick market building constructed in 1864.

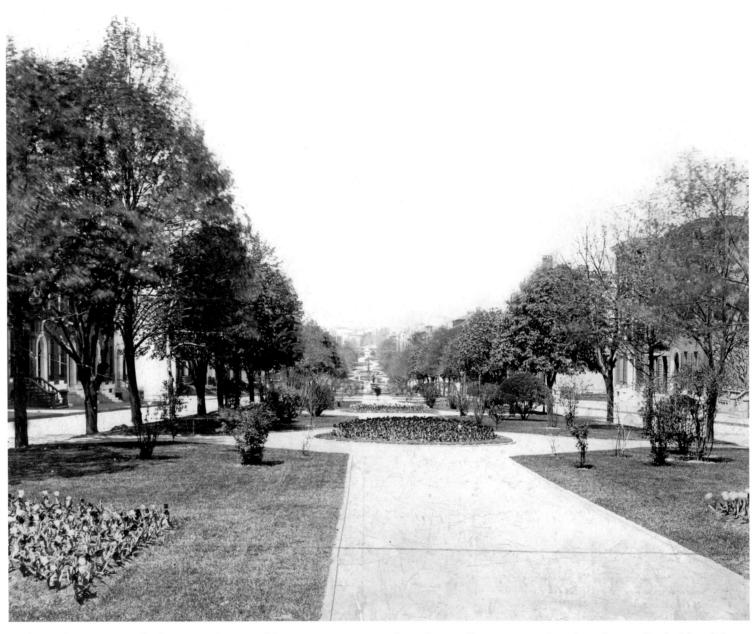

The northwest section of Baltimore at the turn of the century was an appealing mixture of large estates and manicured streets lined with stylish row houses. A major enticement for home seekers was Eutaw Place, which extended from Dolphin Street northward and was a gift from Henry Tiffany to the city in 1853. Seen here about 1905, the wide, ornately landscaped strip of greenery ran for nine blocks.

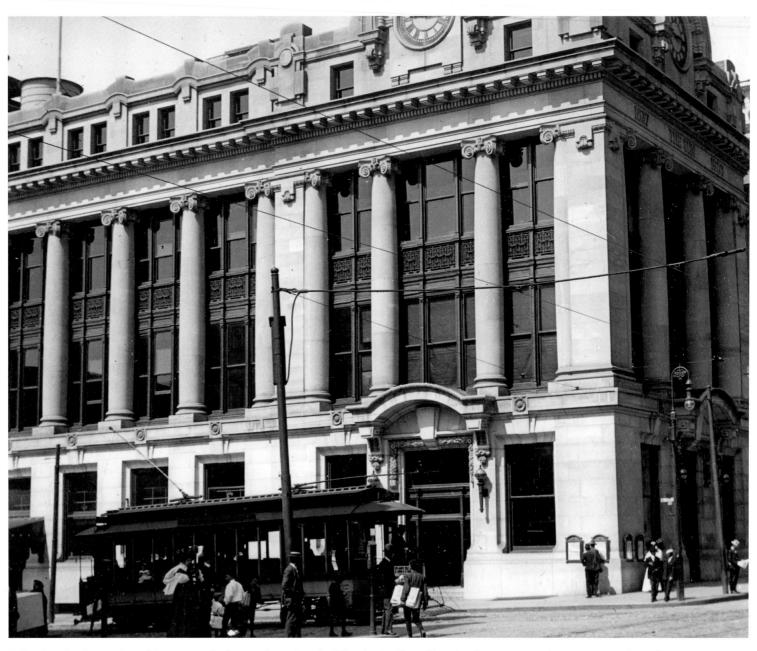

Following the destruction of its supposedly fireproof, cast-iron building in the Great Fire, the *Sun* newspaper began construction of a new headquarters, seen here, on the corner of Baltimore and Charles streets. The massive, classically inspired Sun Building opened for business in November 1906. That same year, a young editor by the name of H. L. Mencken joined the staff to manage the newly created Sunday edition. The celebrated author and American journalist would remain actively associated with the Sunpapers until a stroke suffered in 1948 forced his retirement.

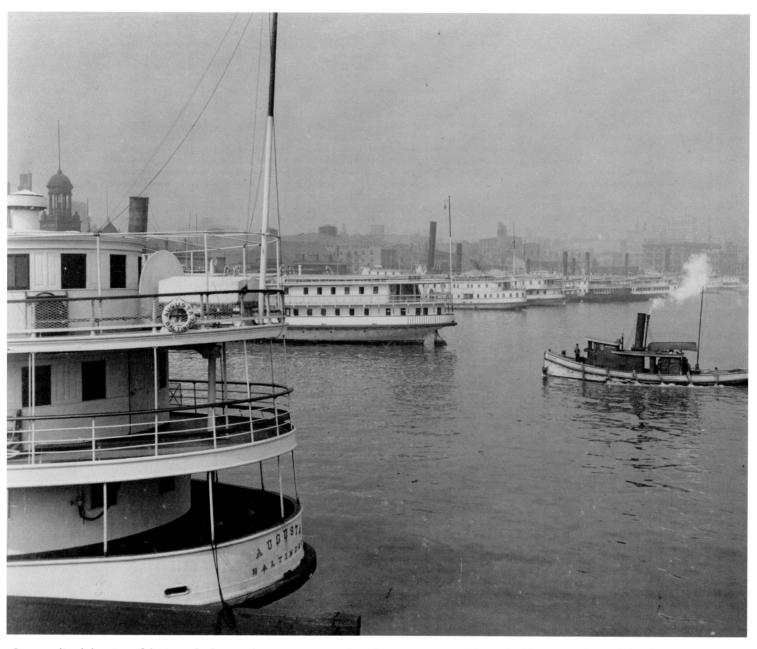

Steamers lined the piers of the inner harbor, ready to transport goods and passengers up and down the Chesapeake Bay and, by the 1870s, across the Atlantic to Liverpool, England, and Bremen, Germany. Chugging back to port here about 1905 is one of the city's inspection steamers, or tugboats, used to welcome new arrivals to the harbor, tow city barges and other vessels when required, and transport harbor officials to work sites.

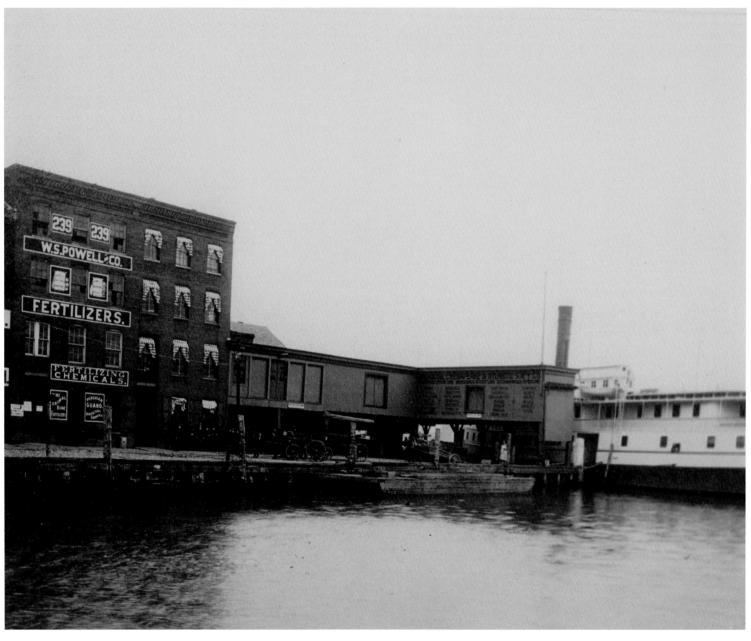

The discovery of the fertilizer guano—bird and bat droppings rich in phosphate and nitrogen—provided area farmers with a powerful means of reviving lands worn by centuries of cultivation. By the mid nineteenth century, Baltimore had become the nation's number-one importer of the natural fertilizer, and by the 1880s, fertilizers would become the second most economically important endeavor in the city, just behind men's clothing. At Bowley's Wharf, off Light Street—one of the first wharves established on the inner harbor—the warehouses of W. S. Powell, seen here in 1904, were filled with all manner of fertilizers and chemicals, including Peruvian guano.

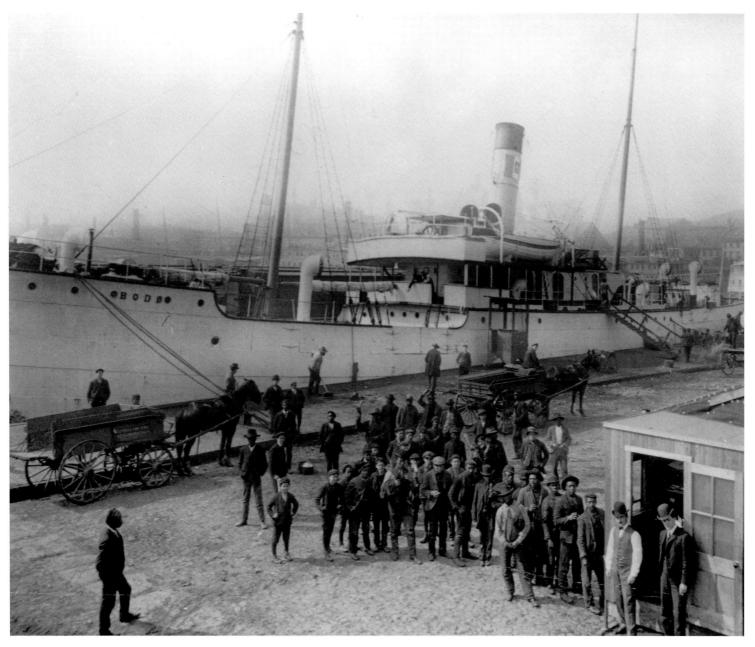

Around 1905, Baltimore stevedores, the port workers whose responsibility it was to load and unload the ships aligning the docks, line up at the paymaster's post to receive the day's wages.

The remnants of a winter's snow dot the sidewalks and perimeter of Howard Street around 1910, as a crush of trolleys carry passengers around the city and out to the steadily growing suburbs.

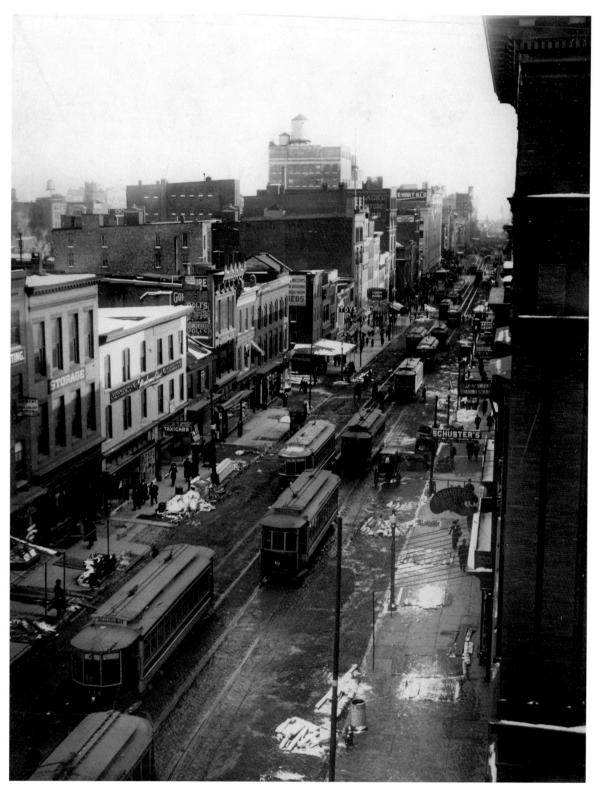

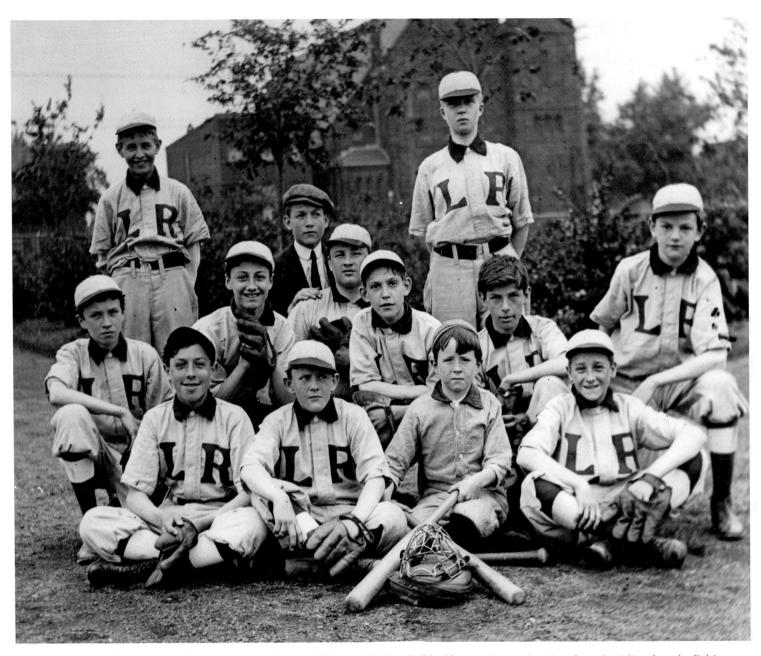

A team of young ballplayers poses for the Baltimore Camera Club in 1908. Baseball had been a city passion since June 4, 1860, when the Baltimore Excelsior Base Ball Club beat the Washington Potomacs in a game played on the Ellipse behind the White House in Washington, D.C. In a fantastically high scoring game, the Baltimore club won, 40–24.

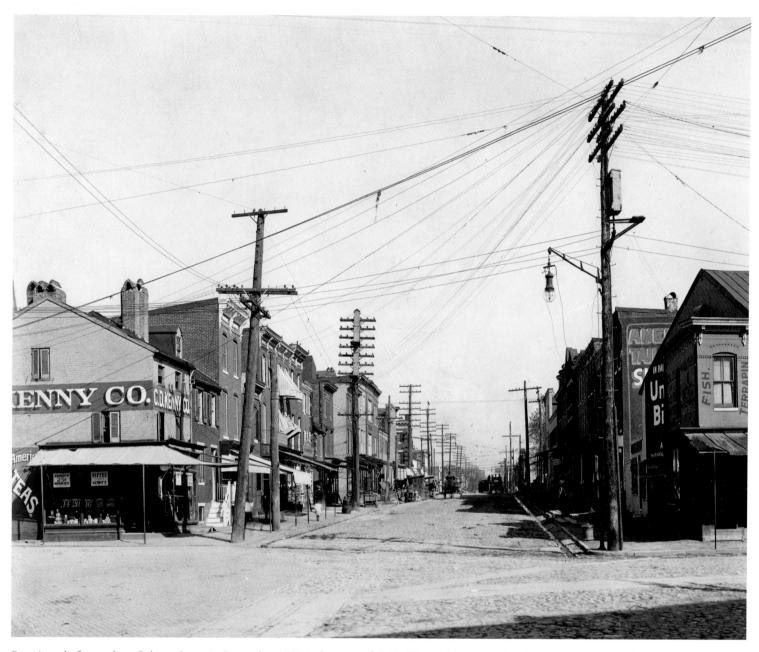

Prominently featured on Orleans Street in September 1908 is the store of C. D. Kenny Company, a local importer of teas, coffee, and sugar originally established in 1870. In 1939, Nathan Cummings borrowed \$5.2 million to buy the Baltimore-based company and immediately began to increase the number of Kenny-label products. The corporation continued to grow through acquisition and in 1985 consolidated all its companies under the name the Sara Lee Corporation.

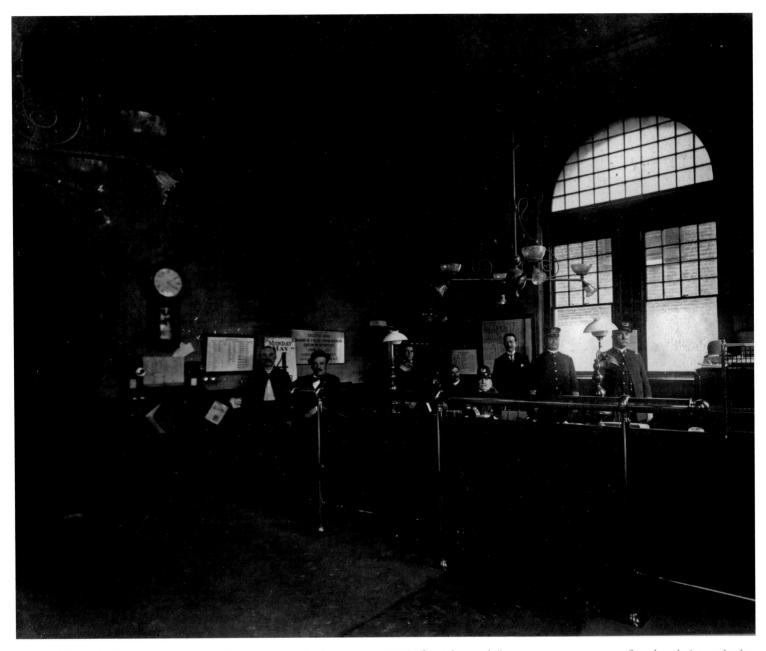

Baltimore had been developing a police force since the formation in 1784 of a night watch "very necessary to prevent fires, burglaries, and other outrages and disorders." By the time of this May 1908 photograph, the force was governed by a state board, appointed by the governor of Maryland.

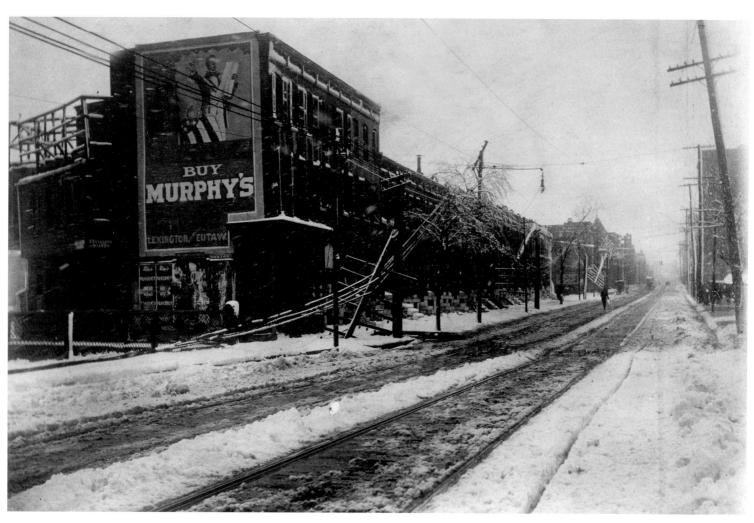

The weight of a late winter storm in March 1909 collapsed poles and trees along Preston Street west of Jones Falls.

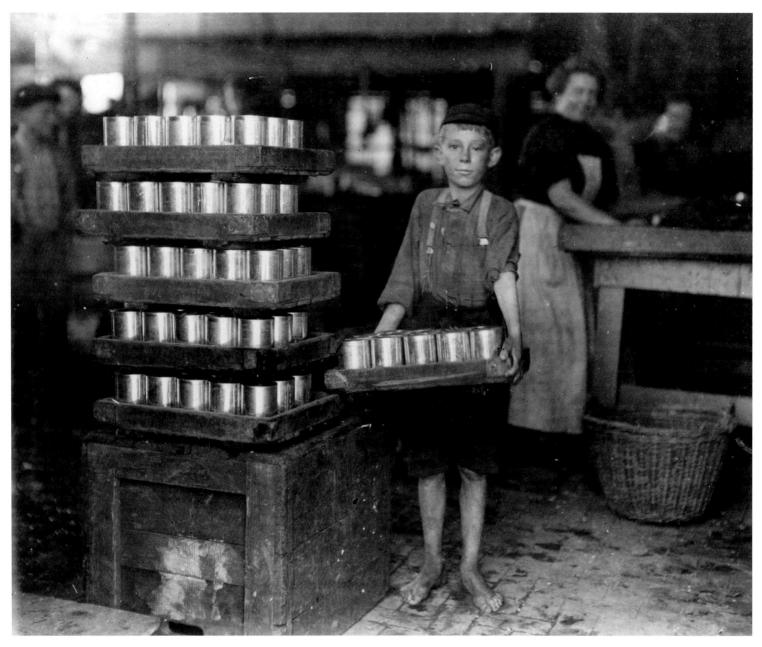

In 1907, Lewis Hine, a pioneering photojournalist, was contracted by the National Child Labor Committee (NCLC) to document incidences of child labor in American industry, to aid the group's lobbying efforts to end the practice. For the Maryland chapter of the NCLC, he photographed children around Baltimore in various occupations. Here he captures a young boy carrying a heavy load at the J. S. Farrand Packing Company in July 1909. Hine said his job was "to show things that had to be corrected."

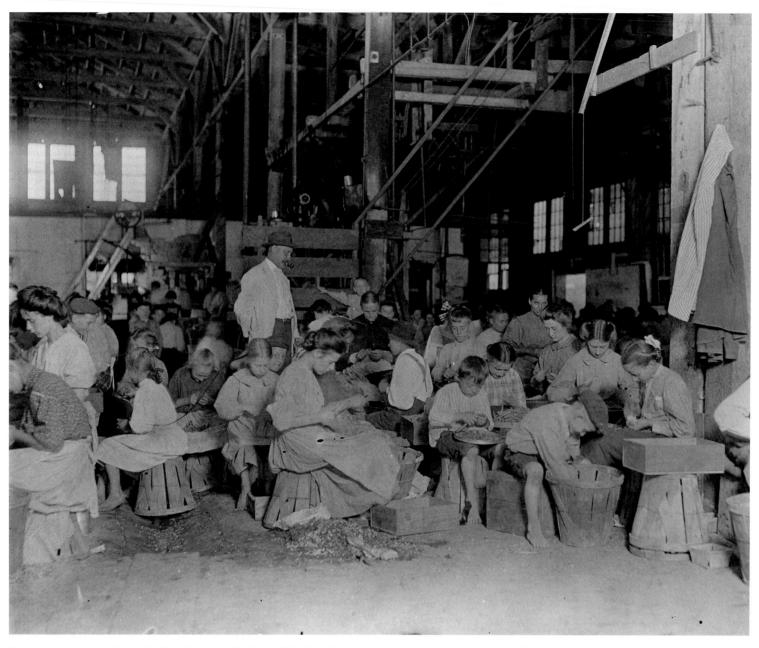

Young workers string beans by hand at the J. S. Farrand Packing Company in this 1909 image recorded by photographer Lewis Hine. Those with babies in tow held them on their laps while working or else "stowed' the babies in empty boxes, the NCLC record indicated.

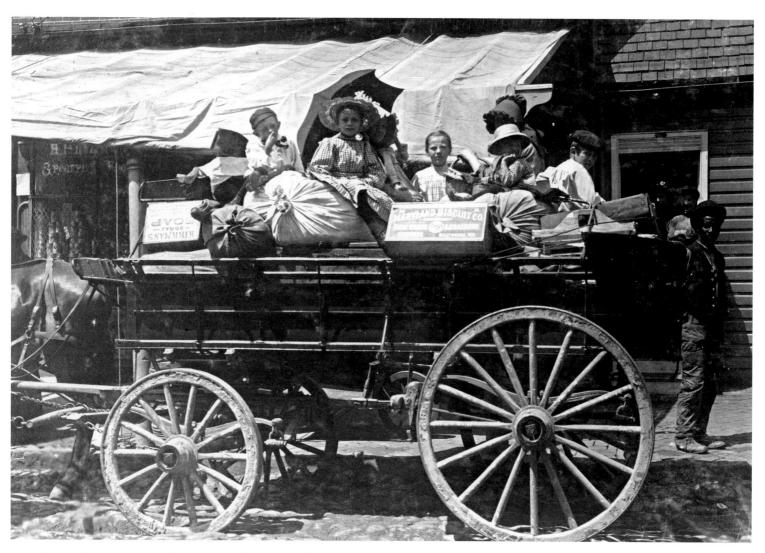

Lewis Hine photographed this wagon of children at Fells Point, ready to be taken to the berry farms in the surrounding Maryland countryside.

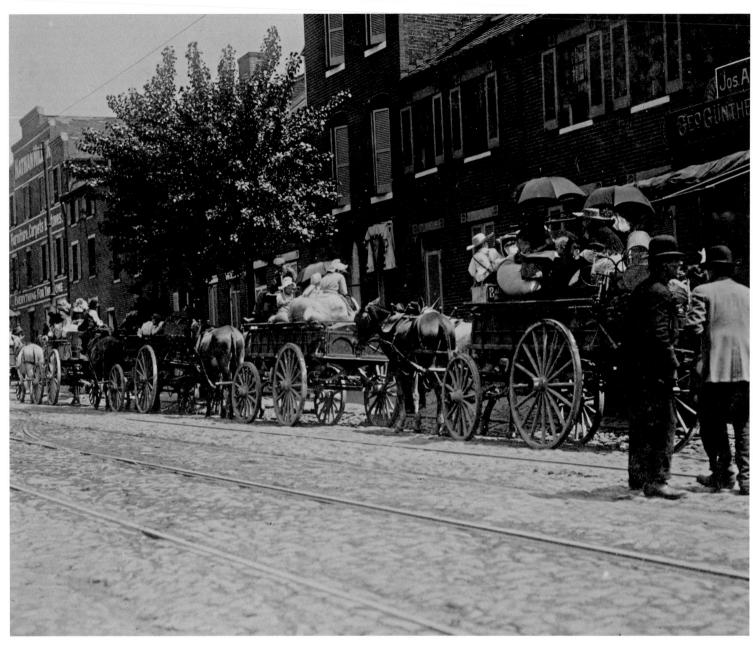

In 1910, Hine captured this image of Baltimore immigrants lined up on Wolfe Street, near Canton Avenue, ready to start for the country to pick produce on area farms.

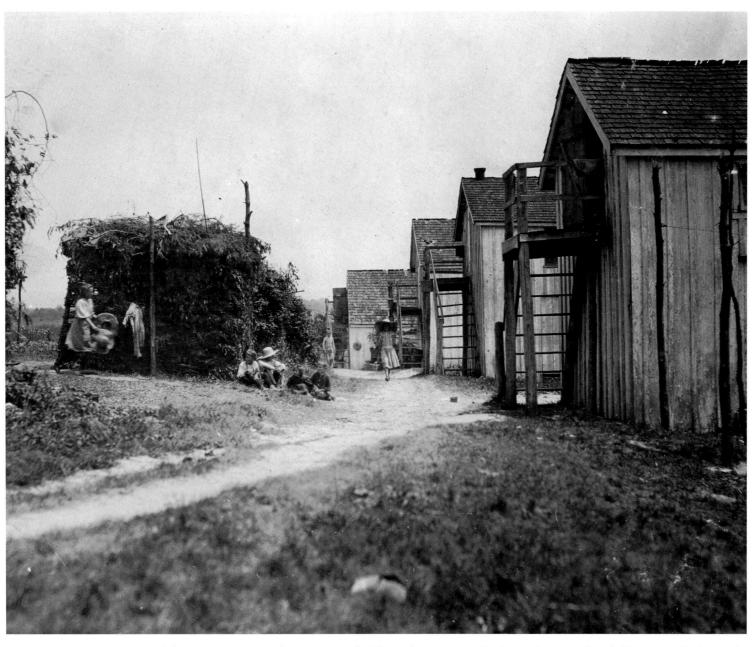

In 1909, Lewis Hine traveled with immigrant workers to Bottomley's berry farm, just outside the city limits, and took this picture displaying the working and living conditions. The cabins on the right housed as many as four families in each two-room shanty.

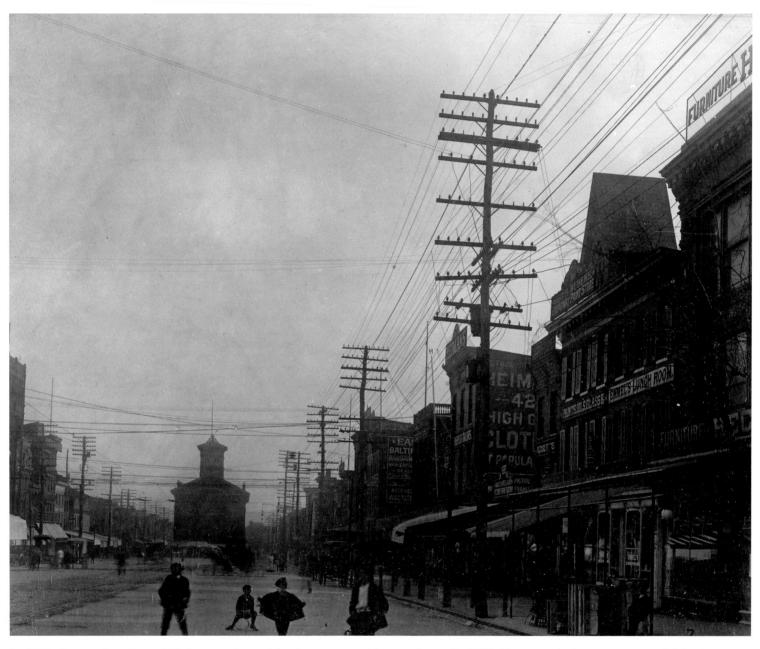

In 1857, city merchant Samuel Hecht opened a used furniture store on Aliceanna Street. By 1870, his venture had grown so successful that he moved to a more auspicious location on South Broadway, shown here in 1911. His name was carved in foot-high letters on the granite lintel over the doorway. By 1879 he had added clothing to his offerings, under the name of "Hecht's Reliable." He opened a carpet and matting store on West Lexington Street shortly thereafter.

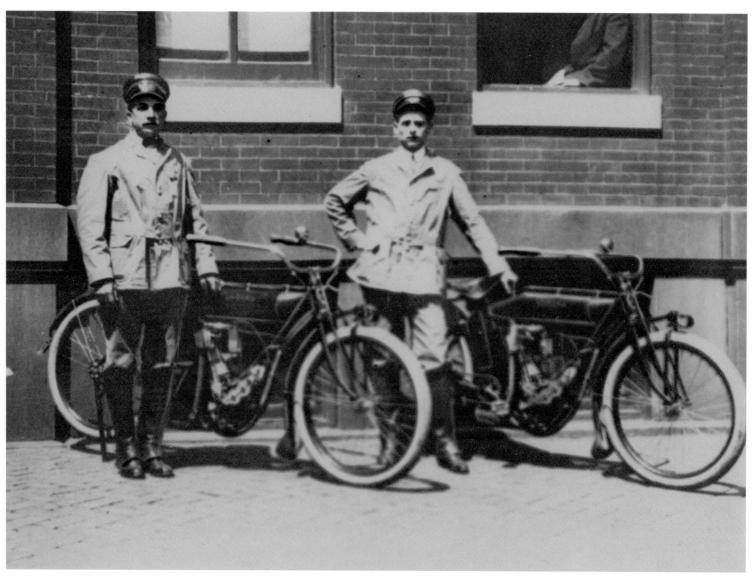

In 1916, the Baltimore police force purchased and put into service its first automobile and motorcycle, signaling the beginning of the end of the horse era.

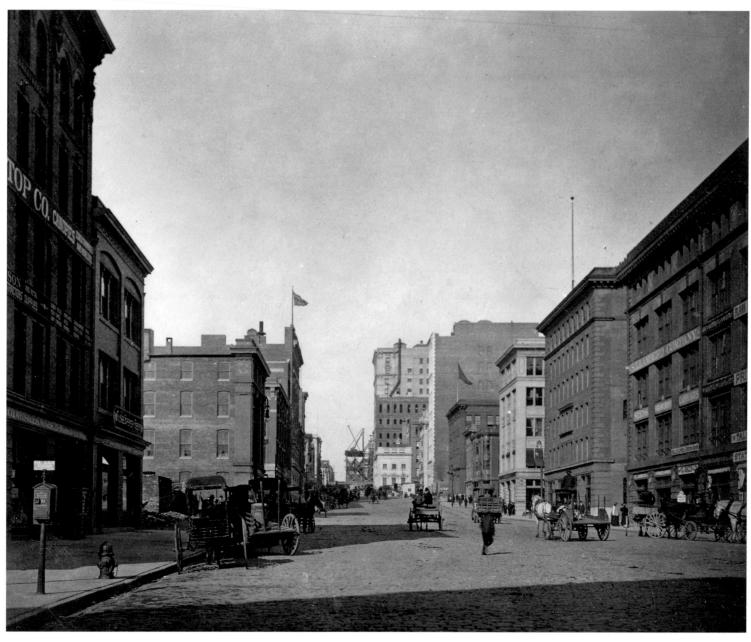

The original offerings of the Larrimore Buggy Top Company, standing along Light Street in 1911, would soon go the way of the horse and carriage as the automobile age entered full swing in the first decades of the twentieth century.

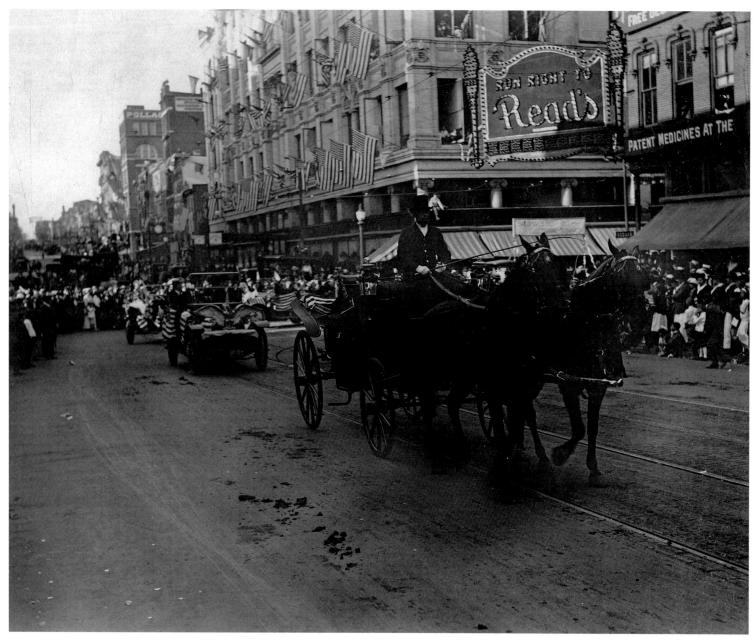

A patriotic parade passes by Read's Drug Store in 1911. The popular chain of pharmacies located throughout the area in the twentieth century—with its familiar slogan, "Run Right to Read's"—was eventually bought by the Rite Aid Corporation as part of its 420-store acquisition campaign along the East Coast in the early 1980s.

South Broadway indeed lives up to its name in this 1911 view near the intersection with Gough Street.

The Broadway Market in Fell's Point is a visible and familiar landmark in this 1911 view looking down South Broadway to the harbor.

The gas lanterns lining Howard Street in 1912 are reminders of Baltimore's role in bringing gas lighting to America. In 1816, Rembrandt Peale first demonstrated gas lighting at his museum in town, and it proved such a sensation and success that Peale organized a gas company to light the city—making Baltimore the first city in the country with gas streetlights.

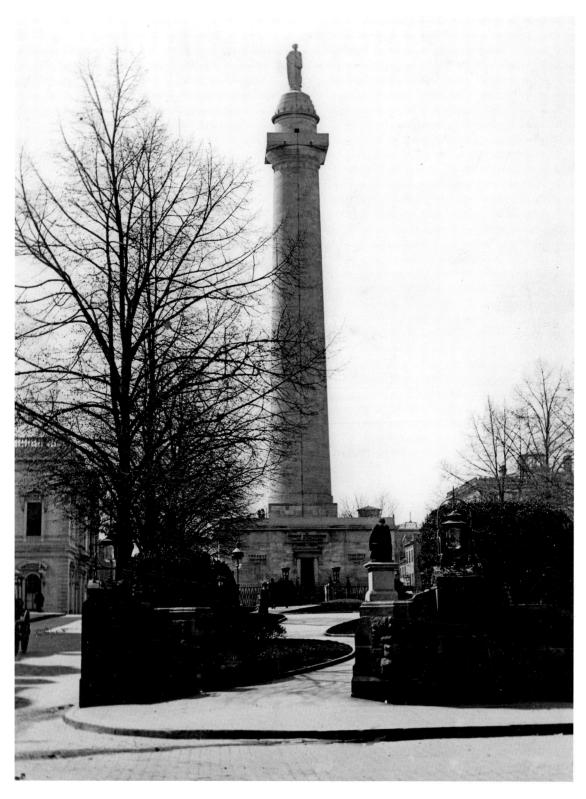

Through the last half of the nineteenth century, Mount Vernon Place's parks were periodically relandscaped to keep with the fashion of the day. Trees were allowed to grow, then cut down because they blocked the view. In the east and north squares, the city erected statues to the memories of notable residents George Peabody, the merchant and philanthropist; Severn Teackle Wallis, an early political reformer; Roger Brooke Taney, chief justice of the United States Supreme Court; and John Eager Howard, Revolutionary War hero. This view shows Mount Vernon Place in 1912.

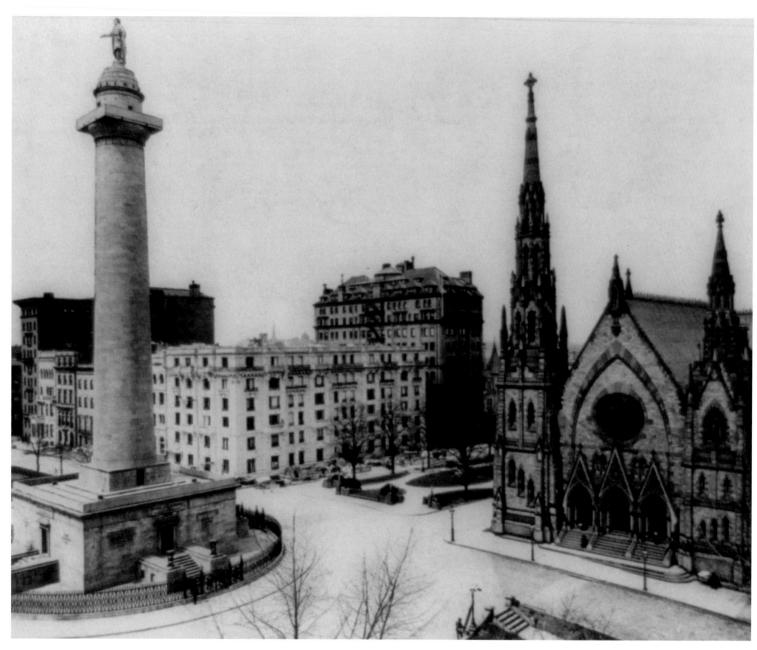

On the corner opposite the soaring Mount Vernon Place Methodist Church stands the Washington Apartments, a dignified and refined six-story structure designed in 1905 by Edward H. Glidden, who trained at the Ecole des Beaux Arts before moving to Baltimore around 1900. Seen here about 1912, the building is reminiscent of the fashionable apartment buildings then lining the streets of Paris and New York City.

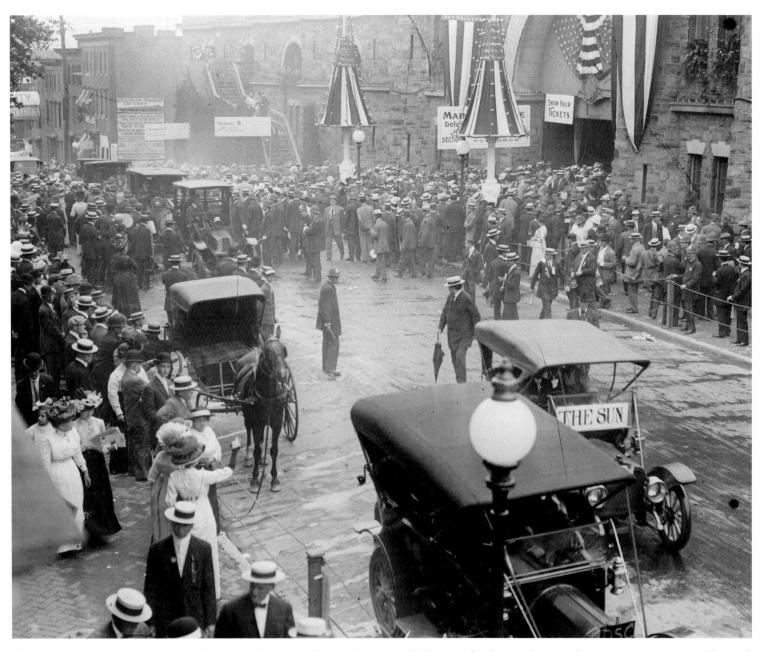

As seen here, Democrats from across America gathered in Baltimore in June and July 1912 for the party's national nominating convention. The city's advantageous geographic location and accessibility by rail, road, and water made Baltimore a desirable meeting place. More than 80 years earlier, in Baltimore in 1831, a splinter party called the Anti-Masons held the nation's first such convention, setting an example followed the next year by the Jackson Democrats—a Baltimore event distinguished as America's first major-party nominating convention.

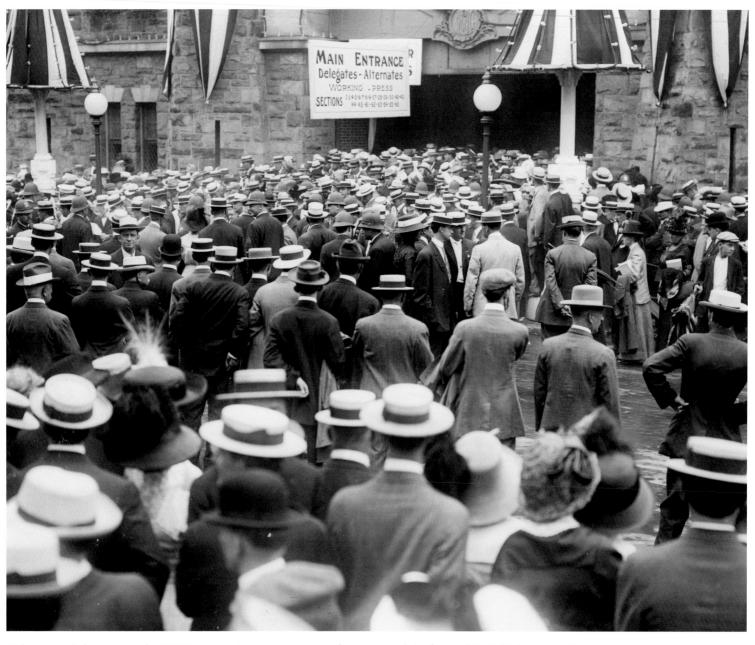

Delegates and alternates at the 1912 Democratic Convention in Baltimore crowd the front of the Fifth Regiment Armory, anxious to enter the hall.

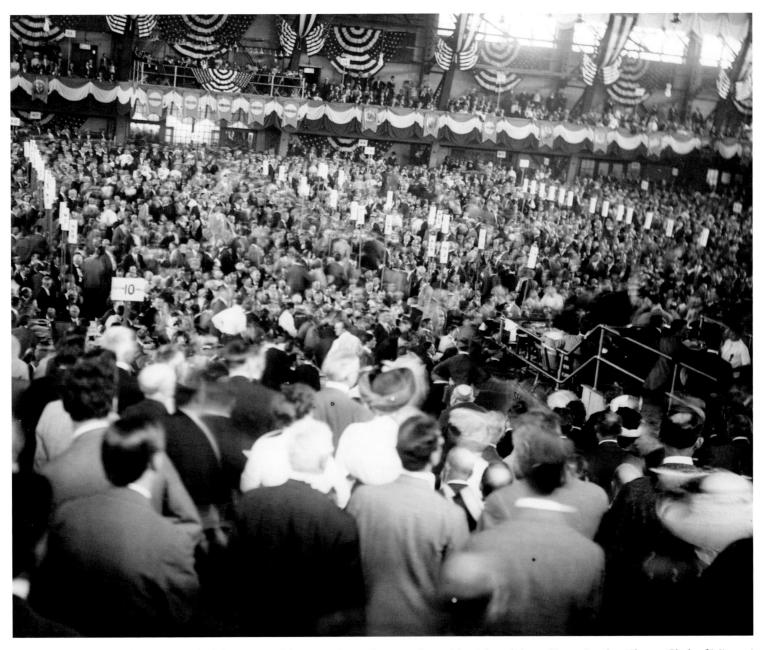

Inside the hall, delegates weighed the merits of the two primary Democratic presidential candidates: House Speaker Champ Clark of Missouri and Governor Woodrow Wilson of New Jersey. Clark entered the contest with a majority of the delegates behind him, but without the two-thirds majority necessary to secure the nomination. After a long deadlock, former Democratic presidential candidate William Jennings Bryan threw his support to Wilson, giving Wilson the 1912 nomination on the forty-sixth ballot.

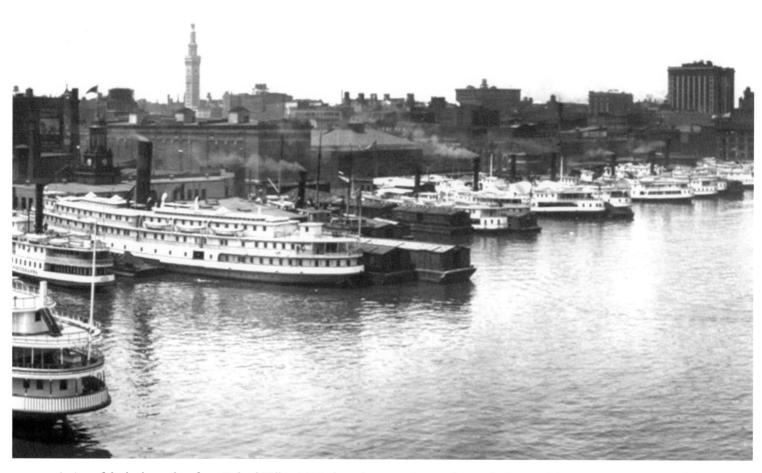

A view of the harbor, taken from Federal Hill in 1912, shows how prominent a feature the Bromo-Seltzer tower seen at center-left was to the Baltimore skyline.

Here in 1914, East Lombard Street retained much of its early nineteenth century charm.

Rutted, dirt wagon roads of the nineteenth century were unsuitable for automobile travel, so the state and the city began paving streets with macadam, seen here on a road near the city limits in 1915. The process involved laying down three layers of crushed stone, which were then compacted with cast-iron rollers to create a hard surface.

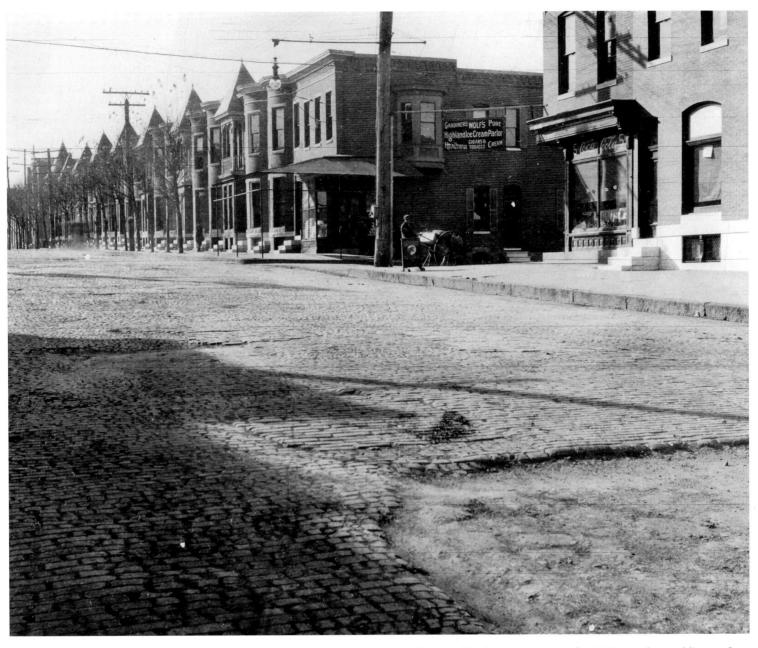

Against the advice of state roads engineers, brick pavement was laid on a gravel base on this city street, creating by 1915 rutted, crumbling surfaces that jarred passing automobiles.

Despite the growing availability of motorized transportation in 1915, the city roads maintenance crews still relied on the horse and cart.

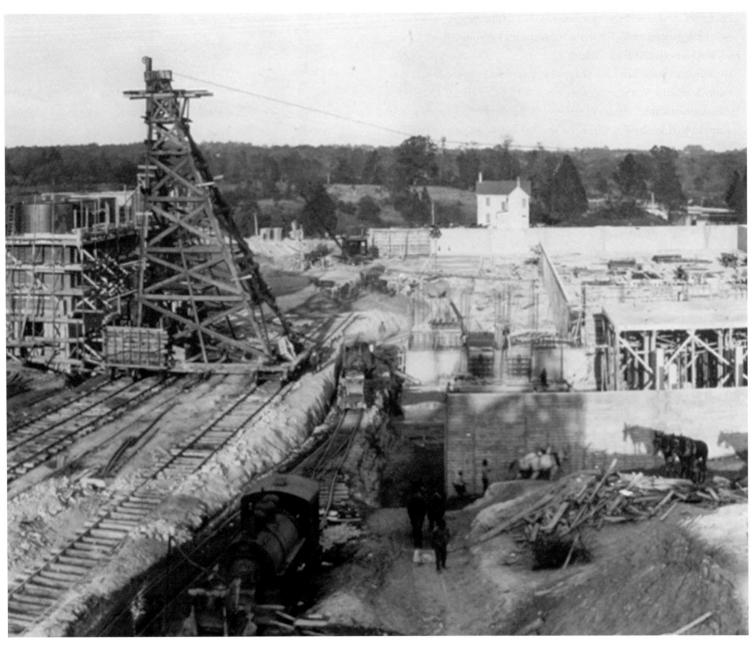

Growing public health concerns about the potability of the city's water led to the construction of Montebello Filtration Plant 1, which went into operation in 1915 after a two-year construction period.

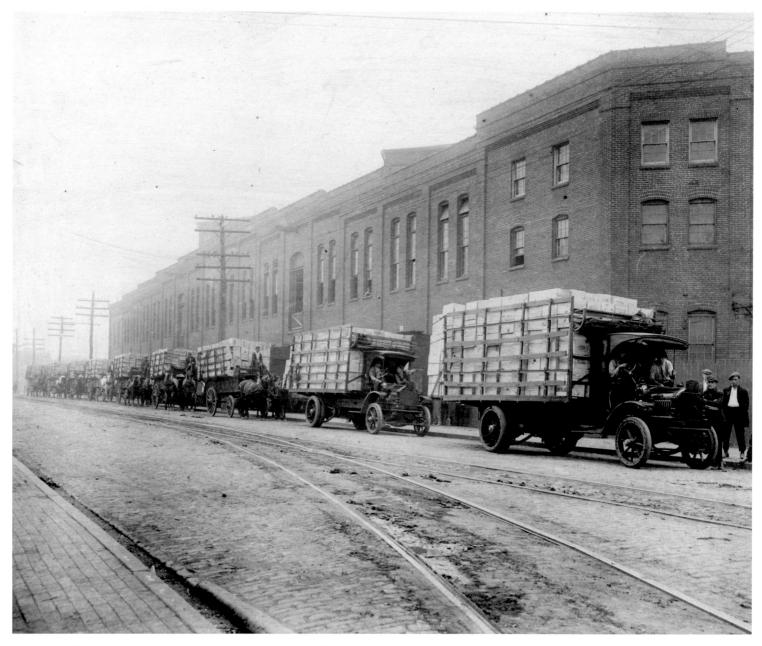

Loaded trucks line the curb outside the Baltimore warehouse of the American Can Company around the time of World War I. Originally a property of the Norton Tin Plate and Can Company, the Baltimore facility was eventually absorbed by the American Can Company, which by 1908 had grown to be the largest can manufacturer in the world.

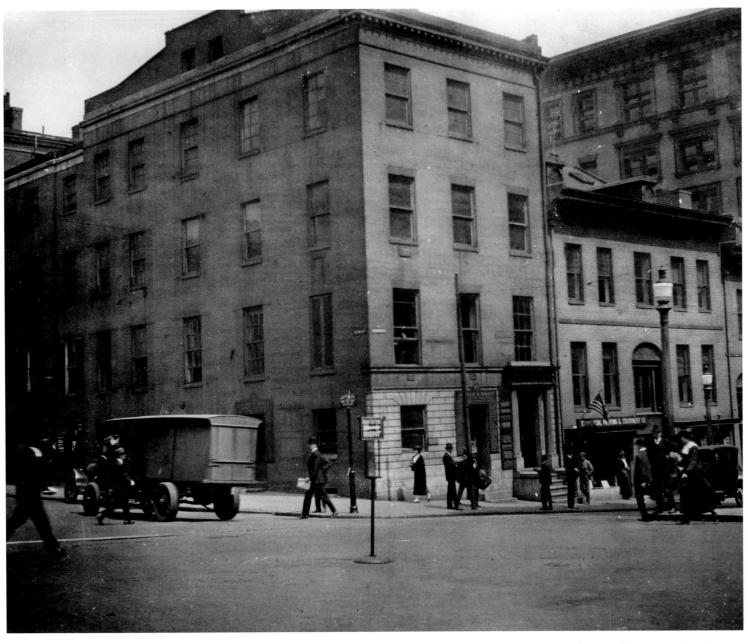

By 1918, the traffic along East Lexington Street was primarily autos and trucks, necessitating the emergence of new traffic signs such as this one reminding vehicles to keep to the right.

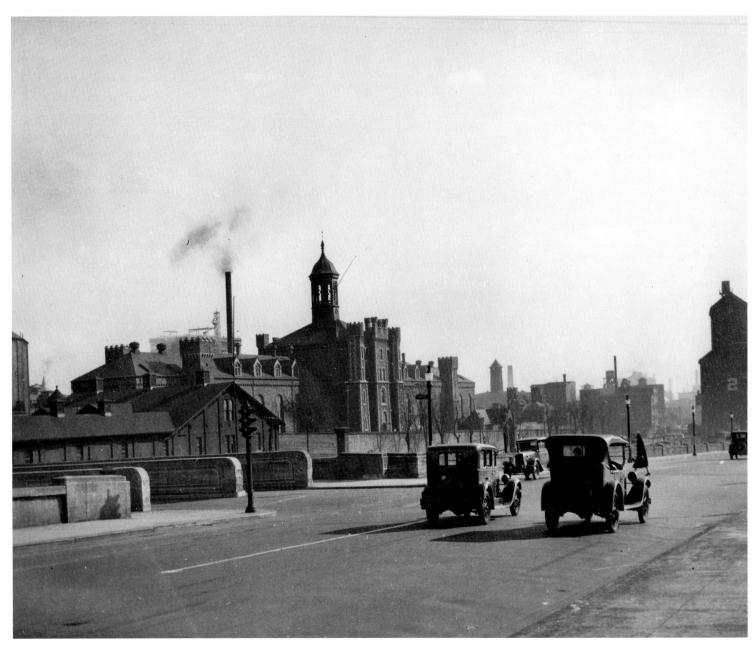

In 1855 the architectural firm of Dixon, Balbirnie and Dixon won a city competition for the design of a new jail. The firm received \$500 as its prize. Completed in 1859, the jail contained 300 cells in each of two wings that extended from a main administrative block distinguished by a somber gray stone exterior and crenellated towers, which one contemporary Baltimore paper stated was "decidedly appropriate."

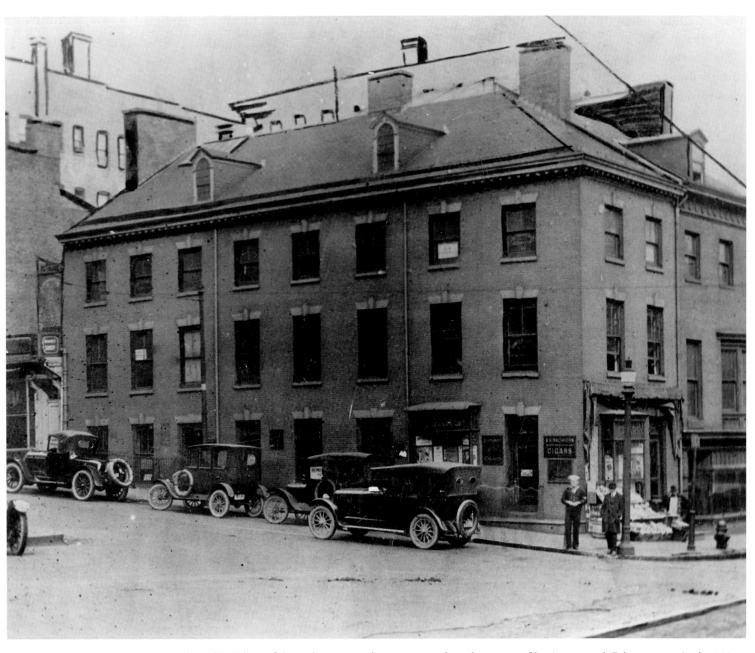

A surviving residential building of the early nineteenth century stands at the corner of Lexington and Calvert streets in the 1920s.

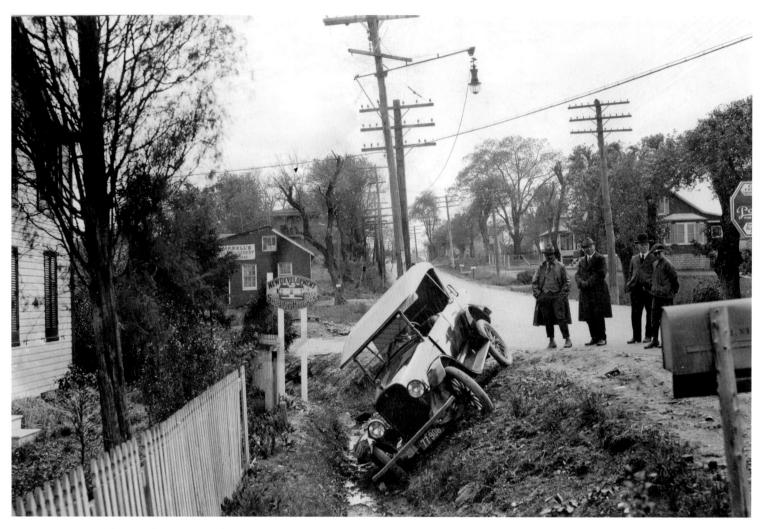

An automobile accident on the outskirts of Baltimore in the 1920s is a persuasive argument for guardrails.

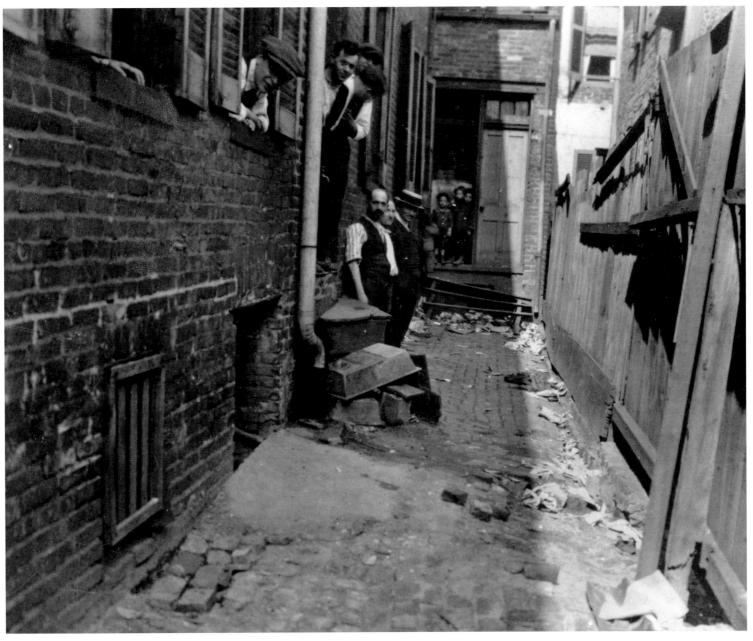

Baltimore in the early twentieth century remained an important part of the nation's ready-made clothing trade, but working conditions could be abysmal. Here, in 1921, employees pose in the littered alley leading to the entrance of one of the city's many garment factories.

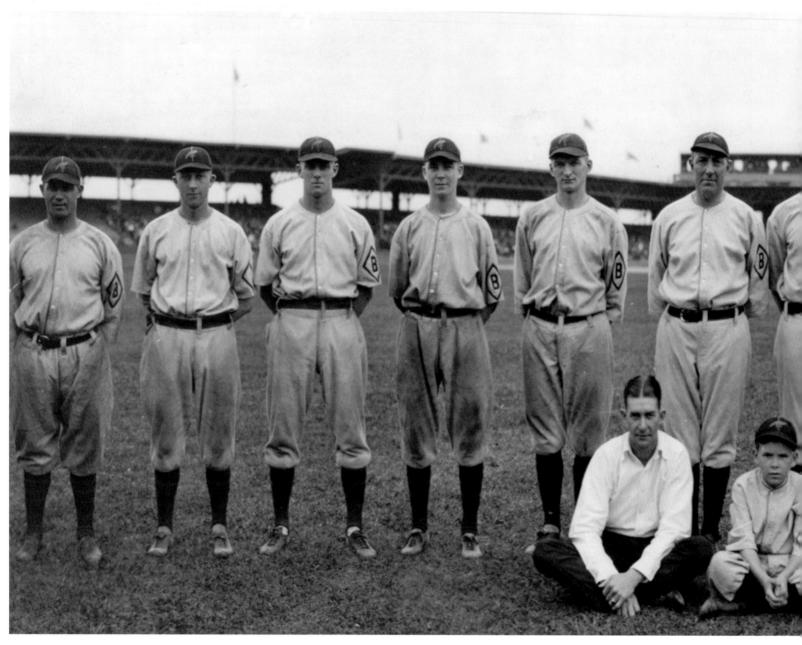

After fielding several amateur and professional teams in the early days of baseball, the Baltimore Orioles joined the International League in 1903 and by 1919 had captured the pennant as the first 100-win champion in league history. Baltimore followed in 1920 with a 110-victory pennant-winning season. The 1921 team, seen here, shattered all International League records, finishing the season 119-47 while setting records for runs, hits, doubles, home runs, total bases, batting average, and attendance, drawing 308,970 fans.

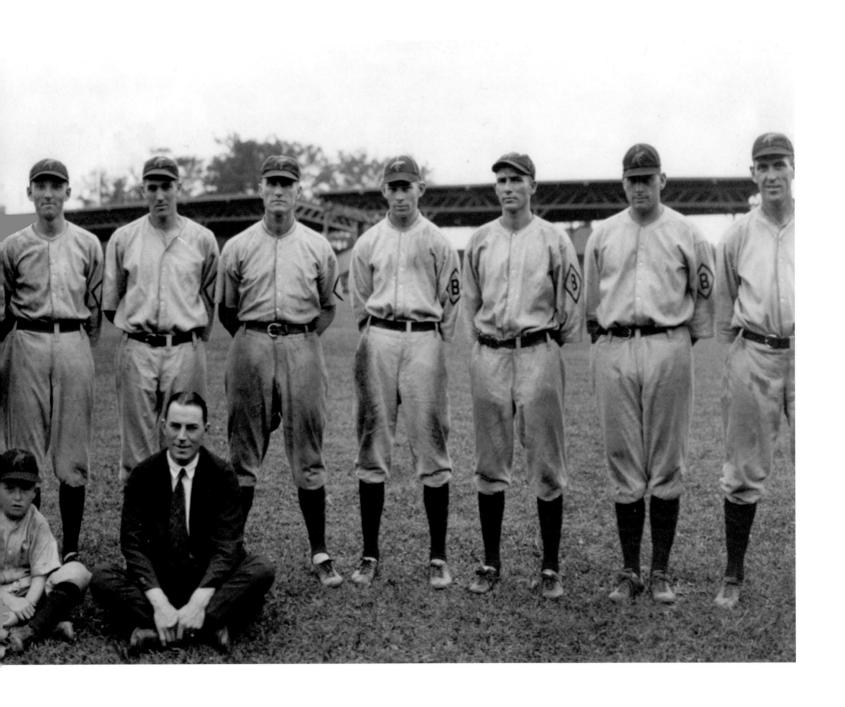

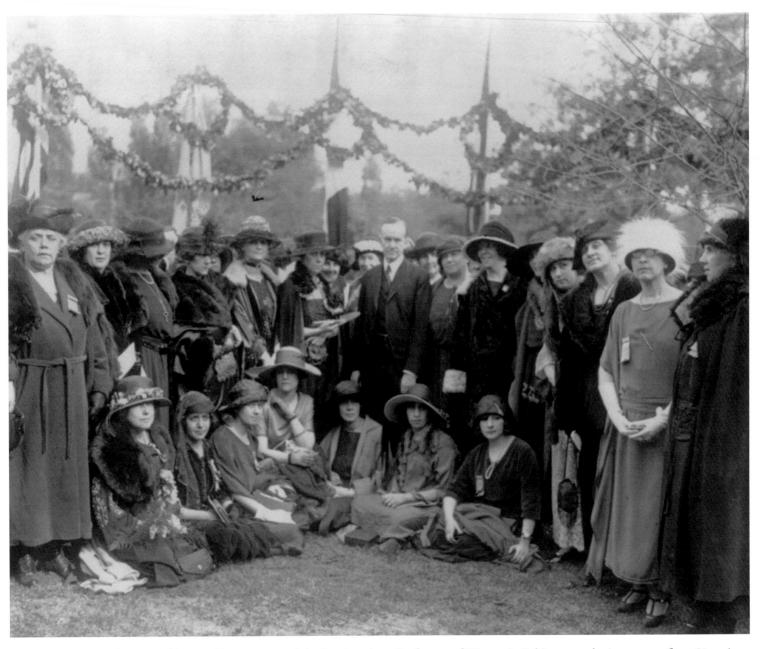

In 1922, the National League of Women Voters sponsored the Pan American Conference of Women in Baltimore, gathering women from 21 nations to examine pressing issues of the day. Delegates took time out from the conference to participate in an International Tree Planting ceremony in the city, attended by Vice President Calvin Coolidge, at center.

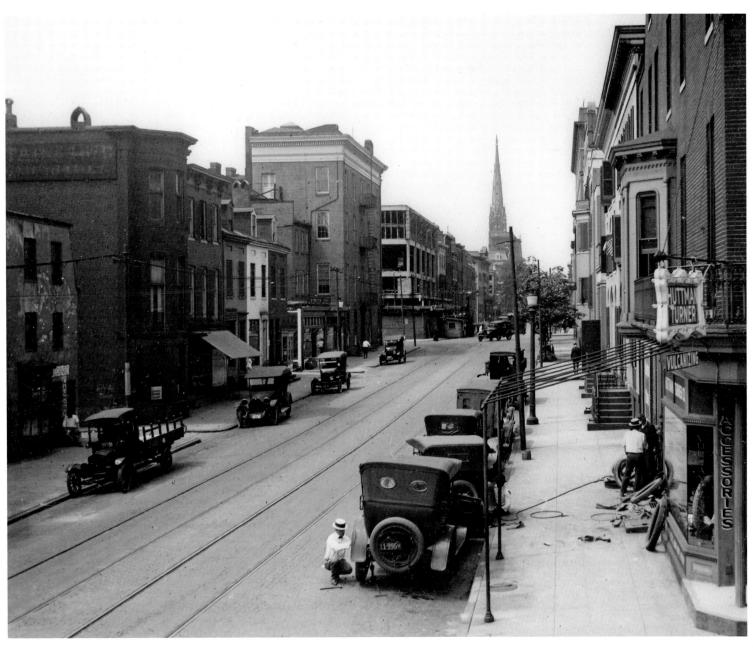

A car gets a needed tire change in 1923 outside Huttman Turner's auto parts store on Park Avenue.

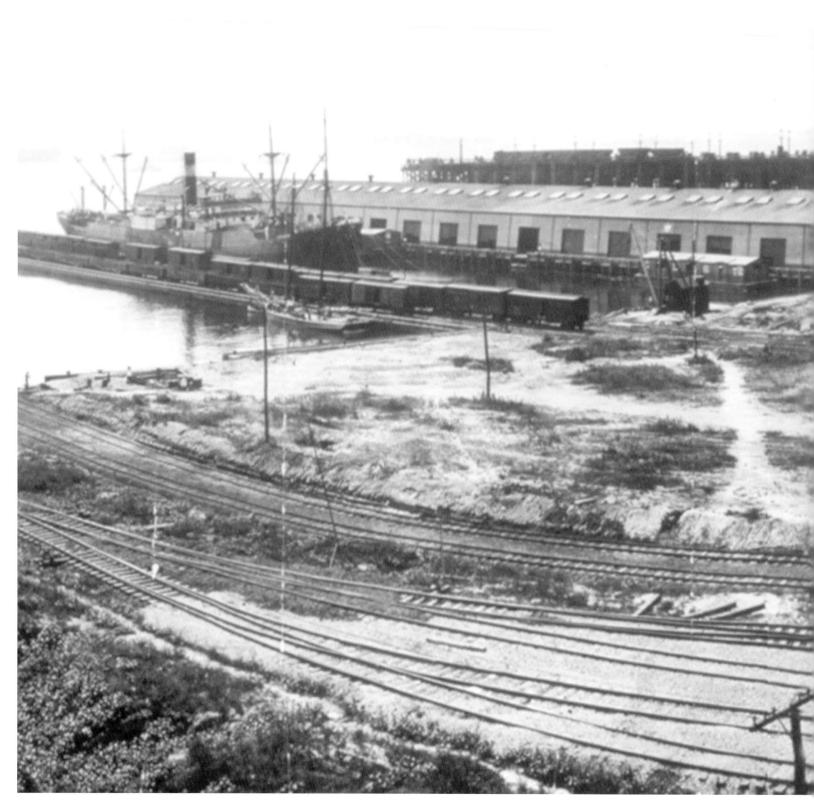

The Western Maryland Railroad Company originated with the earlier line of the Baltimore, Carroll and Frederick Railroad, chartered in 1852 and headed for points west of the city. By 1872 the road had been completed out to Hagerstown, Maryland, and the name was changed to Western Maryland. In 1904, the railroad began construction of this sprawling terminal at Port Covington on the Patapsco, on the site of Fort Covington, one of the defenders in the Battle of Baltimore in 1814.

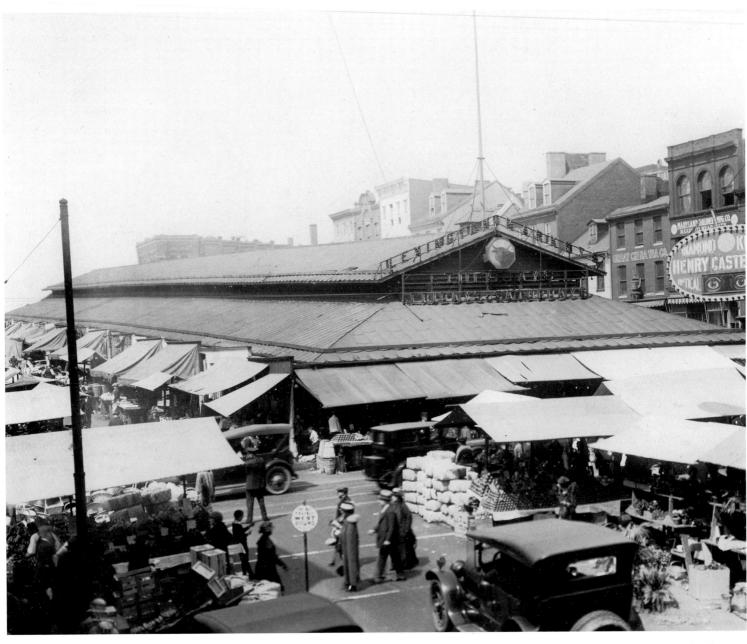

Lexington Market in the 1920s remained as vital as ever, attracting farmers and merchants from all over the region and fostering the growth of a dizzying collection of commercial establishments hawking everything from diamonds to spectacles.

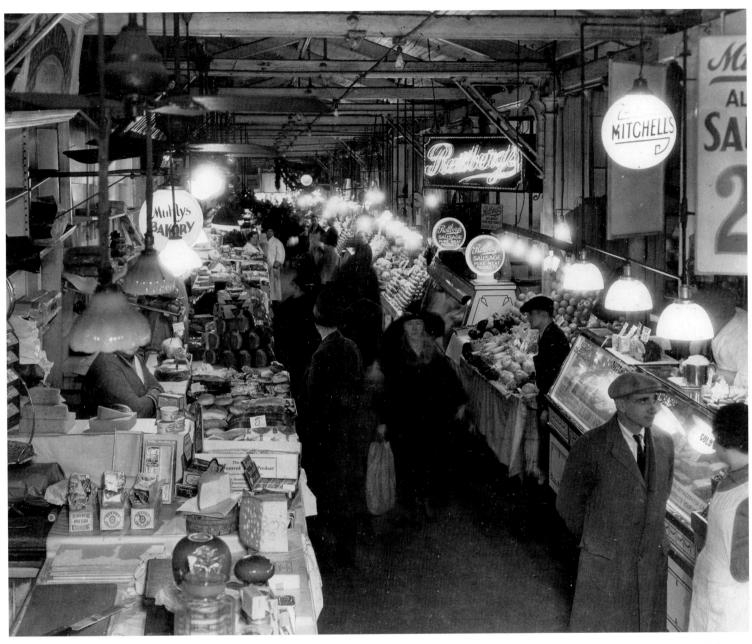

Inside Lexington Market, shoppers of the 1920s are presented with an appetizing array of choices.

Known as that "elegant Rendezvous for taste, curiosity and leisure," Peale's Baltimore Museum and Gallery of Fine Arts on Holliday Street was opened in 1814 by Rembrandt Peale—the classically named offspring of master painter Charles Wilson Peale. The gallery exhibited an eclectic mix of fine paintings and natural oddities, such as woolly mammoth bones exhumed by father Charles, all housed in what was the world's first building constructed specifically as a museum. Later falling into disrepair, as seen here, the building would be restored in 1931.

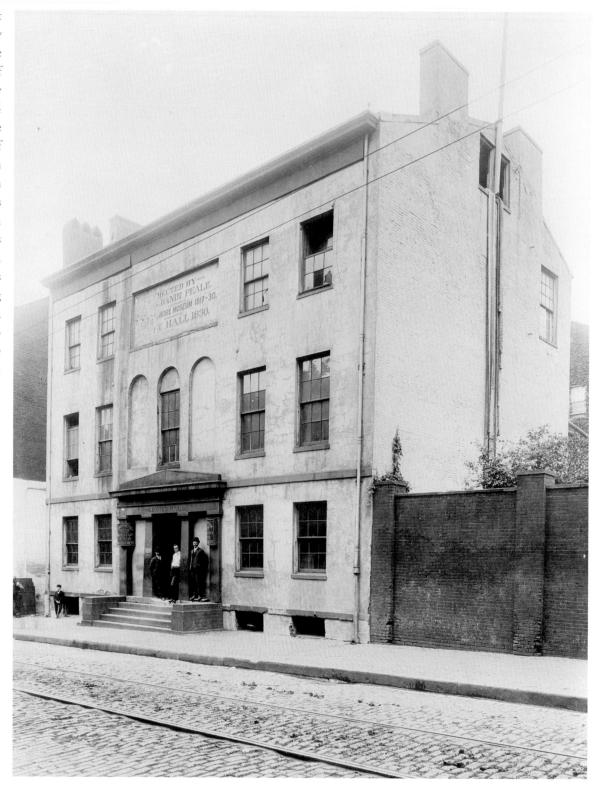

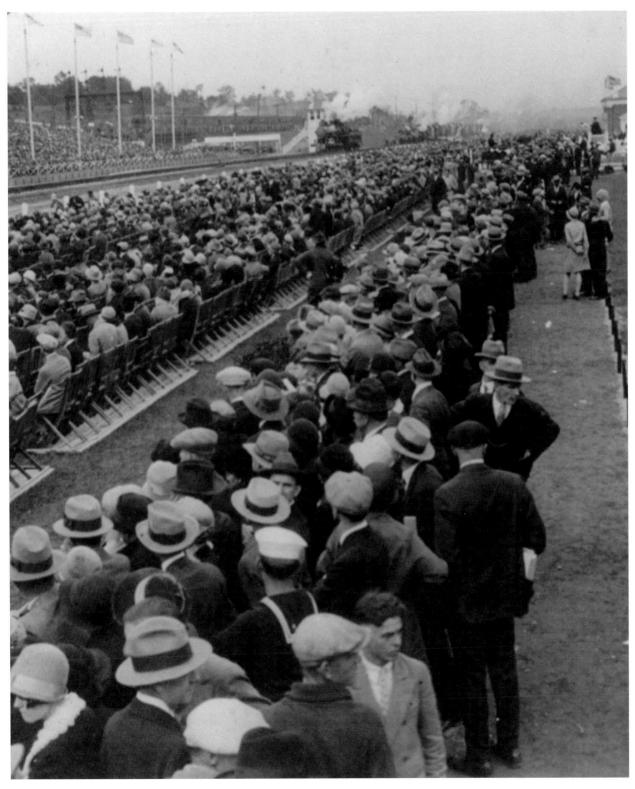

Spectators lined both sides of the B&O Railroad tracks as the city and the company celebrated the centennial of its chartering as America's first public and passenger railroad in 1827. "The Fair of the Iron Horse," as the exhibition and pageant was called, was held between September 24 and October 8, 1927, partially across the Baltimore County line, in Halethorpe.

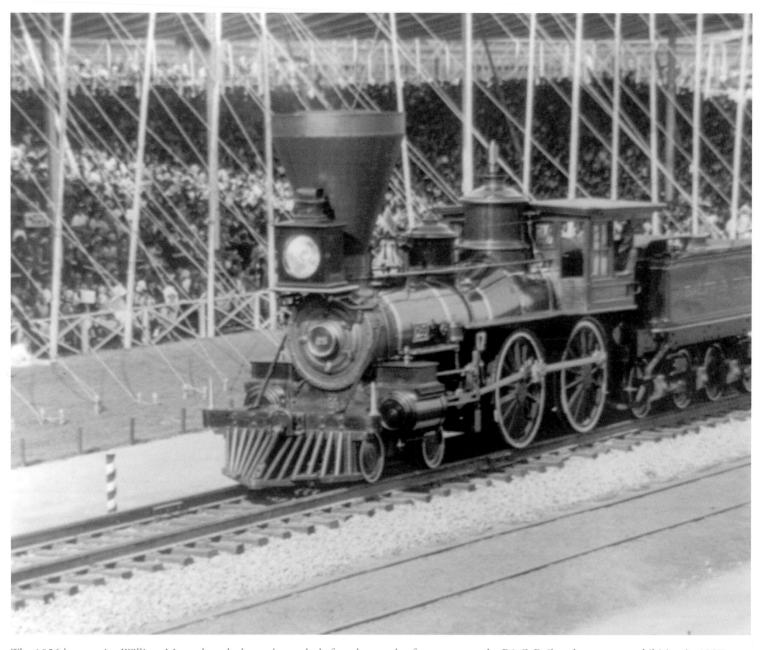

The 1856 locomotive William Mason barrels down the tracks before thousands of spectators at the B&O Railroad centenary exhibition in 1927.

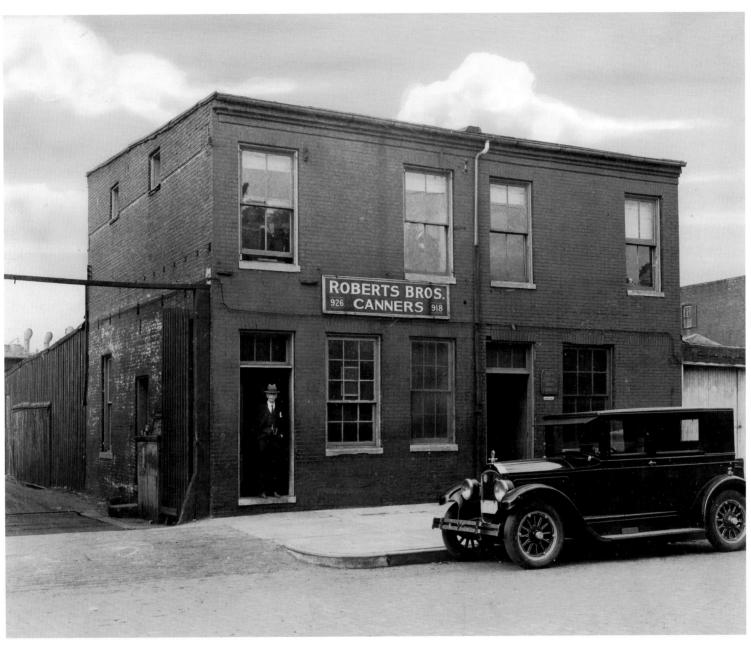

Roberts Brothers Canners was one of more than a hundred packing houses in the early twentieth century that employed men, women, and children to not only process the food that went into the cans, but also the labels that went on them and the boxes they were shipped in. By the 1940s,

Baltimore made more cans than any other city in America.

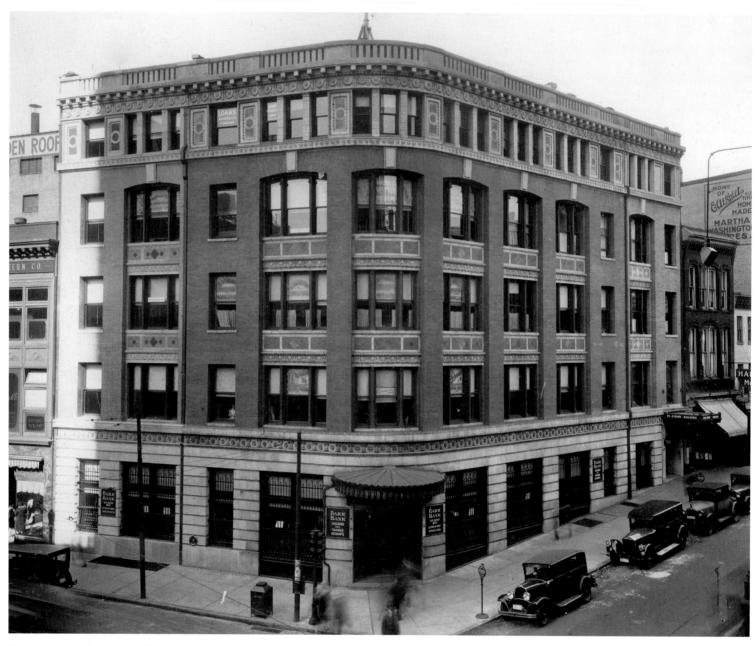

Seen here near the close of the 1920s, the Park Bank building rounded the corner of Lexington and Liberty streets. By 1931, the Great Depression had hit the Baltimore banking industry hard—even the venerable Baltimore Trust Company shut the doors to its 32-story skyscraper. By 1933, the governor of Maryland had closed all banks in an effort to prevent mass withdrawals.

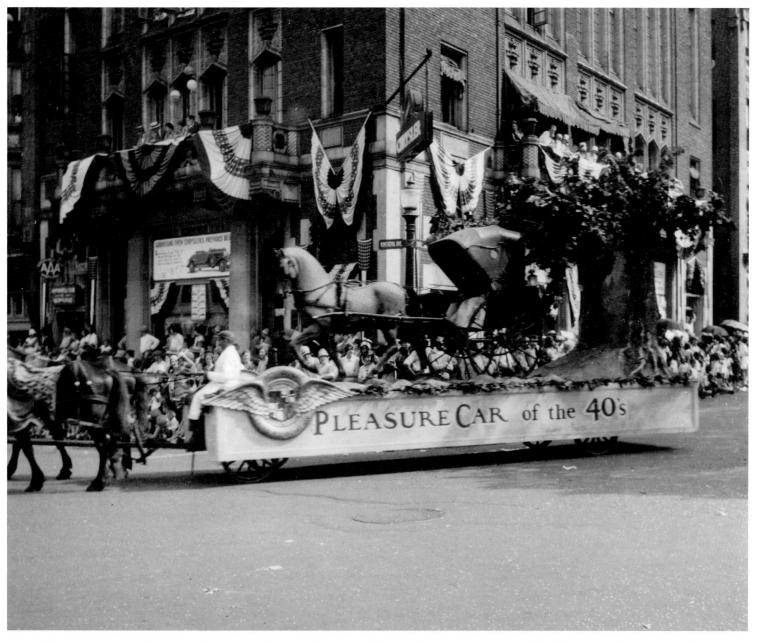

A "Pleasure Car of the 40s," one of hundreds of floats and displays taking part in the 1929 bicentennial celebration of the founding of Baltimore, passes by a Chrysler dealership. A parade of more than 400 cars was a highlight of the ceremonies.

At the corner of Lexington and Liberty streets in 1929, the Consolidated Gas Electric Light and Power Company—which became the Baltimore Gas and Electric Company—presents a dazzling display of the power of electric lighting, majestically illuminating its headquarters building designed by the architectural firm of Parker, Thomas and Rice and completed in 1916.

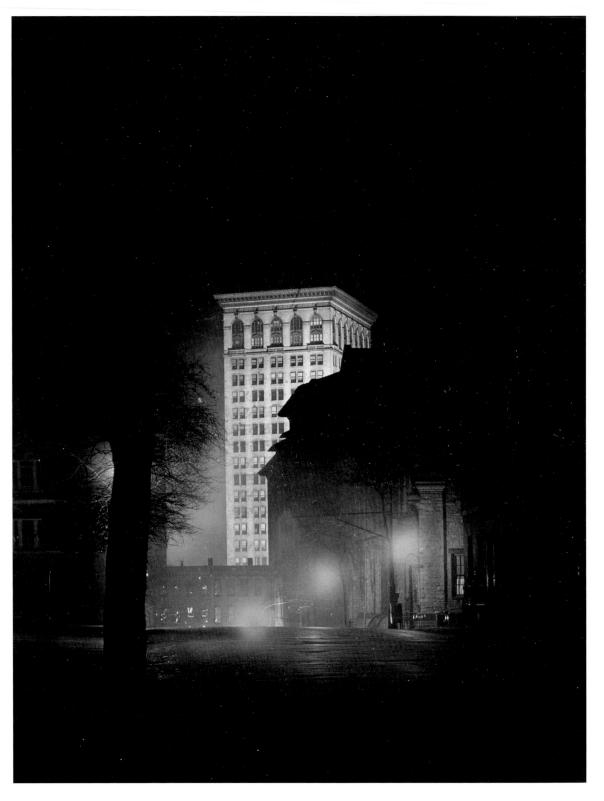

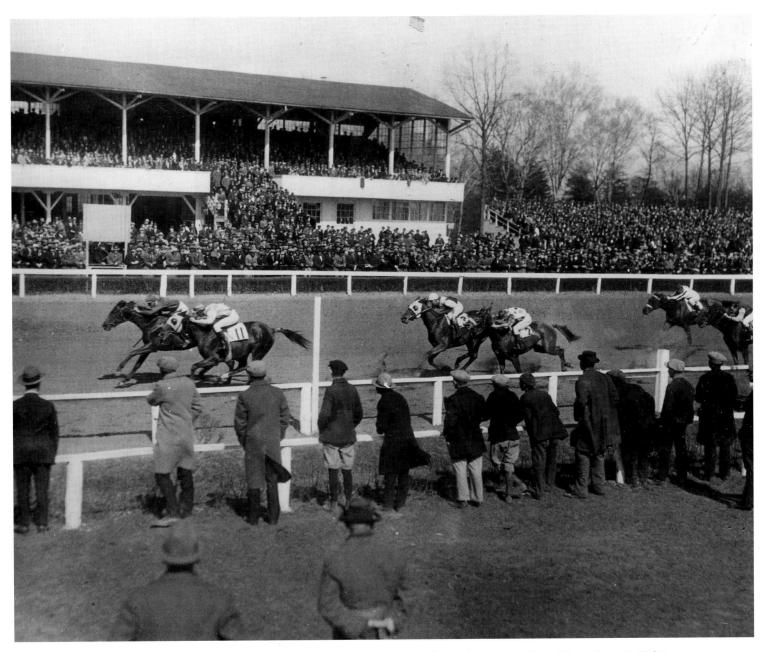

In 1908, the Washington, Baltimore and Annapolis (WB&A) Railroad was opened for service, running from Liberty Street in Baltimore to a terminal at the corner of 15th and H streets in Washington, D.C. A direct competitor of the B&O, the WB&A sought to build ridership by establishing attractions along the route. In 1914, the company convinced the Southern Maryland Agricultural Society to build the Bowie Race Track, seen here in 1930. The track was located near the home of the Belair Stud Farm, founded by Samuel Ogle in 1747 and known as the "cradle of American thoroughbred racing."

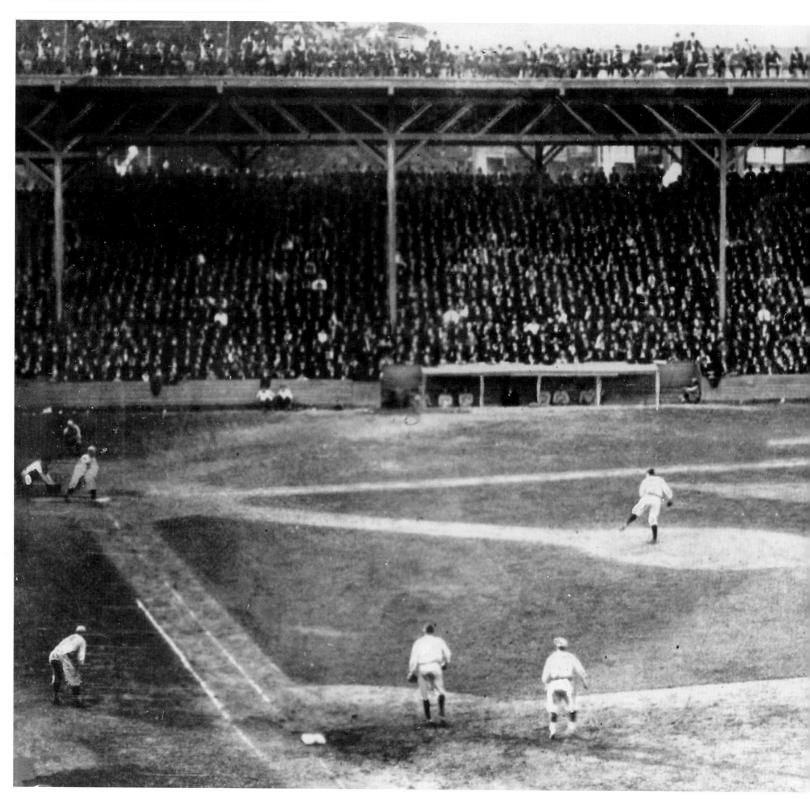

Though no longer dominating the International League as they had in the 1920s, the Baltimore Orioles still filled the stands (and the roof of the stands) here at Oriole Park in 1930. That year, the Orioles' Joe Hauser set an International League record by hitting 63 home runs.

Seen here in 1930 at one of four locations, the Oriole Cafeteria sought to wed the speed and convenience of cafeteria self-service with the dining comforts of a traditional restaurant. In the storefront window next door, at left, a replica of the RCA Victor trademark dog Nipper appears to be pining for Oriole scraps.

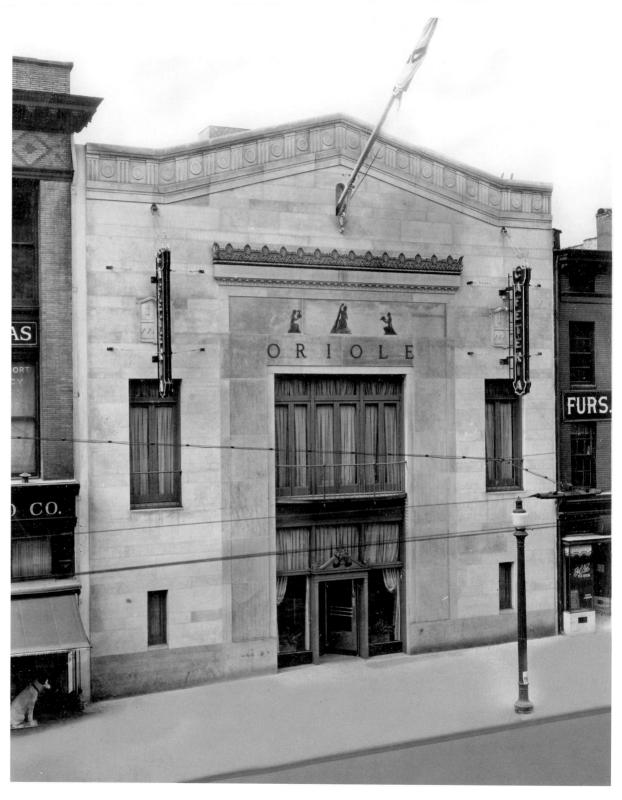

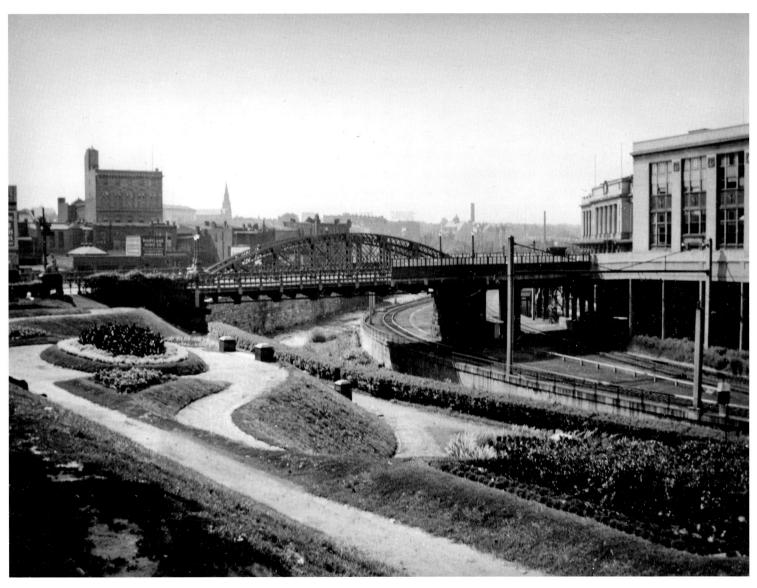

Many of the city's early metal-arch bridges over Jones Falls were built under the auspices of the Jones Falls Improvement Commission, which in 1878 hired prominent Baltimore Bridge Company partner Charles H. Latrobe as consulting engineer. Photographed in 1930, the St. Paul Street Bridge, a 703-foot-long, wrought-iron structure, was the largest of all the bridges erected by the commission between 1878 and 1882.

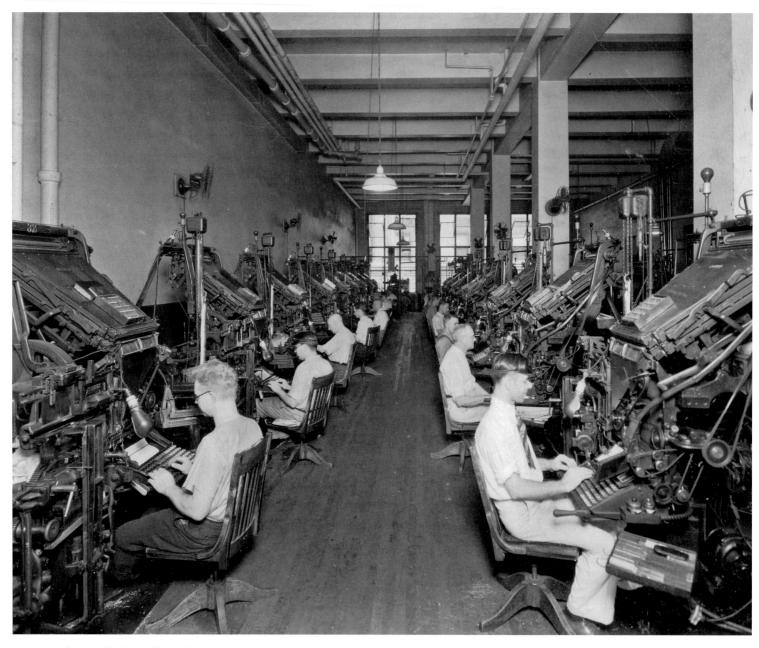

At the *Baltimore Sun* in 1930, workers set type in the Linotype room. Invented by the German immigrant Ottmar Mergenthaler, a watchmaker who set up shop on Bank Lane in Baltimore in 1883, the Linotype machine modernized the newspaper industry, which until then had relied on the much slower process of typesetting by hand. Mergenthaler built his first prototype at the Bank Lane shop, and in 1886 the *New York Tribune* became the first newspaper to use his invention.

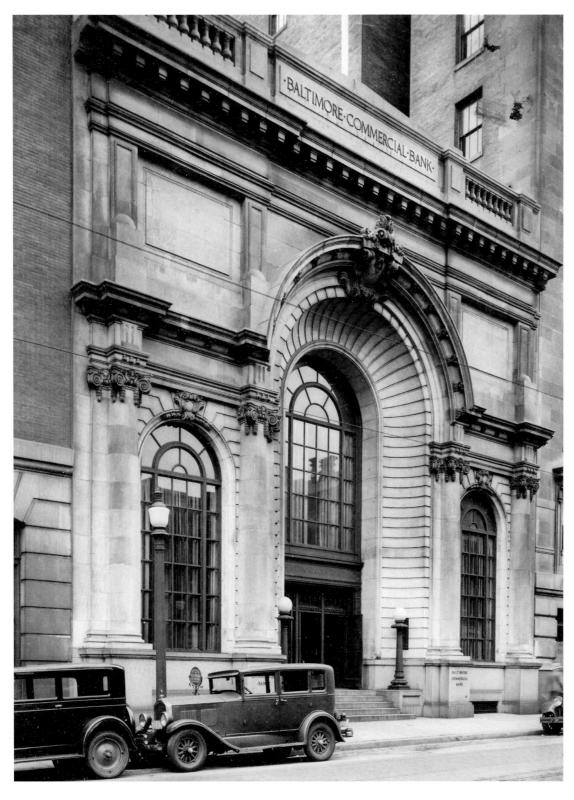

Designed by E. Francis Baldwin and Josias Pennington in the French Renaissance style and built in 1901, the Baltimore Commercial Bank Building at 26 South Street survived the Great Fire of 1904. But here in 1930, the Baltimore Commercial Bank, like all banks, faced a much different crisis, as the stock market had crashed in October 1929 and the Great Depression loomed. In 1994, the historic building was acquired and renovated by the law firm Shar, Rosen and Warshaw.

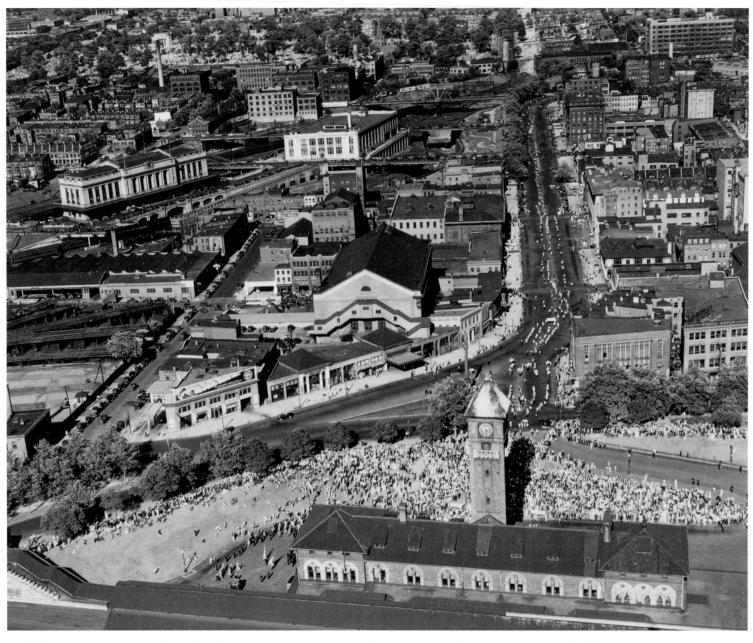

In 1932, Maryland Governor Albert Ritchie, campaigning to capture the Democratic presidential nomination, rallied his supporters in a June whistlestop at Mount Royal Station, shown here. Ritchie was unsuccessful in his bid; Franklin Delano Roosevelt became the Democratic nominee.

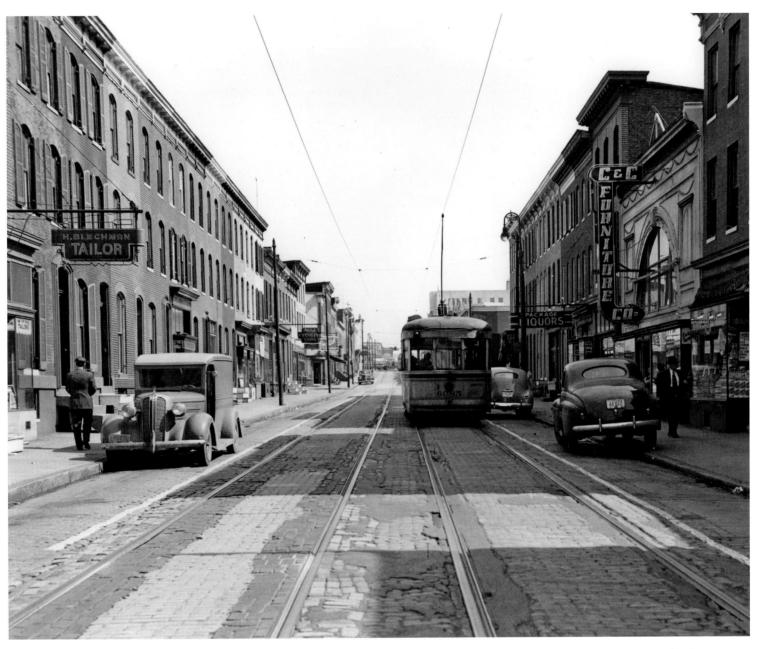

The Great Depression, beginning in 1929 and continuing through the 1930s, took its toll on downtown commercial districts, as local enterprises struggled for existence. By 1934, 29,000 Baltimoreans were officially unemployed.

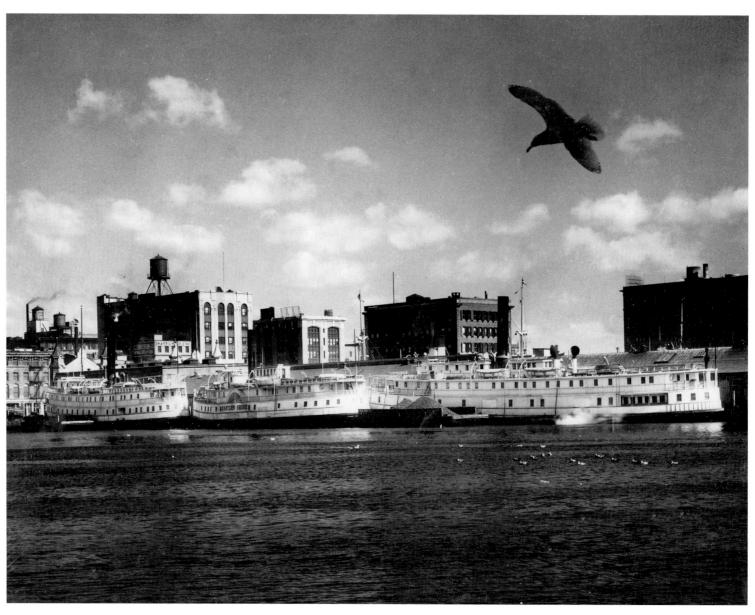

By the 1930s, the once thriving steamboat business had begun its long decline, as rail and motor transportation became more feasible, popular, and economically viable. Steamboats still lined the harbor piers, as in this 1932 view, but service lines were quickly being discontinued. Bay steamer service between larger cities would end after World War II.

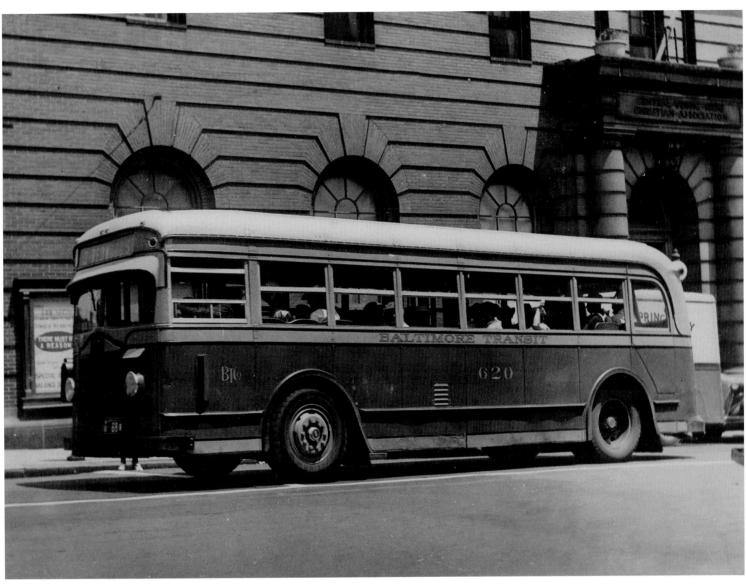

Like steamboats, electric trolleys began to fall out of favor by the 1930s, as the personal auto continued its ascendancy and the Great Depression impacted ridership, with many working-class commuters finding themselves jobless. In response, the Baltimore Transit Company was formed in 1935 to try to resuscitate the declining city transit. It began by investing in a fleet of buses to replace the aging electric trolleys. In 1970, the privately owned transit company was taken over by the Maryland Transit Administration, which put all local buses under state operation.

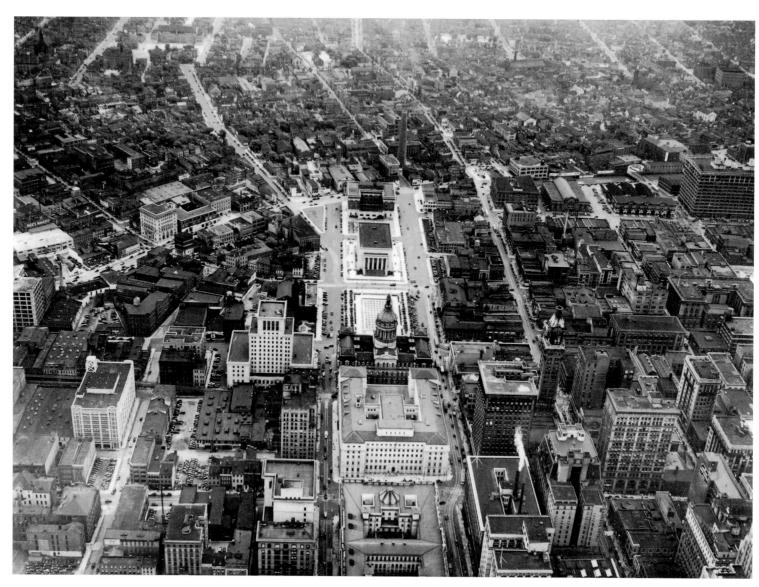

A majestic survivor of the Great Fire of 1904 and seen in this 1933 aerial view, the six-story, domed Baltimore City Hall was designed by 22-year-old architect George A. Frederick. The cornerstone was laid with great ceremony in 1867, yet the building would not be dedicated until October 1875. The segmented dome atop the building was constructed by the firm of Wendel Bollman, the Baltimore civil engineer who developed the pioneering truss system employed by iron bridges throughout the B&O system.

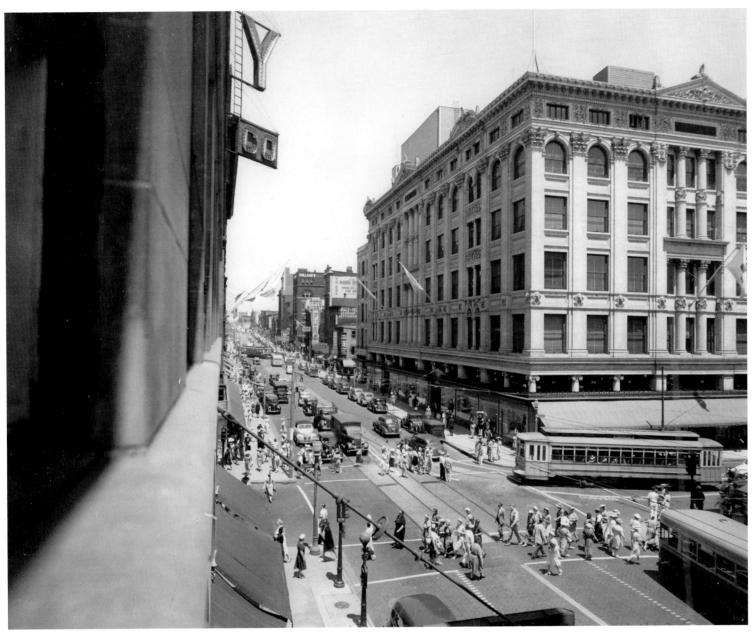

North Howard Street, anchored by the venerable Stewart's Department Store, became known as the "ladies shopping district," a name that stuck through the early twentieth century.

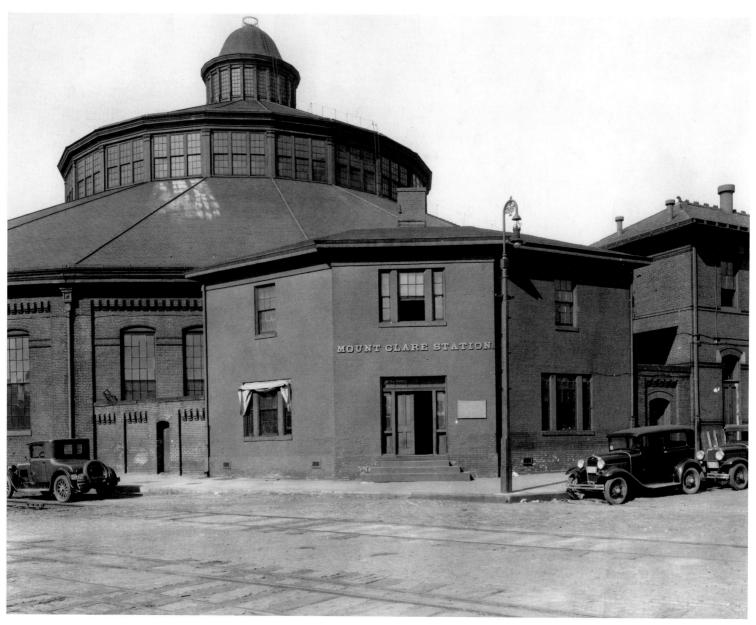

The Mount Clare station, constructed around 1830, is the nation's oldest railroad terminal, a unique polygonal building where regularly scheduled trains would begin the 13-mile trek to Ellicott Mills. Rising behind is the Passenger Car Roundhouse, designed by E. Francis Baldwin and completed in 1884. The roundhouse consists of 22 equal sides, creating a nearly circular brick structure into which trains on 22 separate tracks entered, reoriented, and exited. On May 24, 1844, the nation's first telegraph message, sent by Samuel Morse from Washington, D.C., was received at the station.

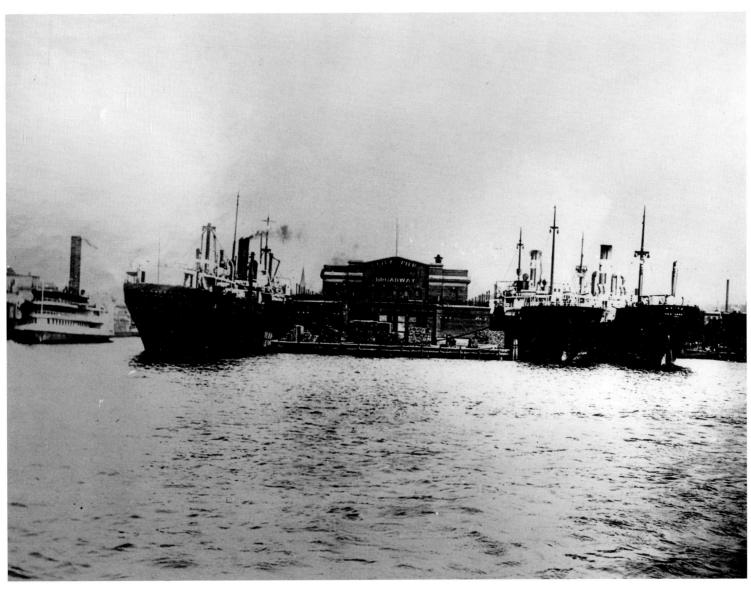

During the nineteenth century, Broadway Pier at Fell's Point was the nation's second-busiest immigration point, behind New York's Ellis Island. By the 1930s, the pier remained a significant point of entry for freighters carrying a world of cargo in and out of Baltimore.

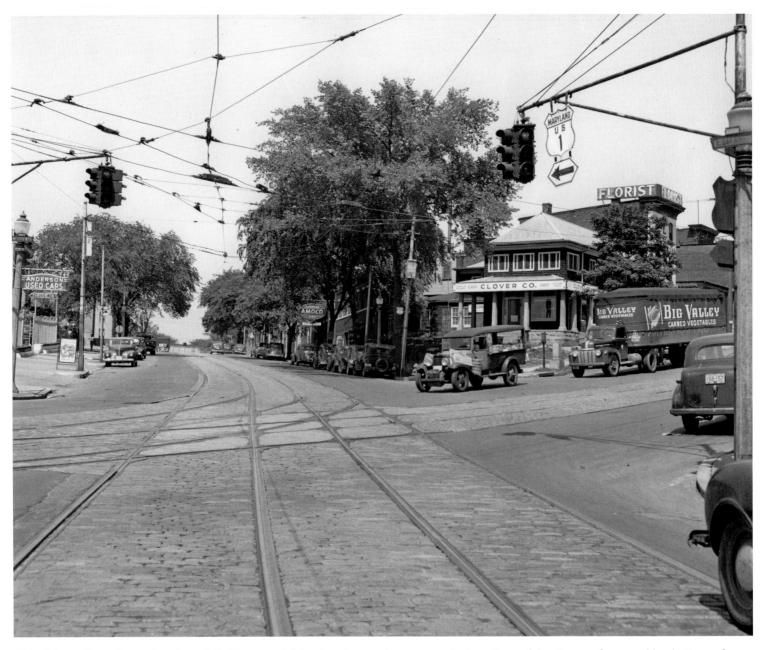

United States Route 1, running through Baltimore and following nineteenth-century paths in and out of the city, was first paved by the State of Maryland in 1914 and was officially named U.S. 1 with the creation of the national highway system in 1926. Auto-oriented services quickly sprang up along the route to cater to passing motorists.

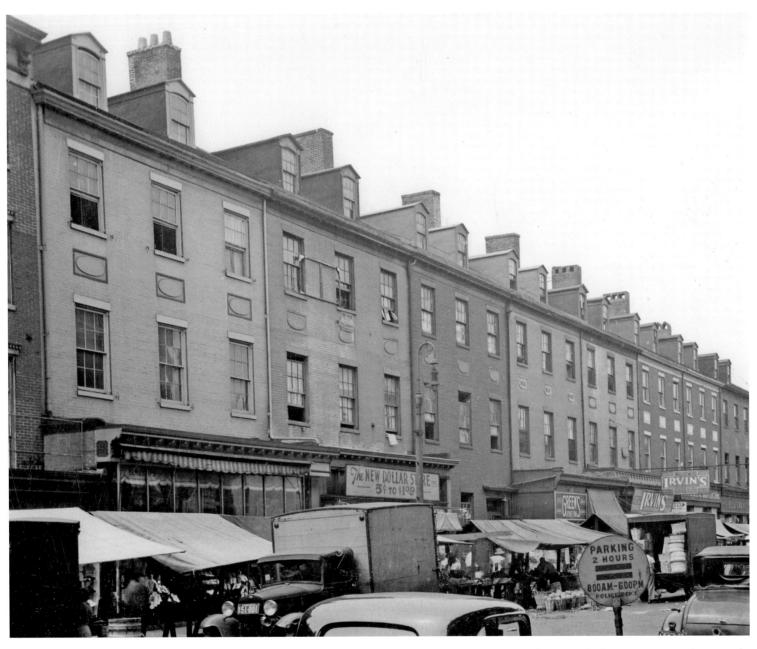

Pascault Row along West Lexington Street, designed by architect William Small, was originally developed by Jean Charles Marie Louis Felix Pascault, Marquis de Poleon, as speculative houses on his estate Chatsworth. Once a distinctive residential enclave for prominent Baltimoreans, the row by the 1930s had taken on a decidedly commercial appearance.

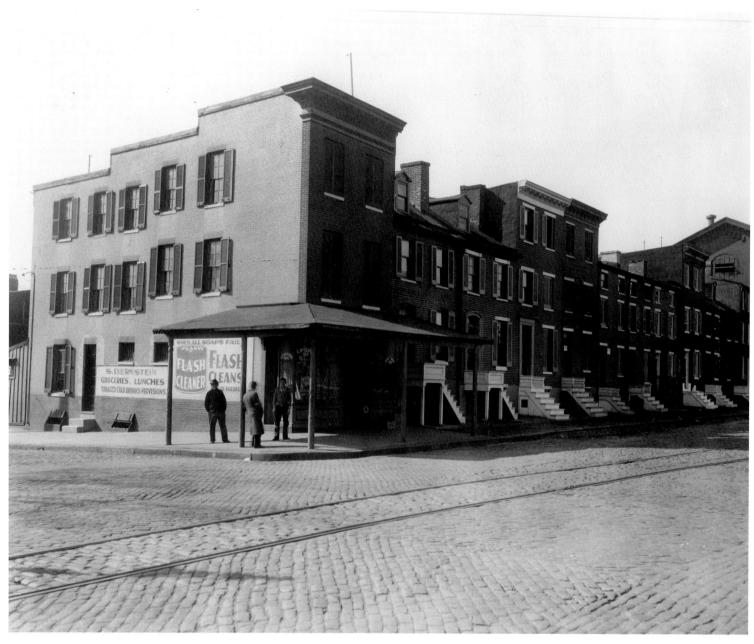

Baltimore's famed row house stairs gleam in this 1933 photograph, taken by J. K. Hillers, of dwellings in the vicinity of Mount Clare Depot. Flash Cleaner, advertised on the side of Bernstein's store, holds the distinction of producing one of the nation's earliest motion-picture commercials, filmed by Thomas Edison around 1920.

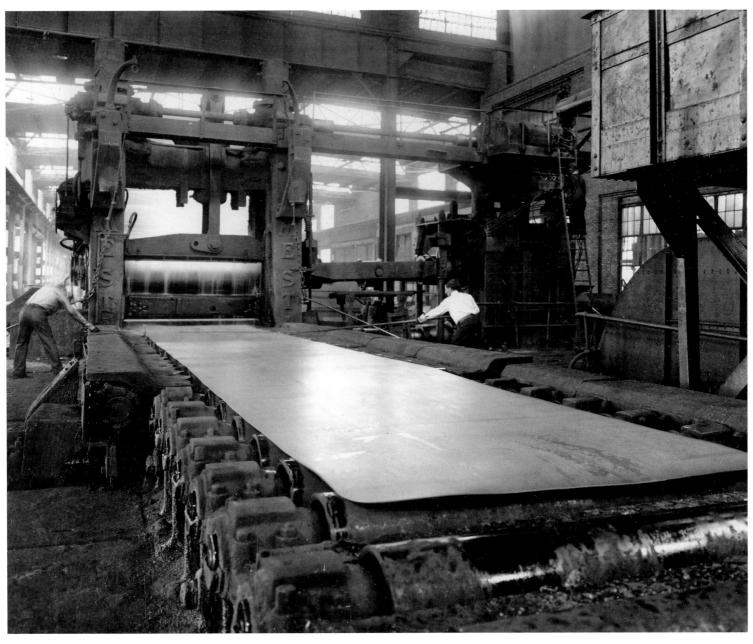

Sparrow's Point mill, originally begun by the Pennsylvania Steel Company in 1887, was purchased by the Bethlehem Steel Company in 1916 and, by mid-century, had become the world's largest steel mill, sprawling for four miles and employing tens of thousands of Baltimoreans. Steel produced at the facility was used to fashion prominent features of some of the nation's most notable structures, including the girders of the Golden Gate Bridge in San Francisco and the cables in New York's George Washington Bridge.

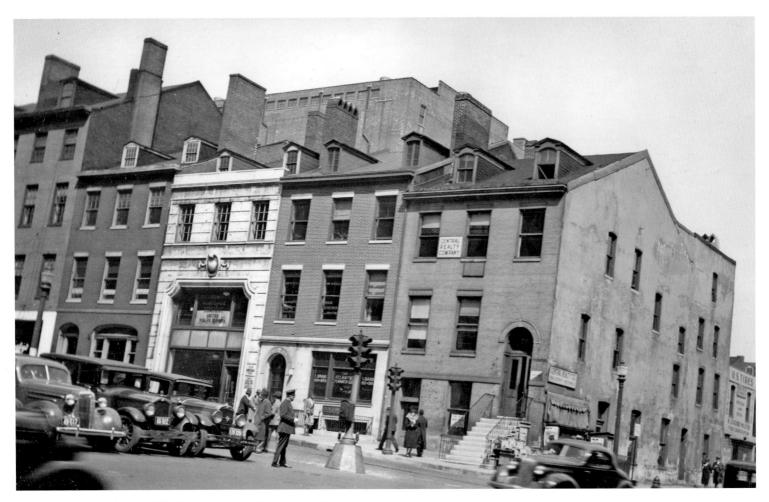

A policeman helps direct traffic along Lexington Street in 1935.

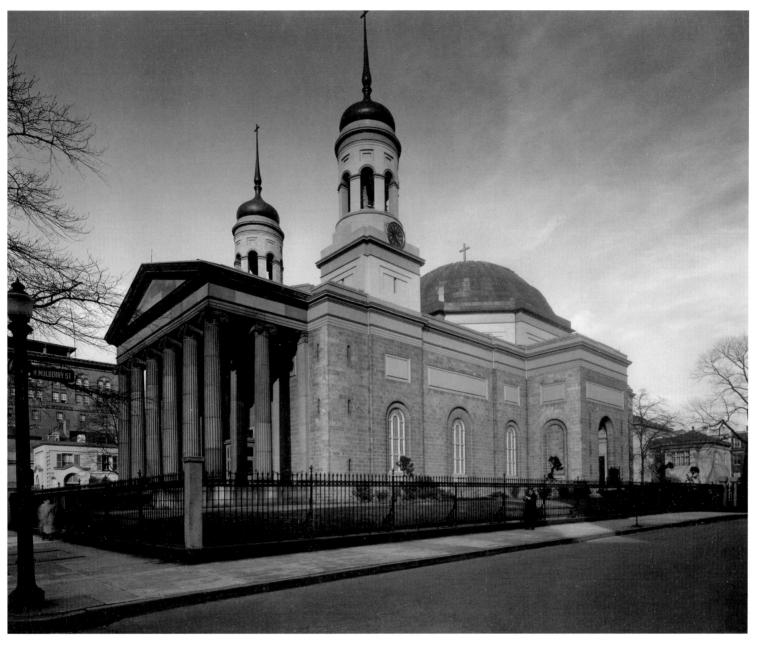

The cornerstone for the Basilica of the Assumption, designed by the noted Baltimore architect Benjamin Henry Latrobe, was laid in July 1806, but construction progressed slowly. In 1821, despite having the towers and porch unfinished, the Cathedral of the Assumption of the Blessed Virgin Mary was formally dedicated. The onion-shaped domes, seen here in the 1930s, were added to the towers in 1832; in the 1870s Latrobe's grandson, John H. B. Latrobe, would oversee erection of the porch.

Pope Pius XI officially elevated the Cathedral of the Assumption to basilica status in the fall of 1937, not long after this photo was taken.

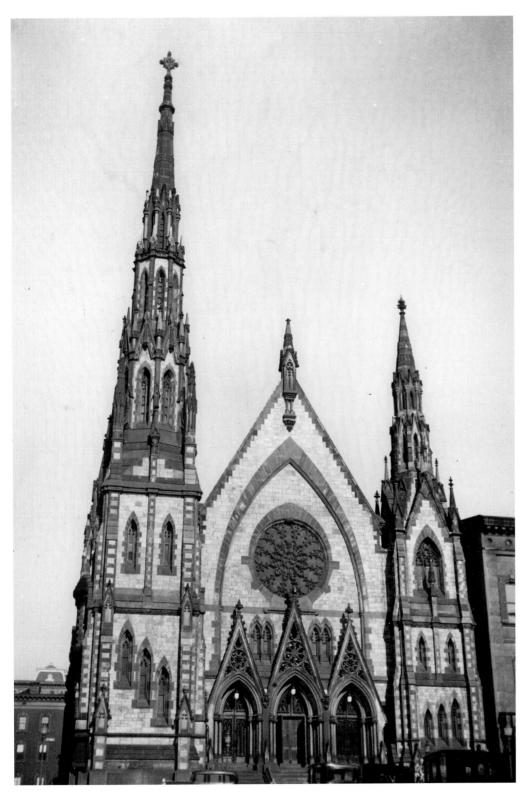

The Mount Vernon Place Methodist Episcopal Church, completed in 1872 and seen here in 1936, was constructed of six different types of stone, including green serpentine marble quarried at the nearby Falls. Major repair and replacement work was done on the stone in 1932.

In the 1930s, patrons of the shop occupying this modest nineteenth-century building at the corner of South Broadway and Shakespeare streets could pick up a Coca-Cola and a copy of *True Story* magazine, begun in 1919 by the eccentric publisher Bernarr Macfadden and offering lurid tales of crime and infidelity.

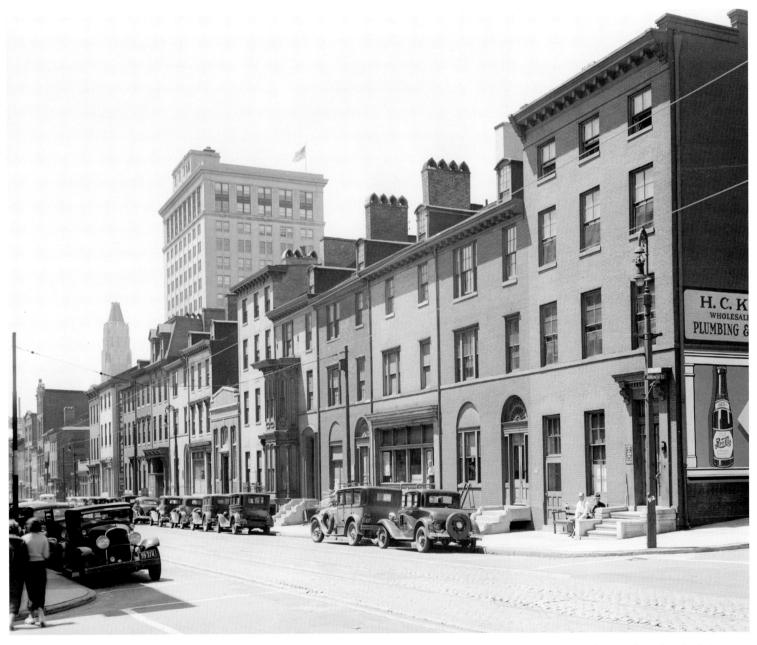

Waterloo Row, reportedly named after the place of Napoleon's final defeat, was designed by the noted architect Robert Mills. When built between 1817 and 1819, they were the most expensive row houses in Baltimore, priced at a staggering \$8,000.

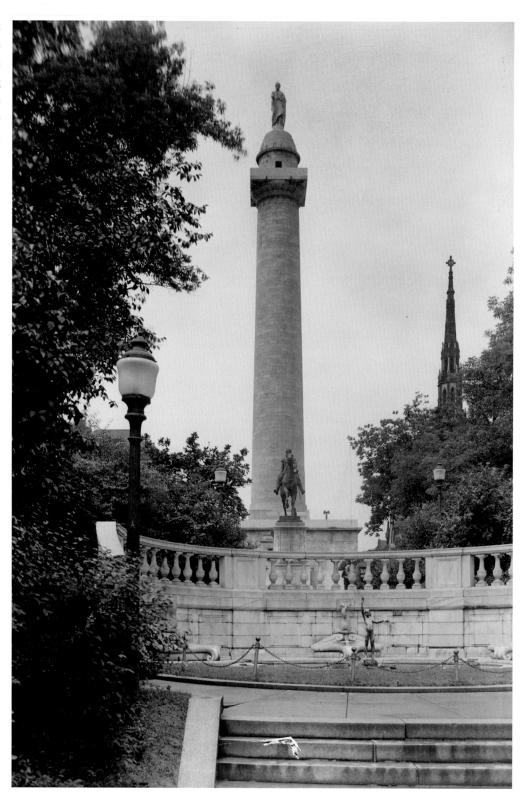

Mount Vernon Place, surrounding the Robert Mill–designed Washington Monument, was adorned by numerous bronze sculptures over the years, the last major piece being an equestrian statue of the Marquis de Lafayette, dedicated in 1924 to the memory of American and French comrades who fell in World War I.

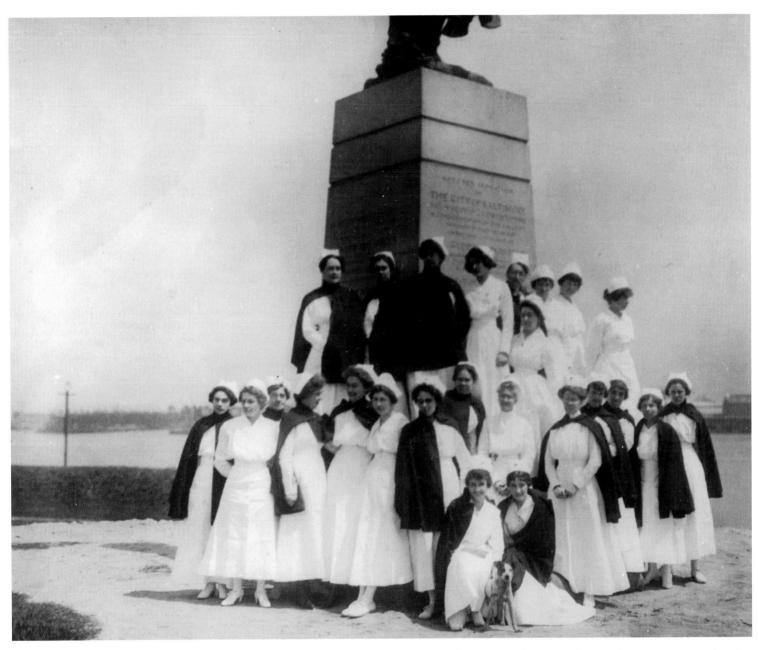

Nurses pose by the statue of Major George Armistead on the ramparts of Fort McHenry, begun in 1776 as an earthen-works structure protecting the city during the Revolutionary War. In 1814, Armistead held command of the fort and successfully defended the city from British attack during the Battle of Baltimore. In 1917, during World War I, the fort became home to General Hospital No. 2, the largest military hospital in the nation. More than a hundred temporary buildings were built on the grounds to accommodate wounded American soldiers returning from the war in Europe.

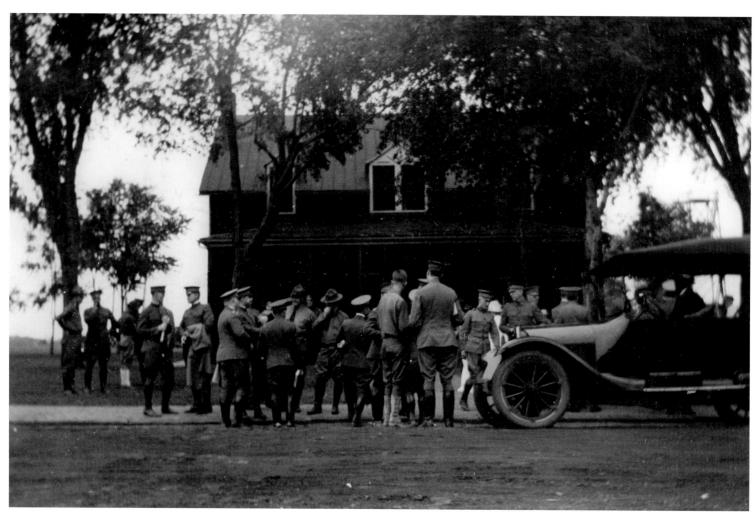

With the end of World War I, the need for the United States Army hospital at Fort McHenry diminished, and by 1923 the temporary buildings had been torn down.

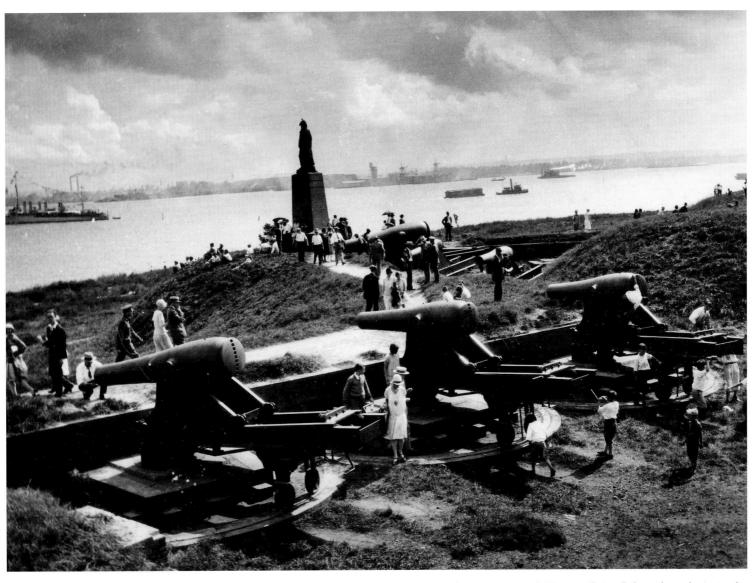

Fort McHenry was made a national park in 1925; in 1939 it was redesignated a "National Monument and Historic Shrine," the only such site in the United States.

Intricate cast-iron work adorns the balcony of a nineteenth-century building on the northwest corner of Exeter and Watson streets. Baltimore by the 1850s was a leading center for the manufacture of both structural and decorative cast iron; the local firm of Poole and Hunt created the cast-iron columns and much of the ironwork for the dome of the United States Capitol, completed in 1866.

Seen here in 1936, the President Street Station of the Philadelphia, Wilmington and Baltimore Railroad was completed in 1850 and served as the line's southern terminal. Passengers continuing onward had to disembark at the station and travel crosstown to pick up another southbound train. On April 19, 1861, the Sixth Massachusetts Volunteer Militia Regiment arrived at the station and, as they traveled along Pratt Street toward the B&O's Camden Station, were attacked by an angry mob of Southern-sympathizing citizens. After the attack, four soldiers and 12 Baltimoreans lay dead in the street, the first bloodshed of the Civil War.

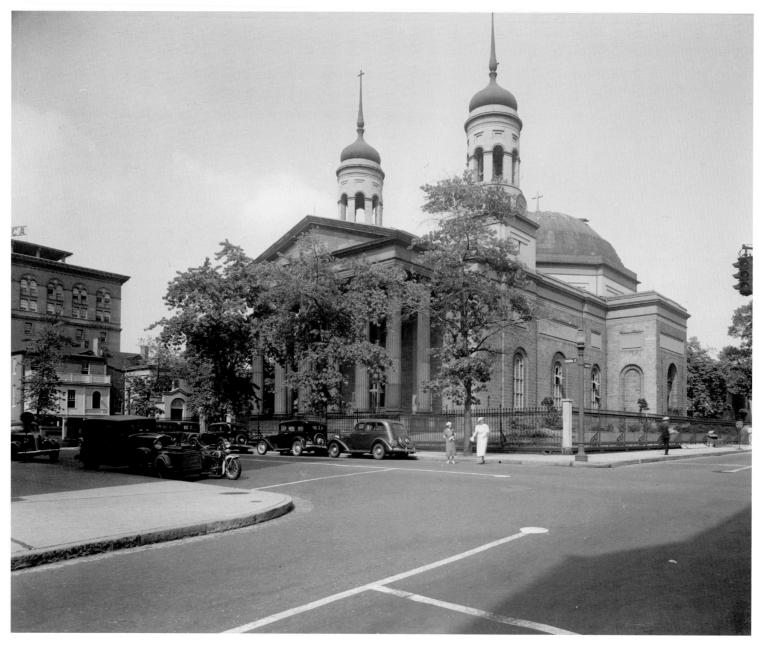

Consecrated in 1821 and seen here in 1936, the Basilica of the Assumption, designed by Benjamin Henry Latrobe, was declared "the finest classical church in America" by Fiske Kimball, the noted American architect and critic.

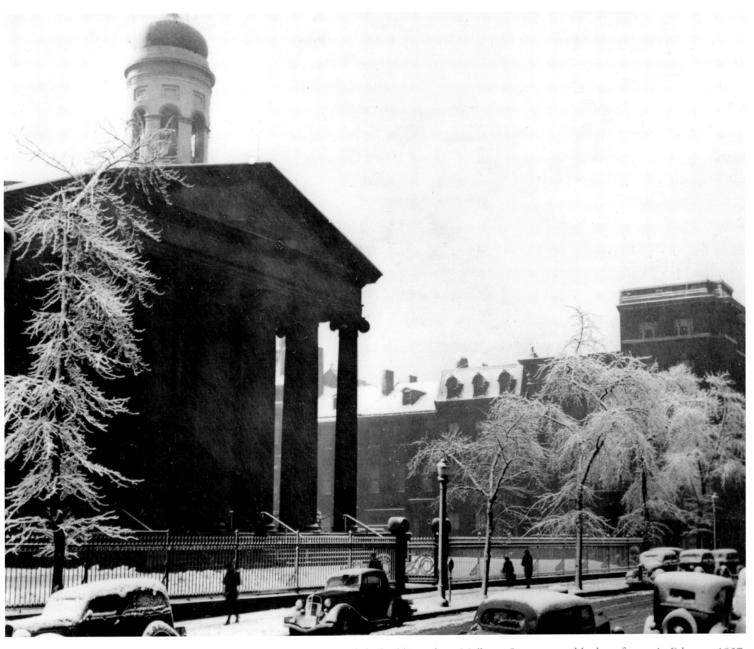

The Basilica of the Assumption and the buildings along Mulberry Street wear a blanket of snow in February 1937.

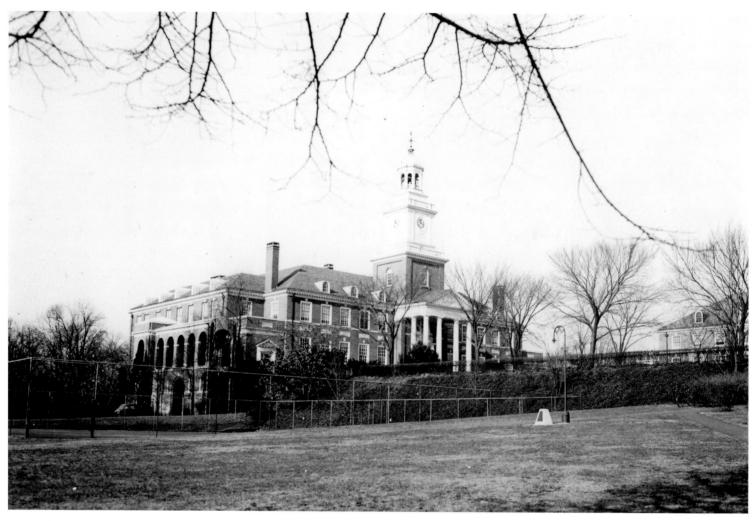

Johns Hopkins University opened on February 22, 1876, with the inauguration of its first president, Daniel Gilman. The school was something entirely new to the American educational system—a research university offering PhDs and dedicated not only to advancing its students' knowledge but to faculty research for the benefit of all humanity. In 1904, the university undertook an ambitious reworking of its overall campus design. The first major academic building on the new campus would be Gilman Hall, designed by the firm of Parker, Thomas and Rice. Dedicated in 1915 and named for the first president, it is seen here in 1941.

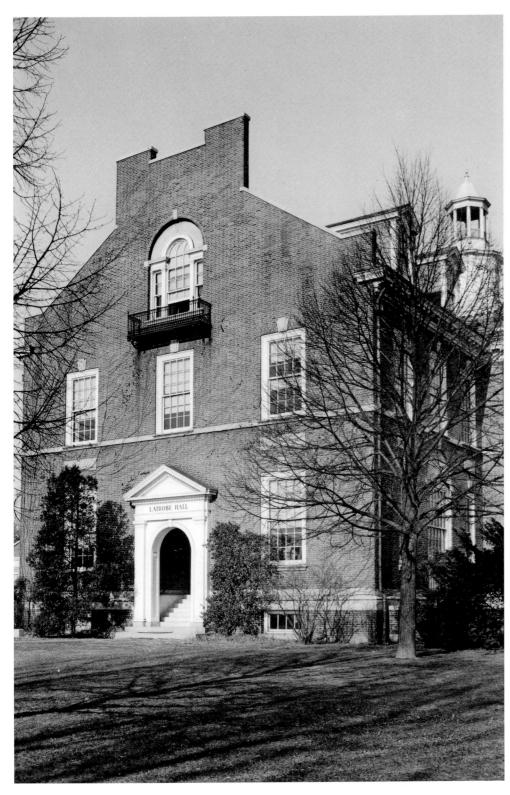

Latrobe Hall on the campus of Johns Hopkins University was designed by Joseph Evans Sperry and occupied in the fall of 1916 by the civil engineering department. In 1931 the building was renamed Latrobe Hall to honor the noted Baltimore engineer Benjamin Henry Latrobe, Jr., the chief engineer of the B&O Railroad at the end of the nineteenth century.

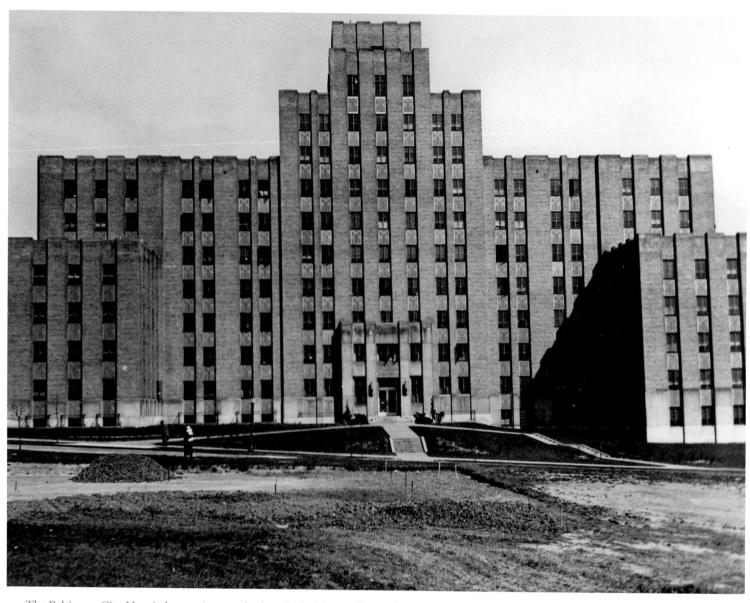

The Baltimore City Hospital traces its roots back to the Baltimore City and County Alms House, established in 1773 to house the poor. In 1866, the Alms House relocated to 240 acres overlooking the Chesapeake and by 1925 had grown into the Baltimore City Hospitals. In 1935, the City Hospitals completed a state-of-the-art, 450-bed general hospital, seen here shortly after its opening.

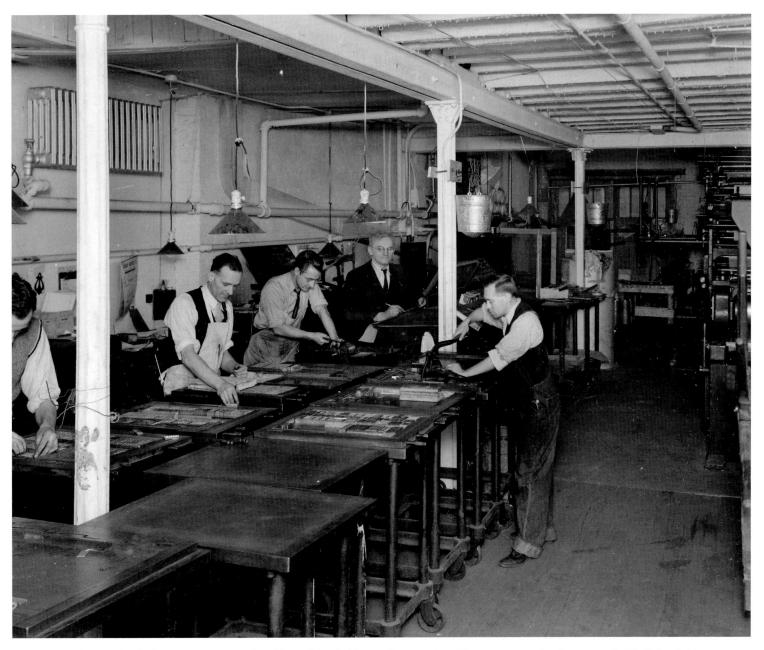

Compositors lay out the day's paper in 1937 at the offices of the *Baltimore Correspondent*. The newspaper, also known as the *Taglicher Baltimore Correspondent*, began publication in 1935 and appeared chiefly in German with some English, continuing a string of German-language newspapers that appeared in the city after World War I.

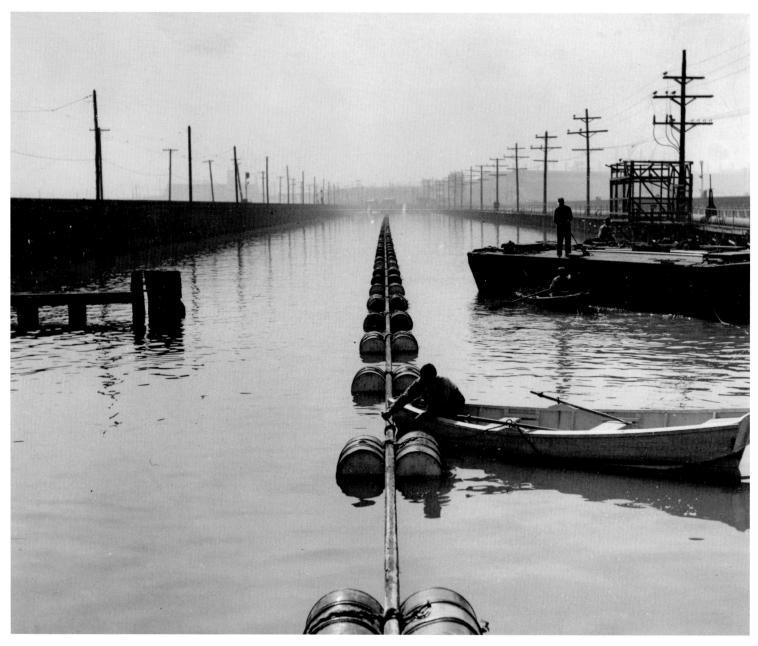

By 1918 the city of Baltimore had extended its limits by nearly 60 square miles, and over the succeeding decade the Baltimore Gas and Electric Company—formerly known as the Consolidated Gas Electric Light and Power Company of Baltimore—rushed to expand its gas and electric lines to meet the service demands of the outlying portions of the city to the north and south, across the Patapsco. Here in 1937, workers attend to a floating pipeline.

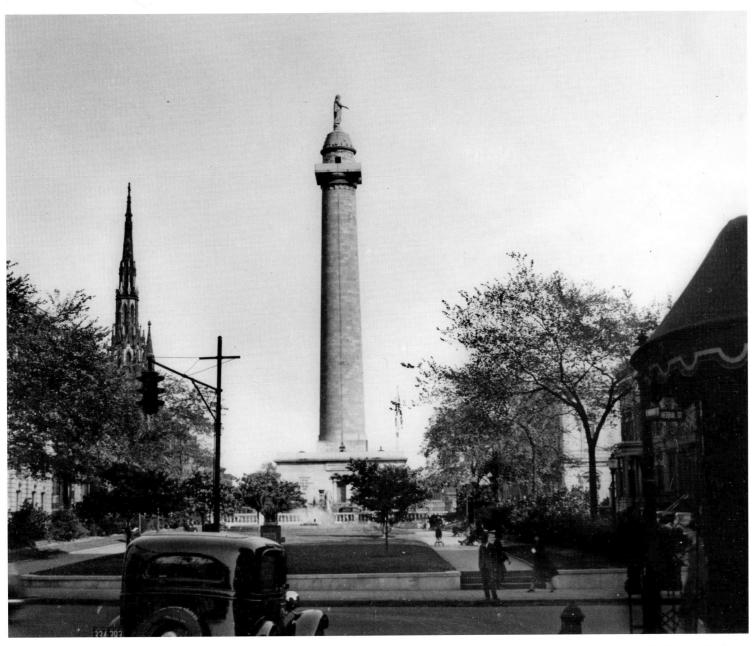

A motorist approaches Mount Vernon Place from the west, at Cathedral Street, in 1938.

The Howard Street Bridge, a twin steel arch–style bridge engineered and built by the J. E. Greiner Company, was constructed in 1938 to carry Howard Street over the Jones Falls and the railroad lines below. The 979-foot span replaced a nineteenth-century iron-arch bridge.

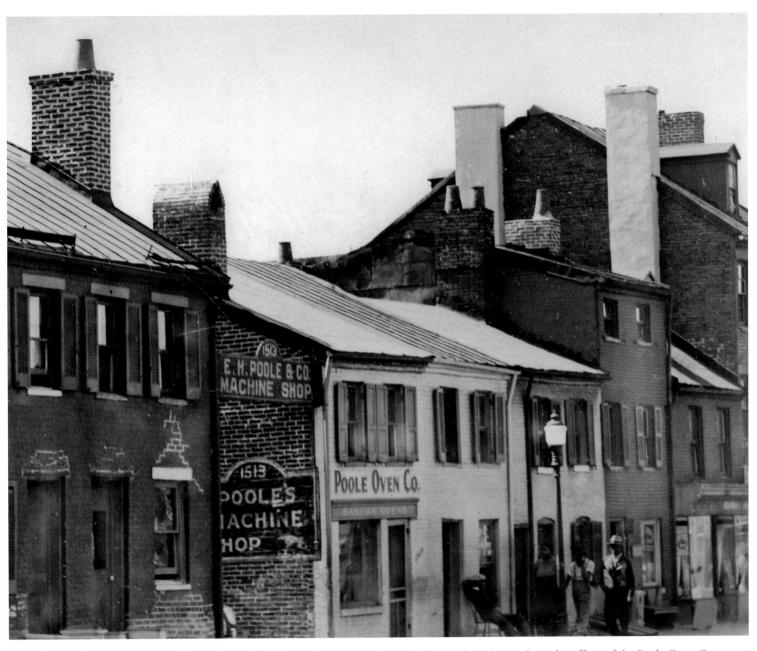

On Orleans Street, just south of Dallas Street, in 1939 sat the machine shop of E. H. Poole and, next door, the offices of the Poole Oven Company, manufacturers of a popular line of baker's ovens.

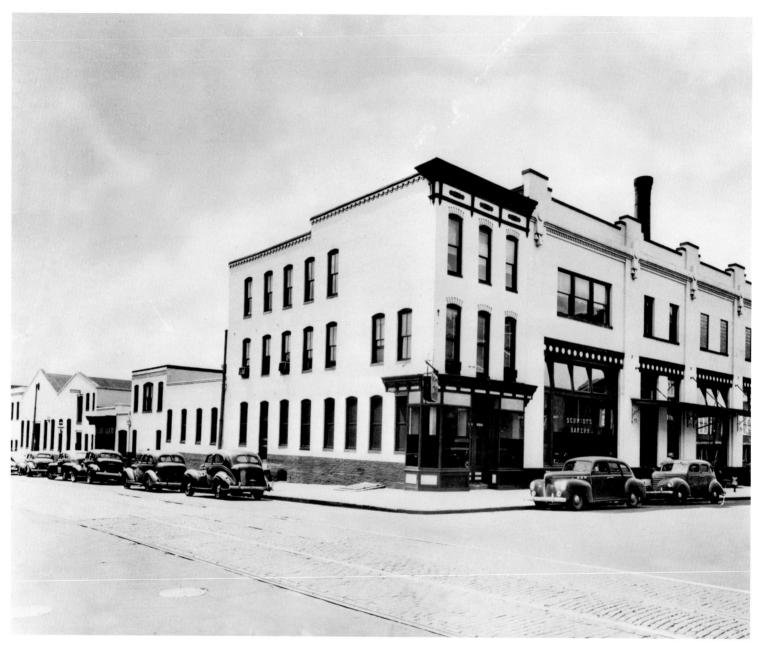

In 1886, German immigrants Peter and Elizabeth Schmidt began a baking company that by the early twentieth century had grown into one of the Mid-Atlantic's largest independent bakeries. In 1914, they opened this state-of-the-art bakery on Laurens Street that was capable of turning out 500,000 loaves of bread every six days.

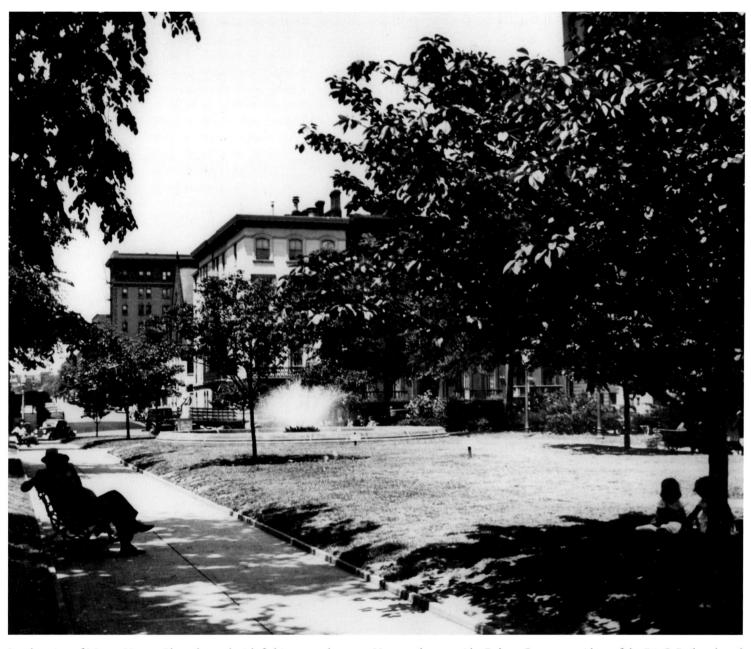

Landscaping of Mount Vernon Place changed with fashion over the years. Here on the west side, Robert Garrett, president of the B&O Railroad, and art collector William Walters landscaped the square in 1884 with bronze statues and a round fountain. These local residents are enjoying the square's shade in 1939.

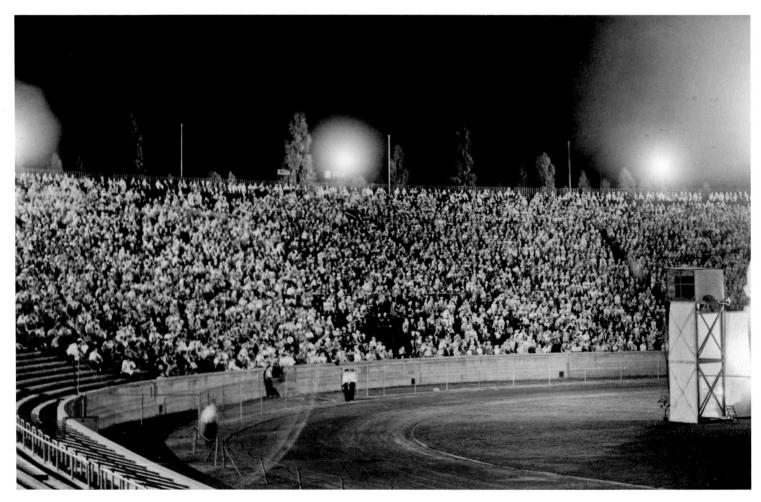

Among Baltimore's historic sports arenas was Municipal Stadium, built in 1922 along 33rd Street in a previously undeveloped area called Venable Park. A large horseshoe of a stadium with an open southern exposure, the stadium in its early years saw primarily football action, hosting various college-level matches including the 1924 Army-Navy game. Seen here in 1939, the stadium was pressed into service as a park for the Orioles in 1944 when the baseball team's previous home was destroyed by fire. In 1950, the stadium was razed to make way for Memorial Stadium.

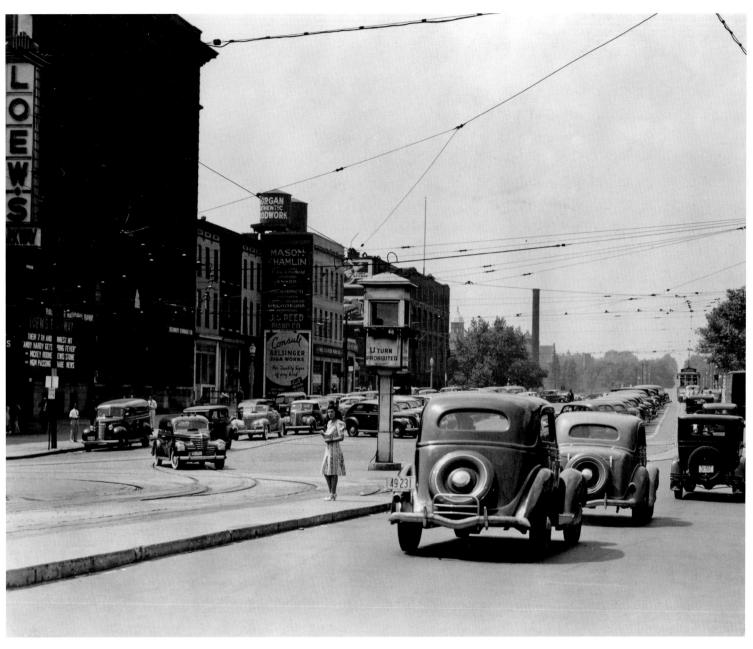

North Avenue—U.S. Route 1—at the intersection of Charles Street was distinguished by Baltimore's first traffic light, contained in the kiosk on the pole standing in the median. At first, the light was manually operated by a policeman stationed in the booth; in 1928, it became automated.

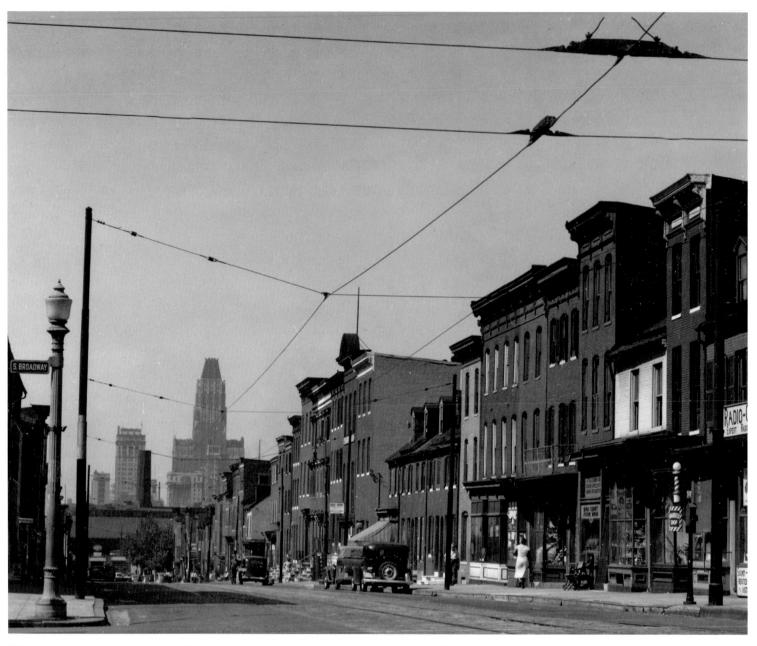

The nineteenth-century row houses lining East Lombard Street, near its intersection with South Broadway, are dwarfed by the looming presence in the distance of the Baltimore Trust Building, which broke ground for its new office in 1924 at the corner of Light and Baltimore streets. The 34-story, 509-foot structure opened five years later.

LIBERTY SHIPS TO HARBORPLACE

(1940 - 1980)

Even before America's entrance into World War II, Baltimore businesses had begun retooling to aid the Allies fighting overseas. After the bombing of Pearl Harbor on December 7, 1941, the refitting of industry in support of the armed forces quickened, with everything from tanks to bombers to gas masks issuing from Baltimore-area factories. Perhaps Baltimore's greatest contribution to the war effort was the Liberty ship, light cargo transports designed to carry supplies and munitions to the front, the first of which slid from the Bethlehem-Fairfield Shipyard in 1941.

As war production rolled on, workers from throughout the South moved to Baltimore, seeking defense employment. And yet, despite the rise in wage-earners, downtown merchants struggled under the constraints of wartime rationing. Little to sell meant little profits. But it was the suburban boom following the war that would truly sound the death knell for the city's long-standing shopping districts.

The population would peak in 1950, reaching 949,708, but as new housing developments sprang up outside the city limits, the numbers would steadily decline. A mass exodus to the suburbs inexorably pulled the retail stores in its wake, as merchants through the 1950s and 1960s abandoned the city center for the new automobile-oriented shopping centers. The inner city became as economically woeful as it had been during the Depression, and the harbor, once the vital center of city life, declined into a blighted collection of abandoned warehouses and rotting piers.

A coalition of municipal, business, and citizen organizations sought to stem the city's decline, beginning in earnest in 1962 with One Charles Center, a redevelopment project featuring a 24-story office tower by the architect Mies van der Rohe. Ten years later, the State of Maryland erected the soaring World Trade Center, designed by I. M. Pei. But perhaps the greatest stimulus to renewal was Harborplace, designed by Benjamin C. Thompson and built by the Rouse Company, a modern retail, restaurant, and entertainment complex that transformed the old harbor when it opened in 1980.

Baltimore's population would continue its downward slide in the last decades of the twentieth century. But the revitalization efforts spreading out from the harbor would spur a remarkable transformation that, to this day, is slowly restoring the luster, reclaiming the vibrancy, and renewing civic pride in the centuries-old city by the bay.

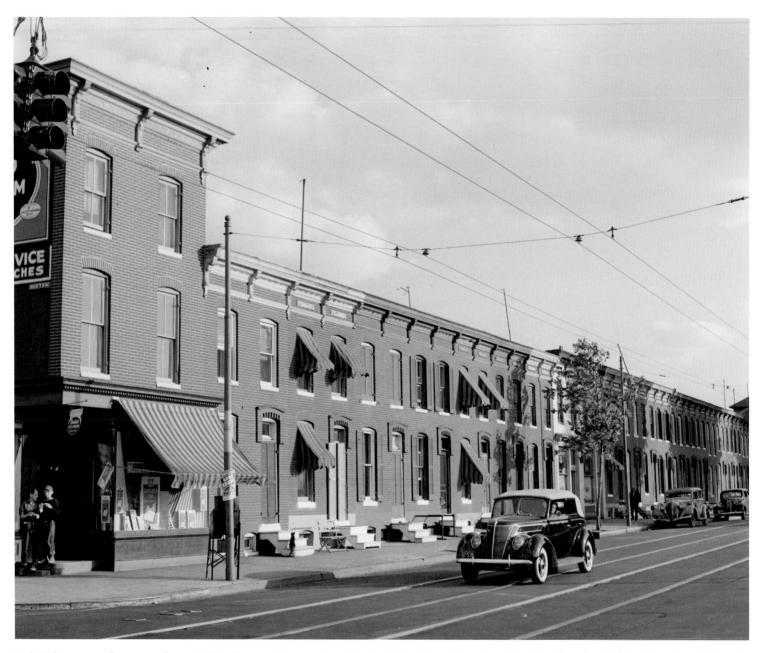

Jack Delano, one of a group of remarkable photographers employed by the United States Farm Security Administration (FSA) during the 1930s and early 1940s to document the effects of the Great Depression, took this shot of a quintessential string of Baltimore row houses in June 1940. Other photographers working for the FSA included Walker Evans, Dorothea Lange, and Gordon Parks.

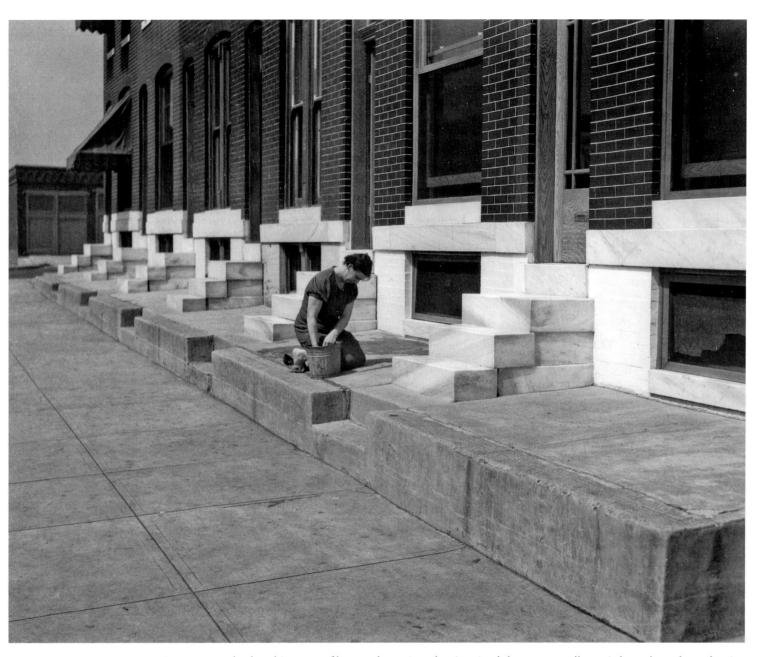

A woman scrubs the white steps of her row house in a cleaning ritual that was proudly carried out throughout the city.

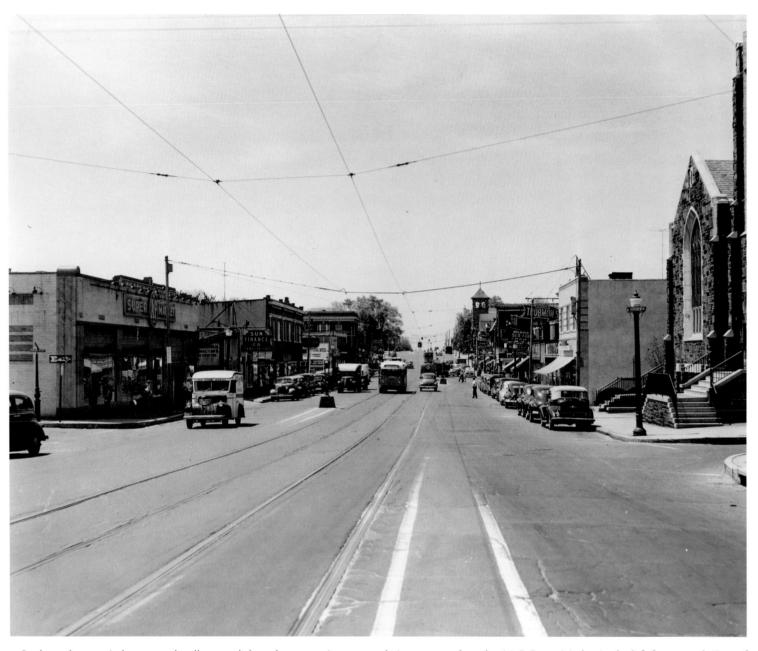

In the early twentieth century, locally owned shops began to give way to chain stores, such as the A&P Super Market in the left foreground. One of the chain's strongest markets, Baltimore at one time boasted four A&Ps—on Broadway, South Broadway, West Baltimore, and North Eutaw streets.

By the 1930s, the chain had grown to 15,000 stores nationwide.

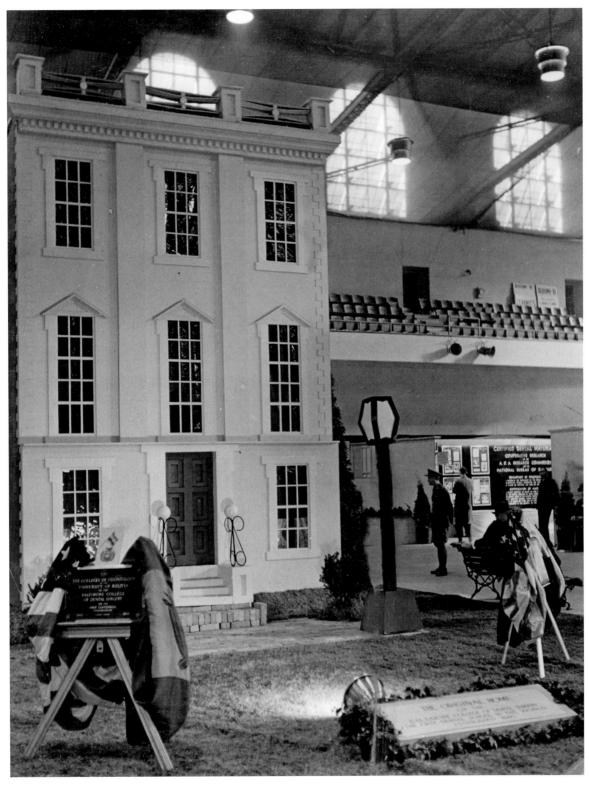

The Baltimore College of Dental Surgery, chartered by an act of the Maryland General Assembly in 1840, is the world's first dental school. In 1940, the school—today a part of the University of Maryland system—celebrated its centennial with displays of salient moments in dental history, including a reconstruction of the college's original home.

During World War II, Liberty ships, created by the United States to transport cargo to fighting forces around the globe, were turned out at an amazing pace. Eighteen American shipyards built 2,751 Liberties between 1941 and 1945. Foremost among the builders was Baltimore's Bethlehem-Fairfield shipyard, whose innovations in mass production reduced the amount of time required to build a ship from 244 days to less than 30 days. Key to the innovation was prefabricating and welding parts for the Liberty ships, undertaken at this former freightcar production site.

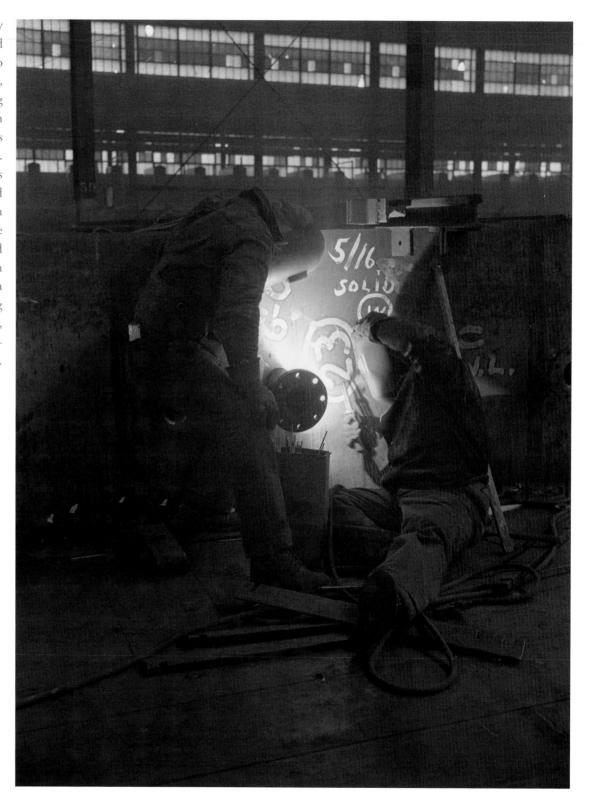

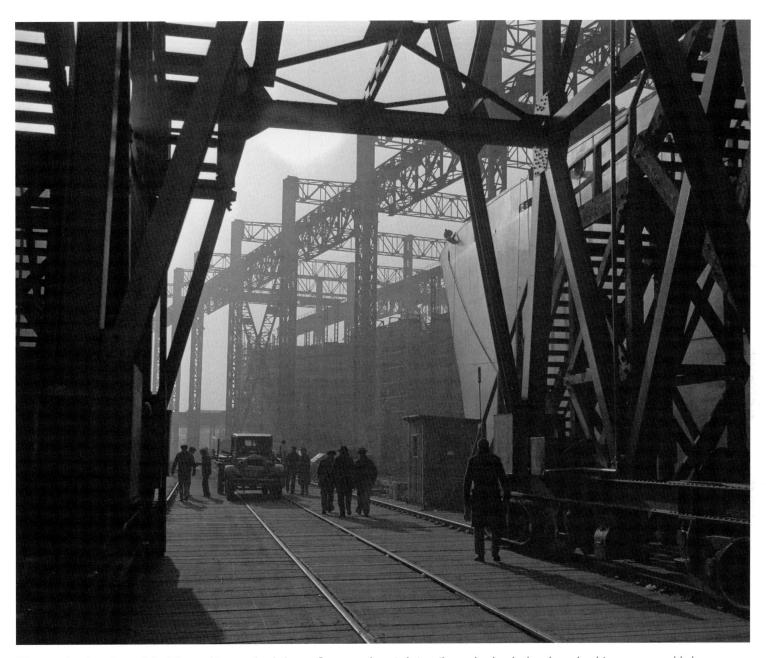

The completed sections of the Liberty ship were loaded onto flatcars and carried six miles to the dry docks where the ships were assembled.

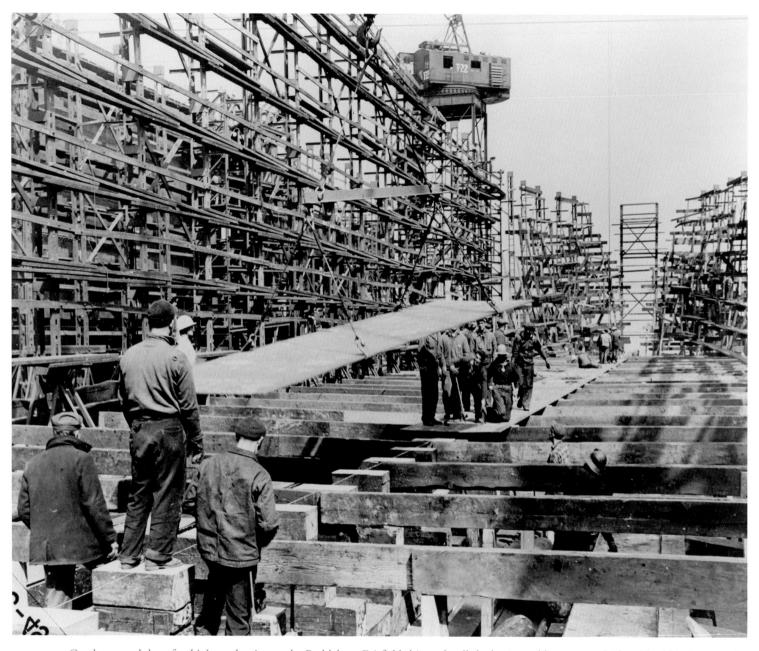

On the second day of a ship's production at the Bethlehem-Fairfield shipyards, all the horizontal beams were laid and keel blocks set at the proper pitch.

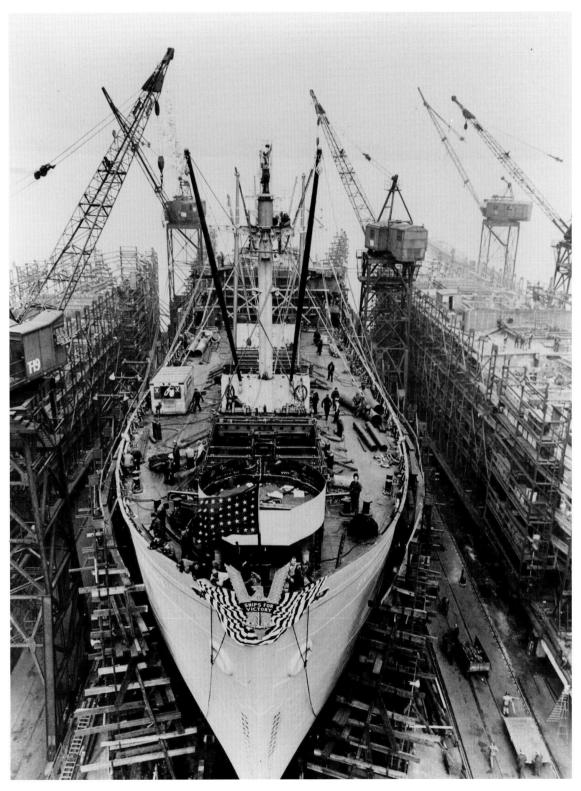

On the twenty-fourth day of production, a Liberty ship such as this one would be ready for launching—with the christening platform in place. On September 27, 1941, the nation's first Liberty ship, the *Patrick Henry*, was launched from the Bethlehem-Fairfield Shipyard.

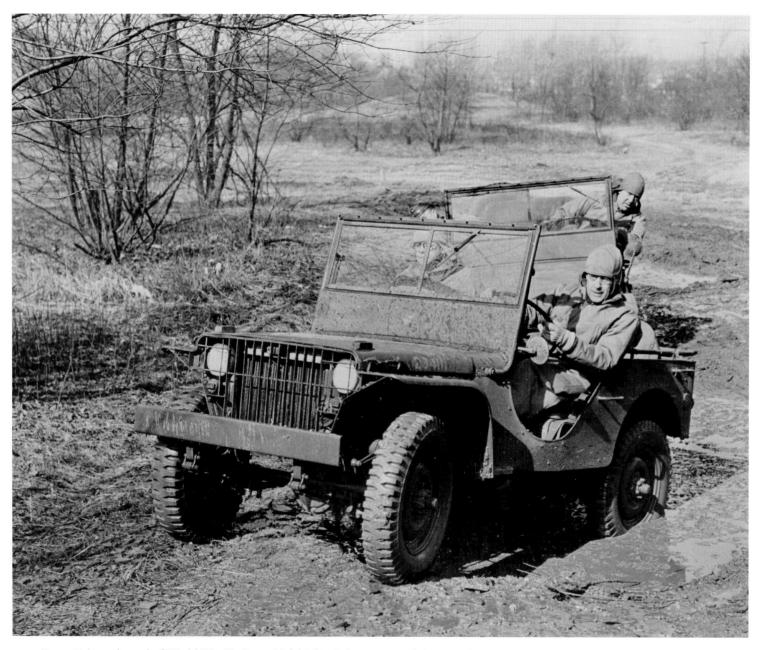

From 1941 to the end of World War II, Camp Holabird in Baltimore served the United States Army as a training and testing center for military transports. Home of the service's Quartermaster Mechanical Repair Unit, the camp encompassed some 350 acres and 286 buildings. In 1940, the camp was the site of field testing for a new type of vehicle, a lightweight alternative to bulky military trucks that often got stuck in the mud. The vehicle became known as the "Jeep." Here, in 1942, Colonel H. J. Lawes, post commander, gives his pupils firsthand instructions in handling the new vehicle, demonstrated on the camp's training ground.

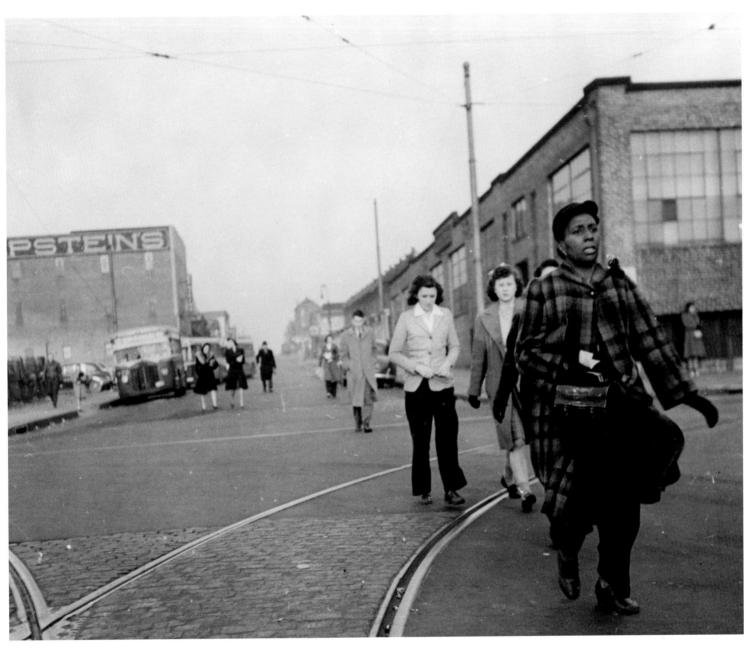

During World War II, in Baltimore as throughout the country, women filled many of the jobs necessary to keep the war industries running at full capacity. Here in April 1943, a group of predominantly female workers are on their way to catch a bus or streetcar to take them to their jobs at 7:00 A.M.

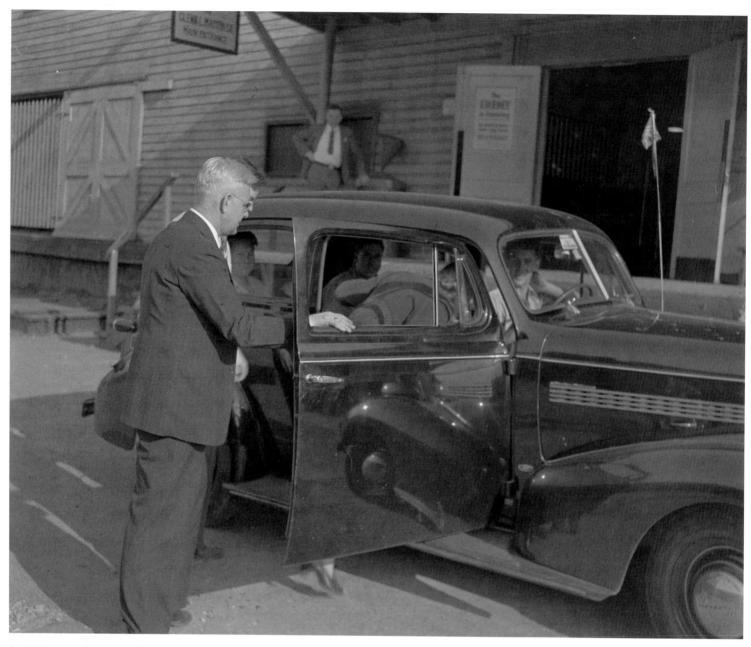

In 1928, aircraft pioneer Glenn L. Martin was lured to Baltimore by promises of a new municipal airport, ice-free water for seaplanes, and union-free labor. The plant he established in Middle River, northeast of the city, became a key part of America's "arsenal of democracy" during World War II, producing among other things the Martin Model 167 plane—known as the "Maryland"—that saw action with the French and British forces. Here, as part of the war effort, the plant's personnel manager joins a carpool to save gas and rubber.

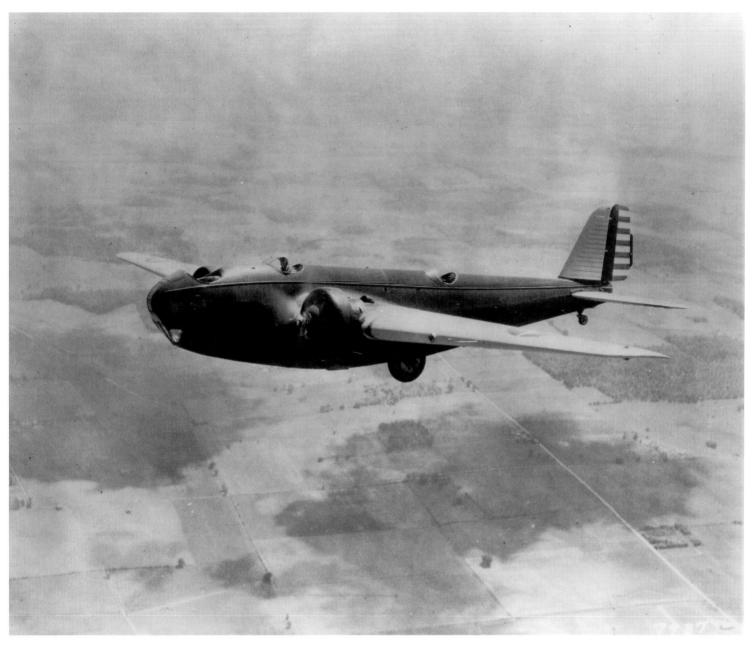

The B-10 bomber, developed by the Glenn L. Martin Company of Baltimore and first flown in 1932, revolutionized bomber design. Innovations such as an all-metal monoplane build, closed cockpits, rotating gun turrets, retractable landing gear, and internal bomb bay would be the standard for bombers for years after.

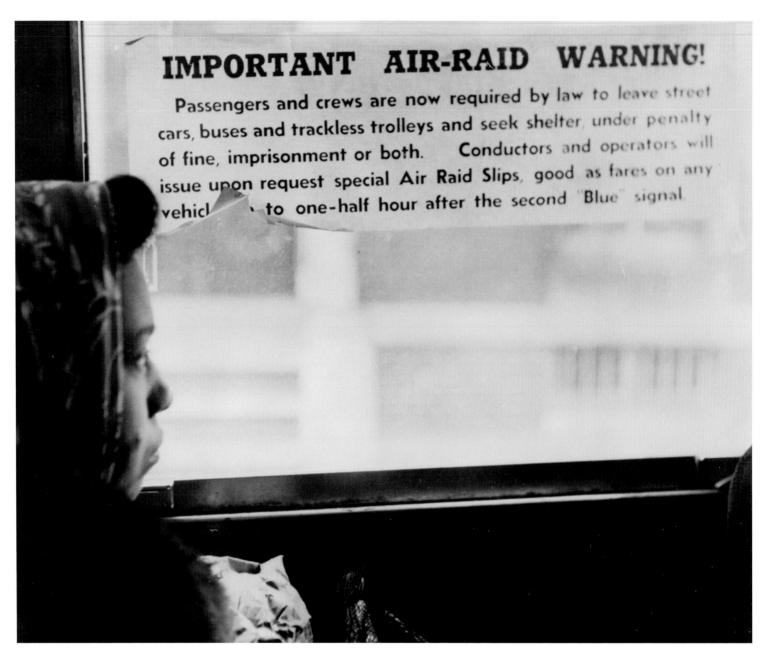

For coastal cities like Baltimore, with extensive shipbuilding and airplane facilities, air raids were regarded as a major threat. As the sign in the window of this bus indicates, if the warning signals sounded, passengers were required to leave the conveyance and seek shelter, though they could request a fare voucher good for reboarding anywhere for half an hour "after the second 'Blue' signal," which was the signal indicating danger had passed, at least for the moment.

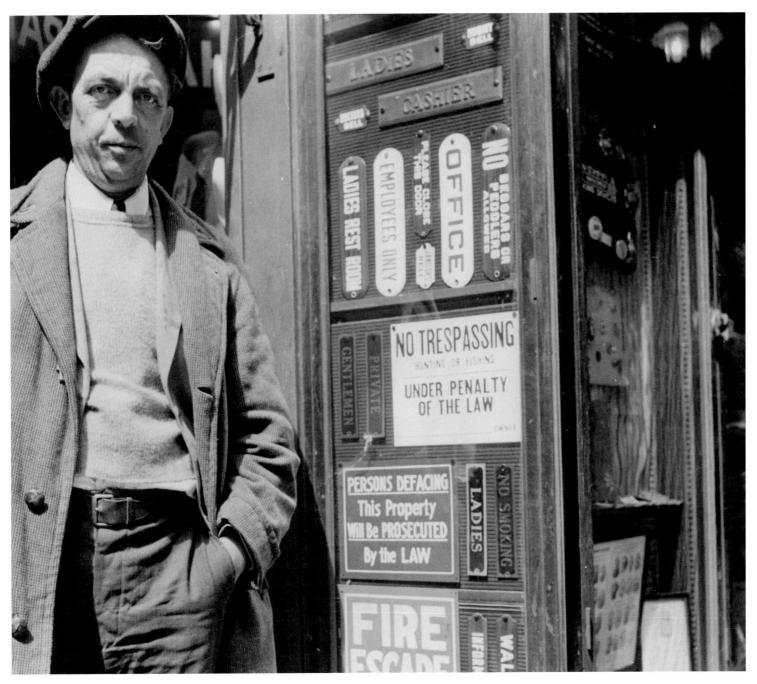

Marjory Collins, a photographer with the Farm Security Administration, snapped this image of a Baltimore sign company in 1943. Collins was a former photographer with the Associated Press.

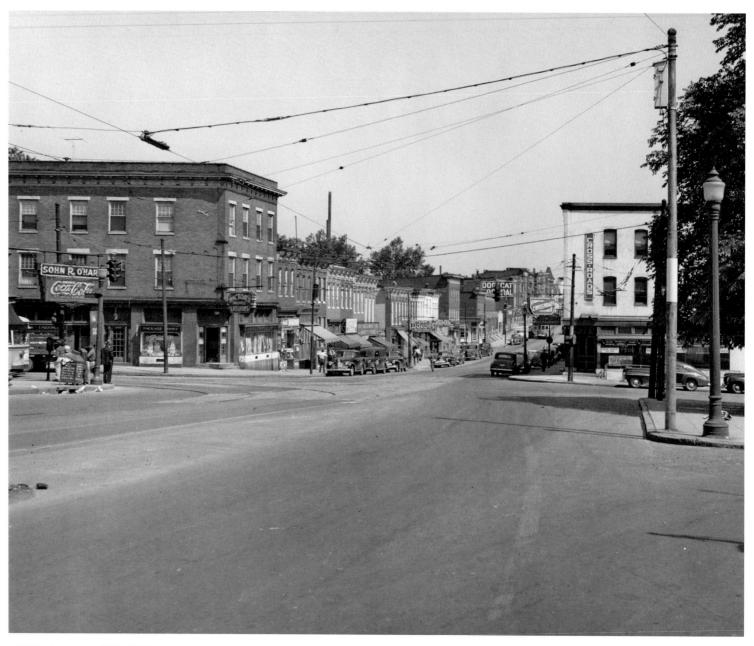

With the onset of World War II, the United States government found it necessary to ration food, gas, rubber, metal, even clothing, all to ensure that a steady stream of supplies could be directed toward the war effort. Hard hit were the commercial establishments of downtown Baltimore, where quiet streets reflected the lack of goods and customers.

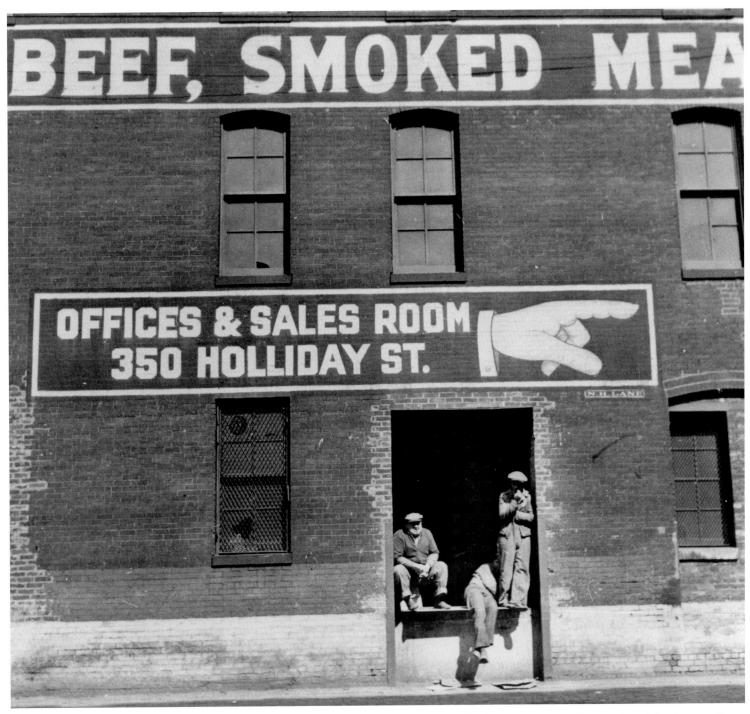

In 1943, when Marjory Collins took this photograph of a meat warehouse in Baltimore, beef and other meats were being rationed for the war effort. Government posters of the era asked Americans to "share the meat" and set the standard for adult consumption at two and a half pounds per week.

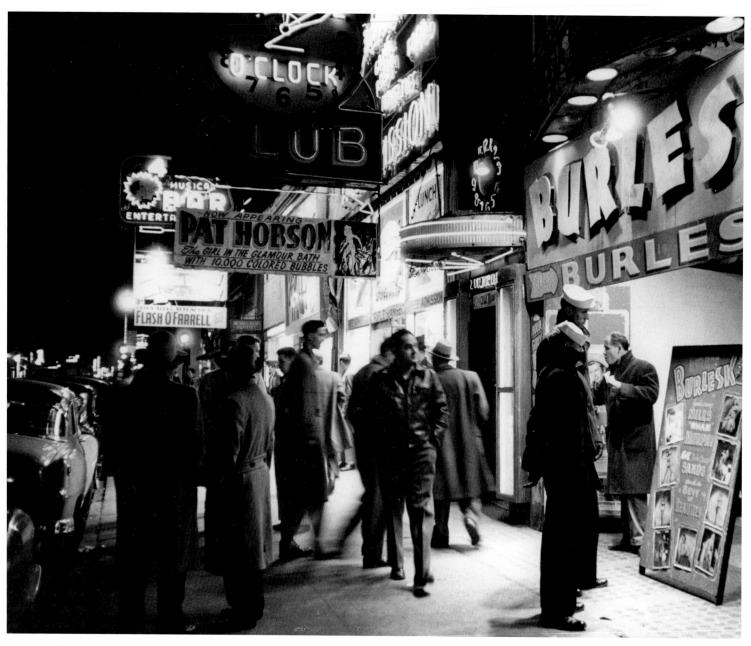

The city's free-swinging entertainment district was known as the Block, centered along Baltimore Street between Guilford Avenue and the Fallsway. In 1906, the Gayety Theatre opened, becoming a popular spot on the American burlesque circuit. By the 1940s it had been joined by a glittering mix of all-night restaurants, peep show emporiums, and cabarets such as the Oasis, the Pussy Cat, and the Two O'clock Club, the latter seen here featuring Pat Hobson, "The Girl in the Glamour Bath with 10,000 Colored Bubbles."

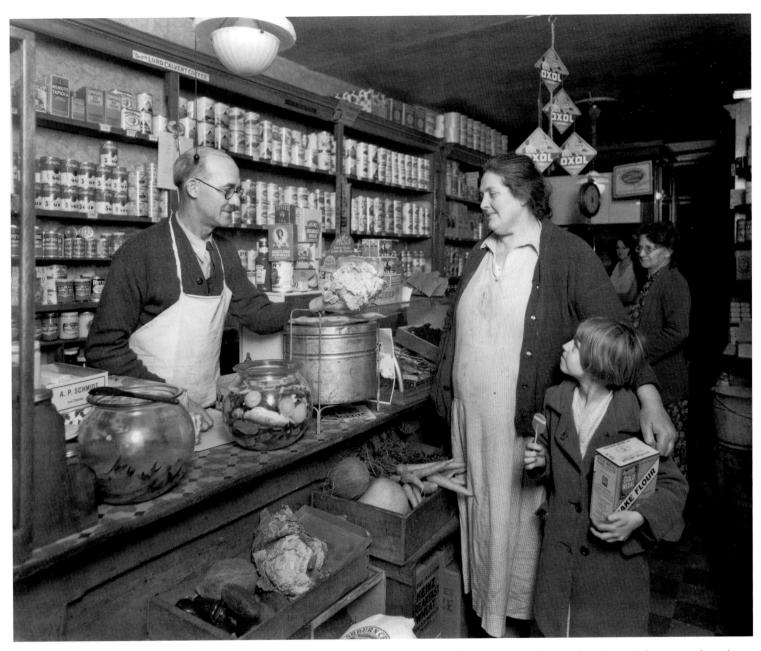

The shelves of Fred Grouer's grocery store on Hare Street are filled with Baltimore's best canned products.

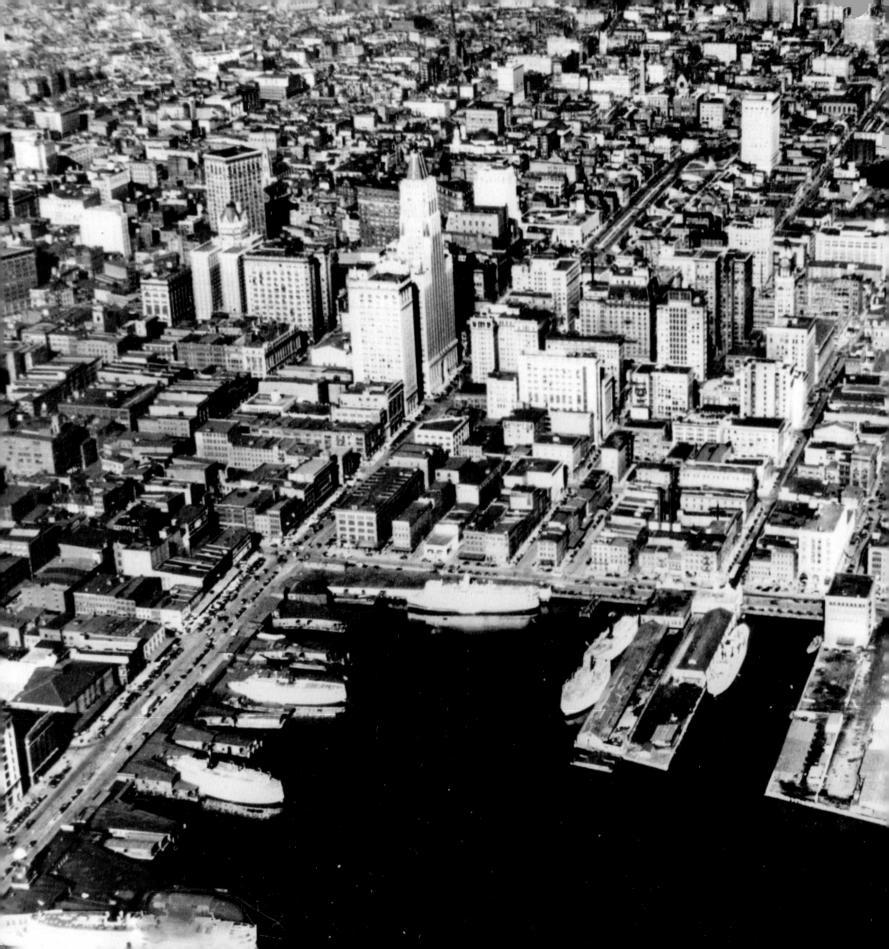

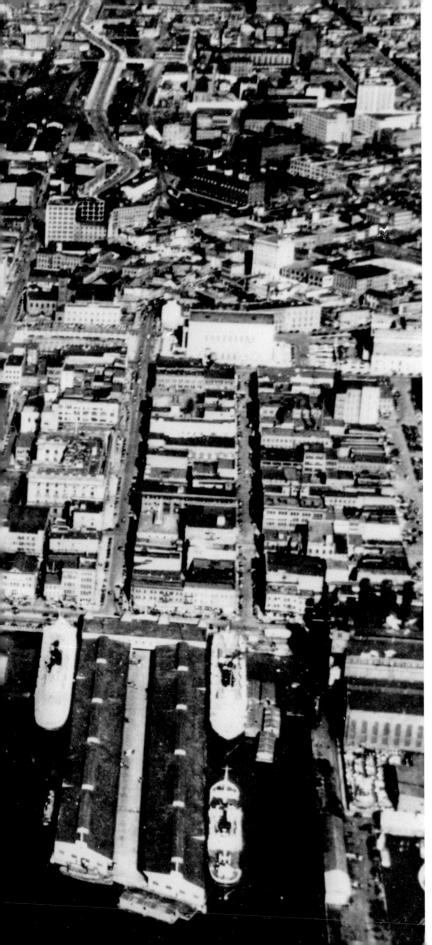

The Baltimore Trust Building at left-center, opened in 1929, dominates this aerial view of Baltimore.

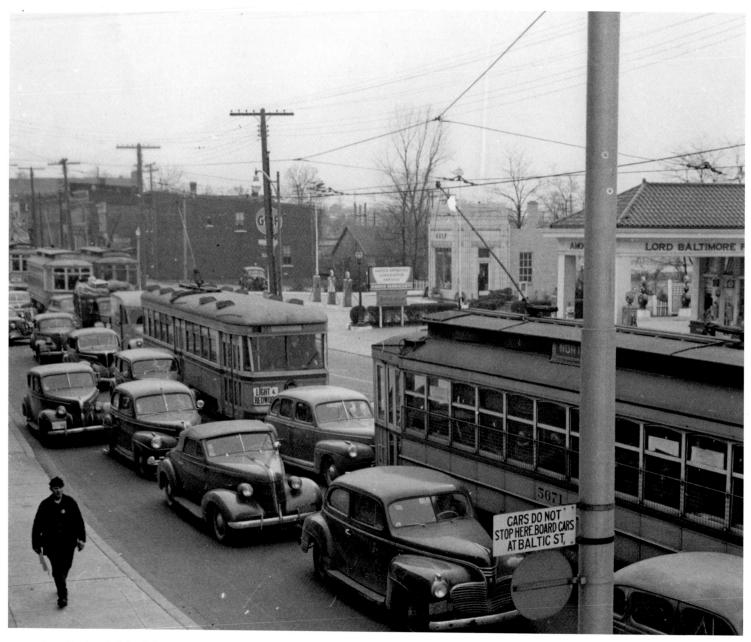

A trolley headed for Baltic Street passes by a Lord Baltimore Filling Station in 1944. Local entrepreneur Louis Blaustein incorporated the chain of area stations in 1921 to market the petroleum products of his American Oil Company, which he formed in 1911 and nicknamed "Amoco." Blaustein pioneered such innovations as one of the first visible globe gasoline pumps—which allowed customers to actually see the gas they were pumping—along with unleaded gasoline and the drive-in station. In 1954, Blaustein's oil company and his service station chain were merged into the Standard Oil Company of Indiana, which eventually adopted his Amoco name.

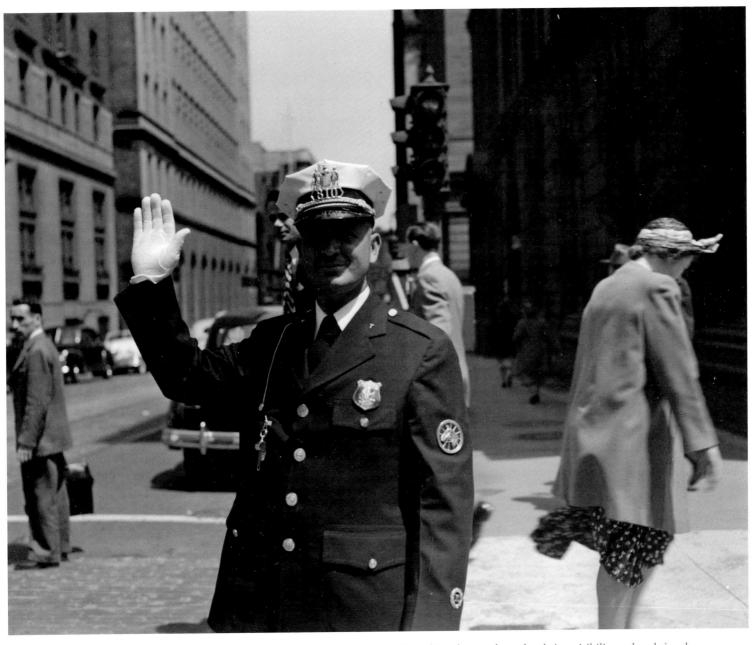

Directing downtown traffic in 1948, a Baltimore city policeman wears the familiar white gloves, adopted to bring visibility to hand signals.

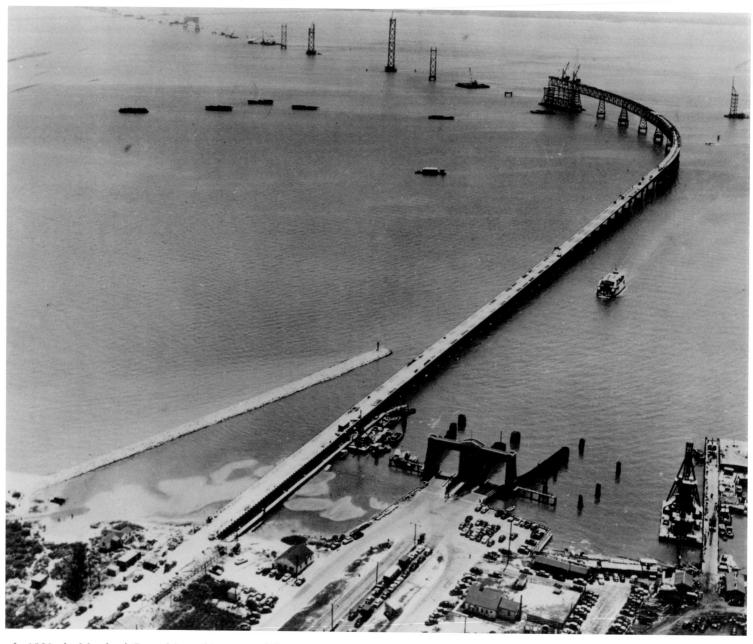

In 1938, the Maryland General Assembly proposed the construction of a bridge across the Chesapeake Bay, from Sandy Point on the Western Shore to Kent Island on the Eastern Shore, to replace the private automobile ferries that had run since the early twentieth century. World War II delayed construction until 1949, when ground was finally broken and work commenced.

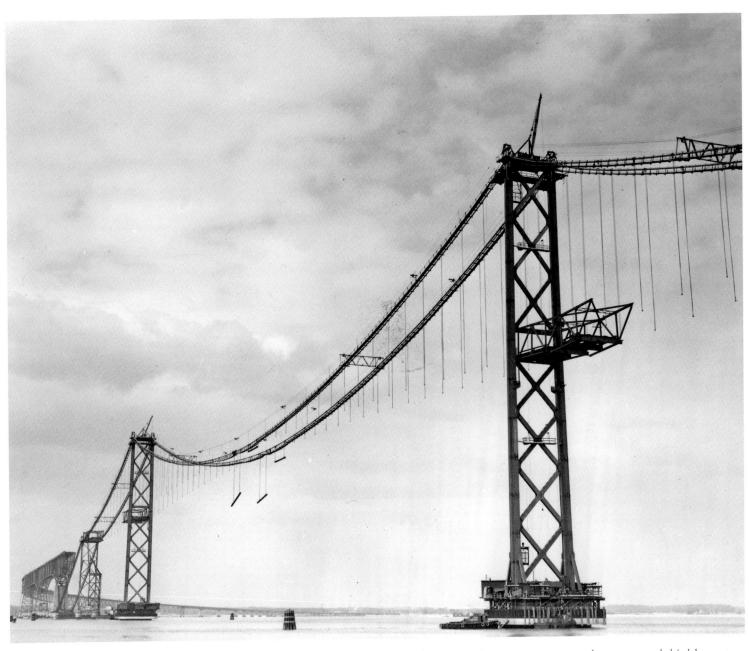

When opened to traffic in 1952, the Chesapeake Bay Bridge, at 4.32 miles, was the longest continuous over-water steel structure and third-longest bridge in the world.

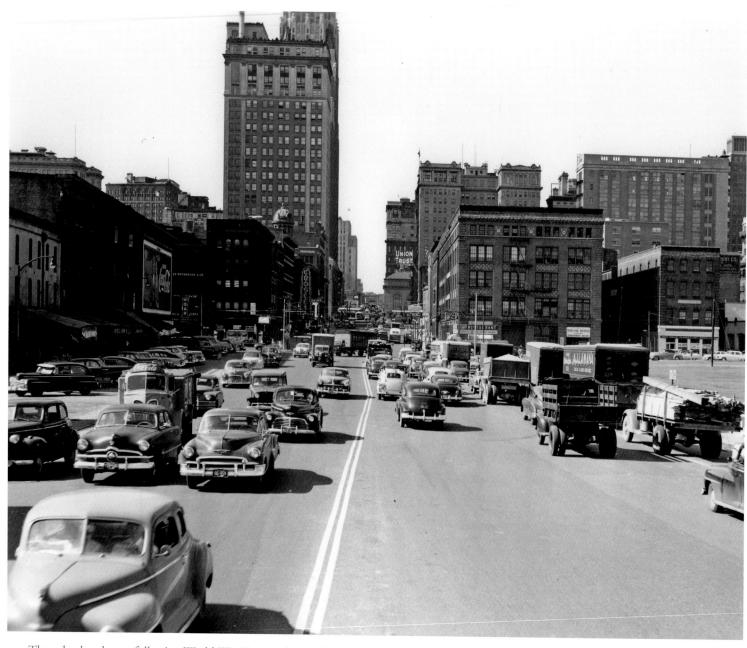

The suburban boom following World War II created new challenges for Baltimore city planners, as they had to contend with a steadily increasing flow of commuters driving to downtown offices—and creating the city's first rush-hour traffic jams. In 1952, a study was commissioned to document the conditions. Here, heavy traffic moves along Light Street between 3:30 and 5:00 P.M.

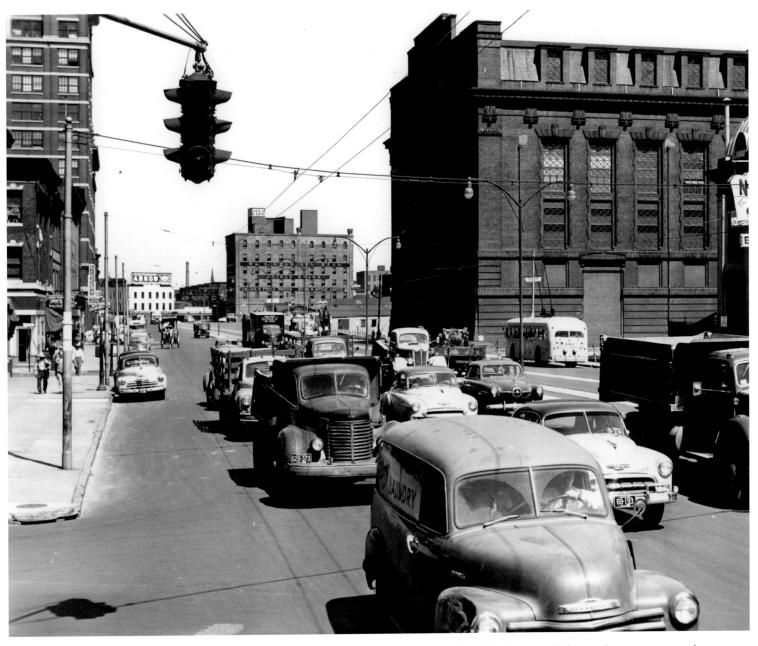

Afternoon traffic crawls down Pratt Street in May 1952. The large building at right is the United Railways and Electric Company power plant on Pier 4, begun in 1895 and completed in stages by 1903.

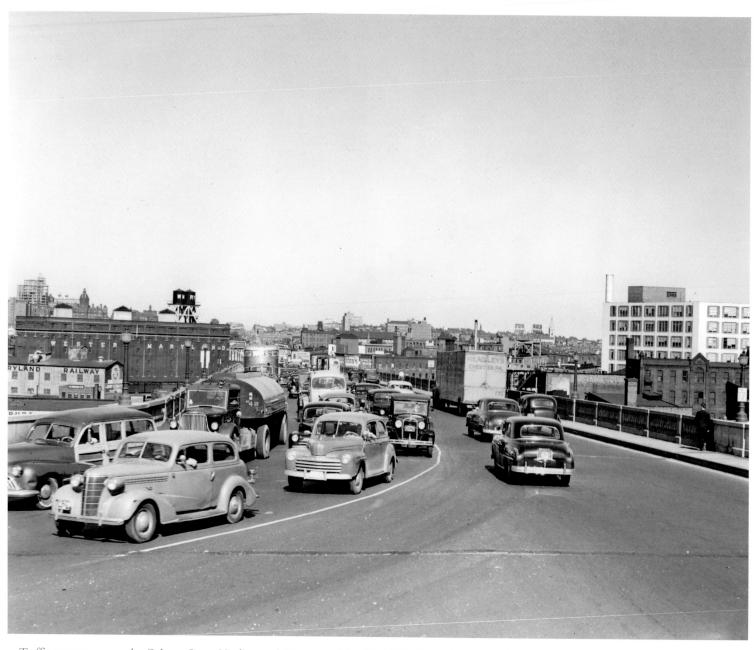

Traffic streams across the Orleans Street Viaduct at 4:50 p.m. on May 27, 1952. Opened in 1930, the 2,200-foot-long, four-lane expressway carried traffic over railroad tracks, Preston Gardens, and Calvert Street—and provided an attractive entrance to the downtown area.

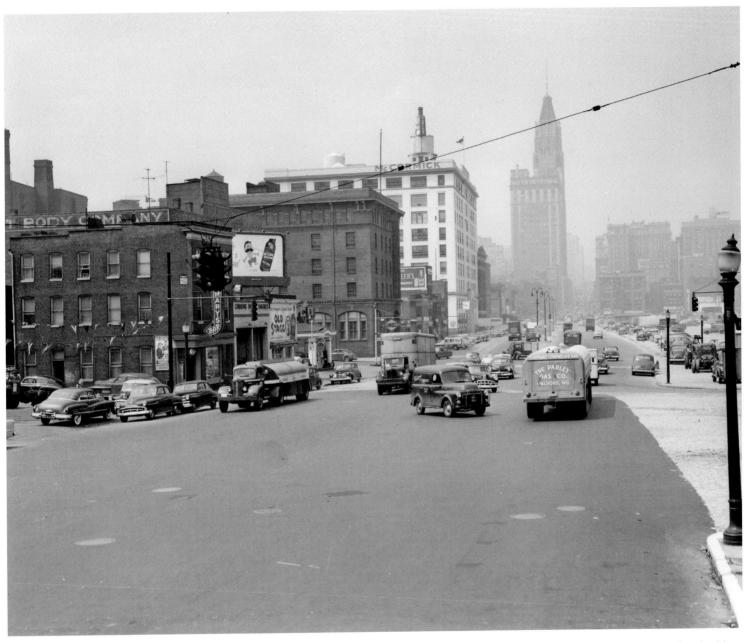

This 1953 view north on Light Street from its intersection with Key Highway shows truck traffic moving to and from the harbor. The white building at center is the McCormick Spice building, built in 1921 for the celebrated Baltimore-based import company.

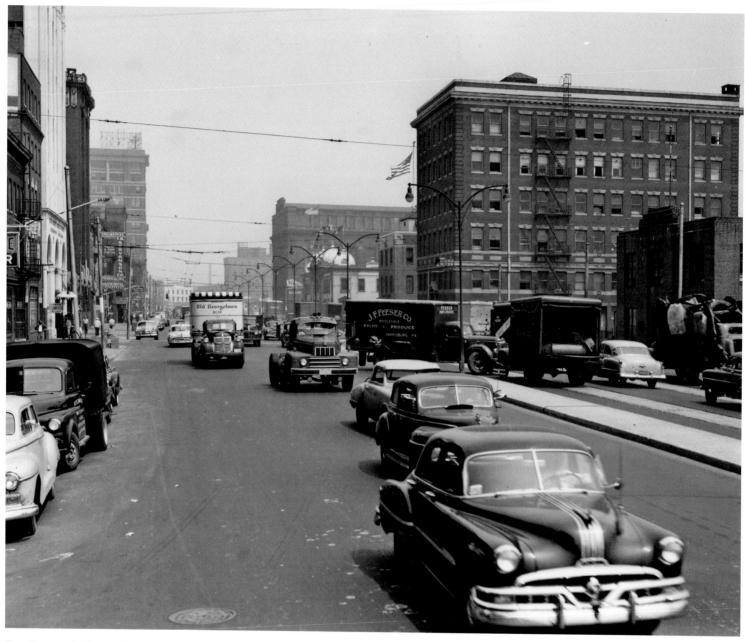

East Pratt and Cheapside streets bear a steady stream of truck and auto traffic in 1953.

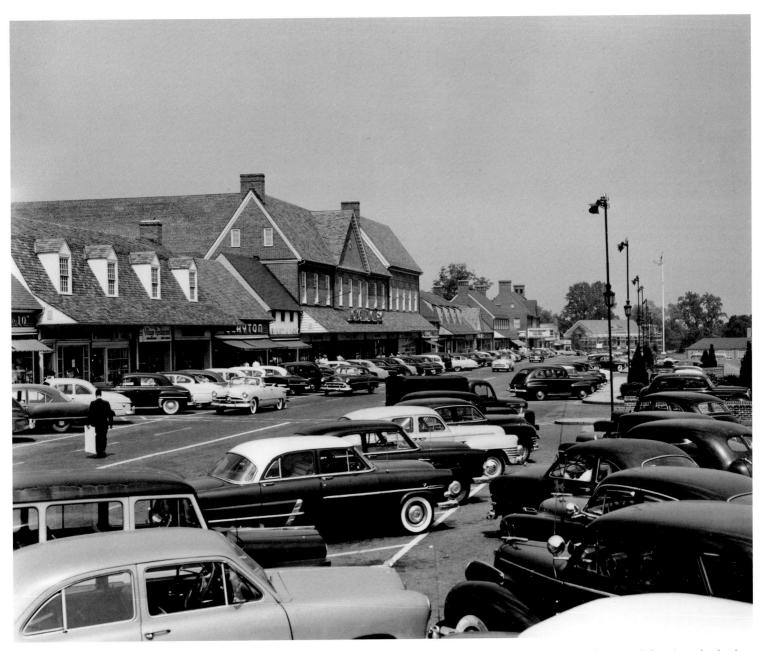

The Edmondson Village Shopping Center went up on an 11-acre site in 1947 as one of the area's first planned, automobile-oriented suburban shopping centers. Local builders Joseph and Jacob Meyerhoff adopted a Colonial Williamsburg motif for the center—featuring 29 stores, including a Hochschild Kohn department store, and a sunken garage to hold 700 cars.

This overhead view of the Maryland Shipbuilding and Drydock Company's Baltimore facility shows it as still an active enterprise 10 years after the end of World War II.

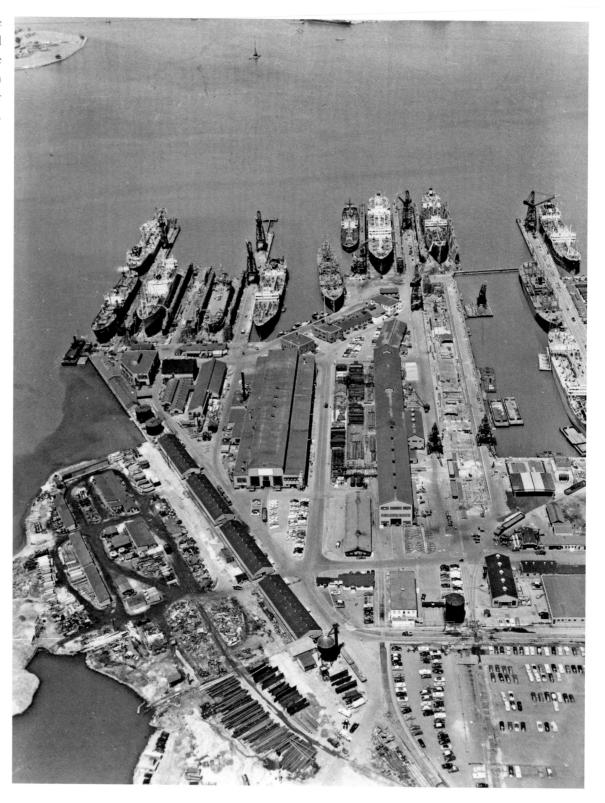

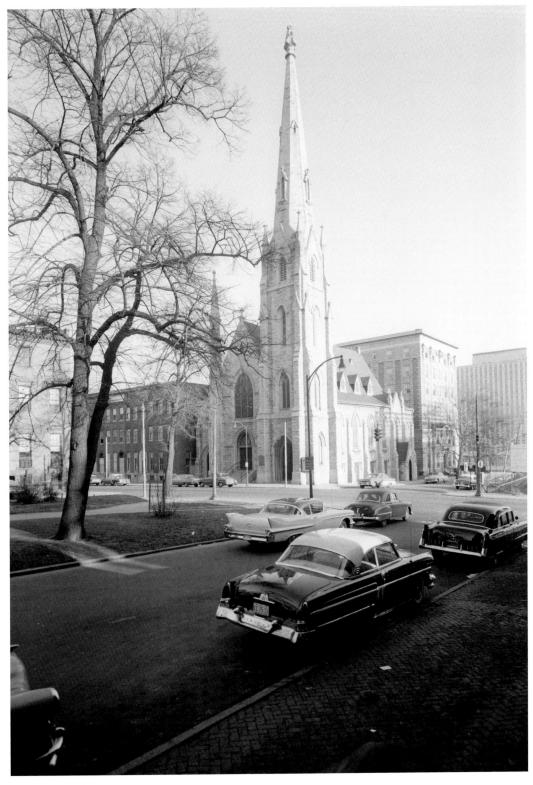

The Eutaw Place Baptist Church, at the intersection of Dolphin and Eutaw streets, was built between 1868 and 1871 and is the only structure in the city designed by architect Thomas U. Walter, whose important design commissions included the House and Senate wings of the United States Capitol, constructed between 1851 and 1859, and the building's iconic dome, completed in 1866.

Rising behind Maximilian Godefroy's

Battle Monument is the Baltimore
Courthouse, the third to occupy this
site, seen here in 1958. Designed by the
architectural firm of J. B. Noel Wyatt
and William G. Nolting, the building,
at its dedication on January 8, 1900, was
described as "a noble pile."

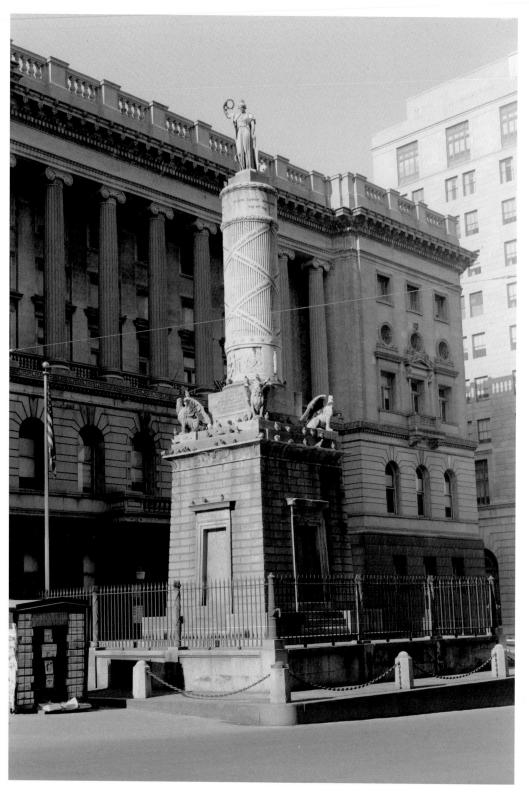

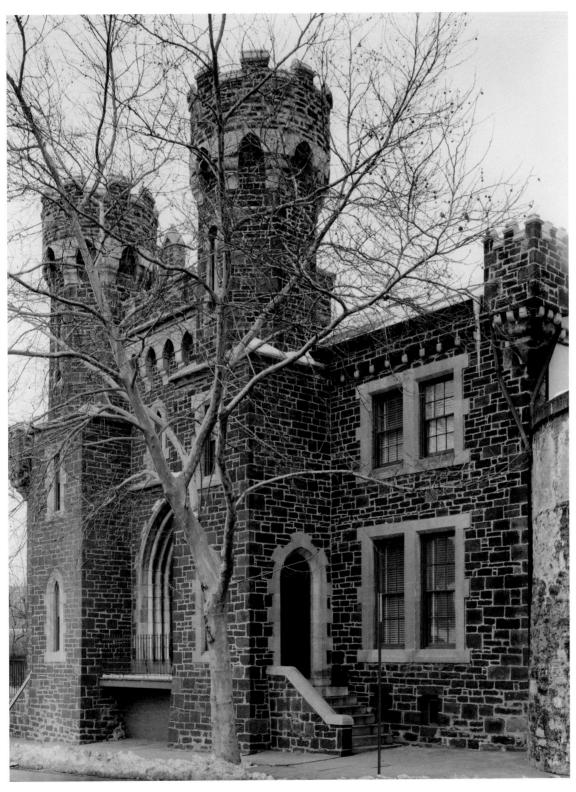

The gateway and warden's house of the Baltimore City Jail on East Madison Street, created by the architectural firm of Dixon, Balbirnie and Dixon in 1857 and seen here a century later, is a brooding Gothic building whose towers and stonework suggest the entrance to a medieval dungeon.

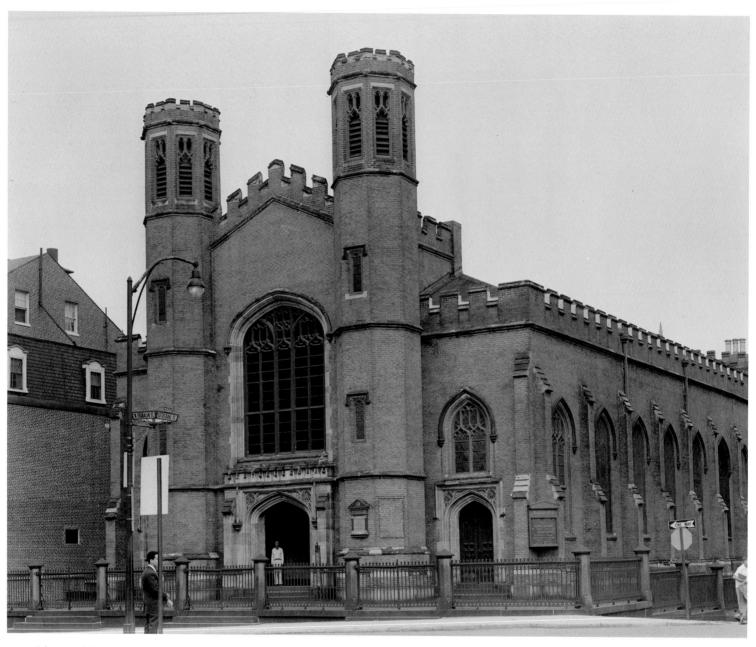

The Franklin Street Presbyterian Church, at the intersection of Franklin and Cathedral streets, is one of a series of city churches designed by the noted local architect Robert Cary Long, Jr. The twin-towered building is one of the city's most impressive examples of the Tudor Gothic Revival style. Long was commissioned to design the building in 1844; the church was opened for service three years later and is seen here in 1958.

The Lloyd Street Synagogue, on the corner of Lloyd and Watson streets, was designed by Robert Cary Long, Jr., for the Baltimore Hebrew Congregation. Constructed in 1845, the Greek Revival building is dominated by its massive Doric columns. The building would be sold in 1889 to St. John the Baptist Roman Catholic Church, one of the first Lithuanian parishes in the United States.

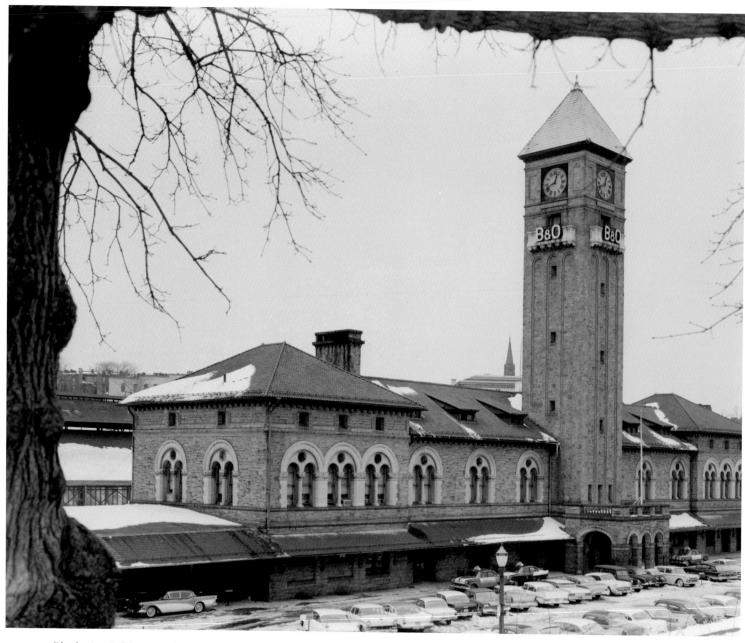

Blanketing Baltimore, a late winter snowfall added picturesque detail to this March 1960 view of the B&O Railroad's Mount Royal Station.

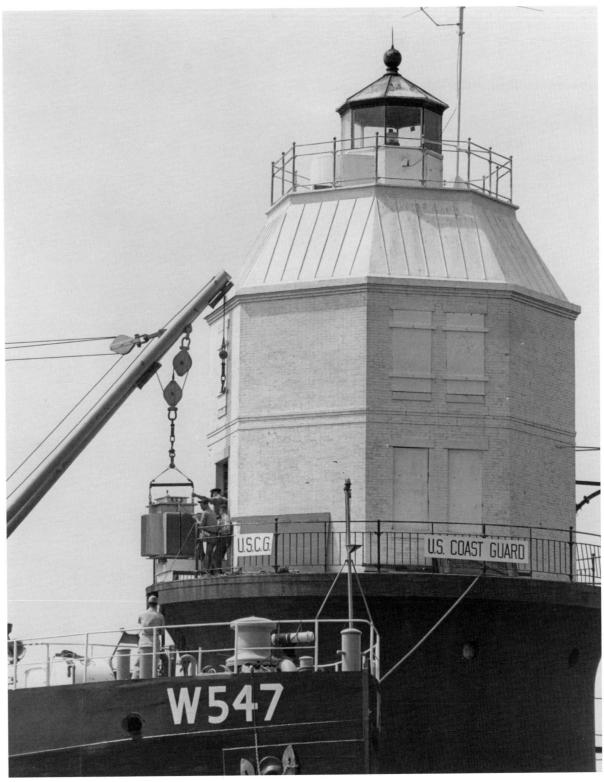

The Baltimore Lighthouse in Chesapeake Bay was first commissioned in 1908, to safely guide ships into the harbor. In 1964, it became the world's first nuclear-powered lighthouse when a 60-watt isotropic power generator was installed, reputedly capable of supplying an uninterrupted 10-year flow of electricity with no refueling. It was removed two years later due to the Coast Guard's concern with environmental issues.

In 1863, German immigrant John Frederick Wiessner leased a plot of land along Gay Street with the intention of starting a brewery. Even though the city and surrounding county already had 21 operating breweries, Wiessner persisted, and his American Brewery grew into one of the largest in the state of Maryland. In 1887 he constructed this imposing brewery building dominated by a central tower that housed a 10,000-bushel grain elevator. The brewery closed in 1973, but the building still stands and is currently under renovation for other uses.

On the 300 block of West Lexington Street in the 1970s, a handful of older buildings and some of the more distinctive signage survive to remind residents of the once vibrant commercial district surrounding the Lexington Market.

Though Baltimore's City Hall was designed by a 22-year-old architect, George A. Frederick, the cast-iron dome on top of the building dedicated in 1875 was the work of Baltimore engineer Wendell Bollman, known for his pioneering work building iron bridges. In 1974, the city voted to renovate the decaying building—including Bollman's dome, seen here during the renovation.

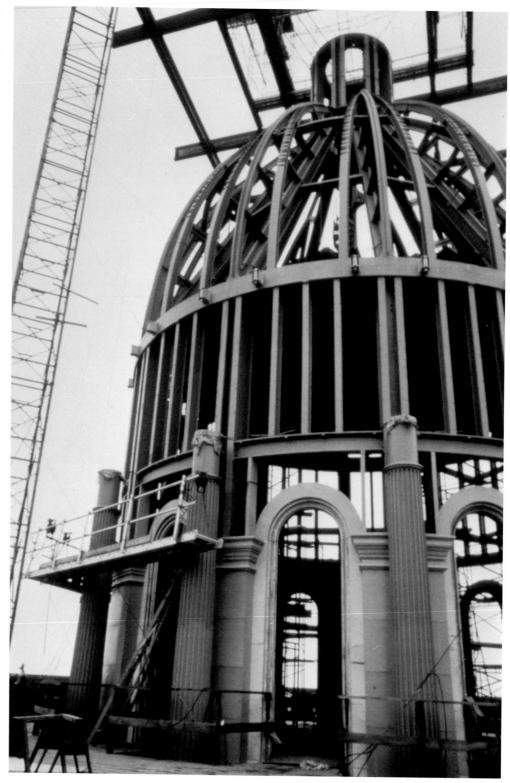

NOTES ON THE PHOTOGRAPHS

These notes, listed by page number, attempt to include all aspects known of the photographs. Each of the photographs is identified by the page number, photograph's title or description, photographer and collection, archive, and call or box number when applicable. Although every attempt was made to collect all available data, in some cases complete data was unavailable due to the age and condition of some of the photographs and records.

II BIRD'S-EYE VIEW OF BALTIMORE Library of Congress

VI ATHENAEUM CLUB
Library of Congress
HABS MD.4-BALT,30-1

LC-USZ62-109352

X GILMORE HOUSE

Courtesy of Enoch Pratt Free Library, Central Library/State Library Resources Center, Baltimore, Maryland EPFL-md1464

2 BATTLE MONUMENT

Library of Congress LC-USZ62-112295

3 METHODIST EPISCOPAL CHURCH

Courtesy of Enoch Pratt Free Library, Central Library/State Library Resources Center, Baltimore, Maryland EFPL-s211

4 Union Troops Defending the VIADUCT

Collection of the New-York Historical Society PR-065-787-1 Negative # ad17001

5 Veiw of Harbor from Federal Hill

Library of Congress LC-USZ62-13366

6 Mount Clare

Courtesy of the Frances Loeb Library, Harvard Graduate School of Design Acc. No. 118311

7 MOUNT VERNON-WOODBERRY MILL

Courtesy of Enoch Pratt Free Library, Central Library/State Library Resources Center, Baltimore, Maryland EFPL-1365

8 Union Bank of Maryland

Library of Congress HABS MD,4-BALT,52-1

9 CITY COURT HOUSE

Courtesy of Enoch Pratt Free Library, Central Library/State Library Resources Center, Baltimore, Maryland

10 Pair of Buggies at Park Entrance

Library of Congress LC-USZ6-1172

11 PIER 2

Courtesy of Enoch Pratt Free Library, Central Library/State Library Resources Center, Baltimore, Maryland EFPL-p679

12 Lexington Market

Library of Congress LC-USZ62-15860

13 EUTAW HOUSE

Library of Congress LC-USZ6-1179

14 TROLLEY

Courtesy of Enoch Pratt Free Library, Central Library/State Library Resources Center, Baltimore, Maryland EFPL-14228

15 THE SUN NEWSPAPER BUILDING

Courtesy of Enoch Pratt Free Library, Central Library/State Library Resources Center, Baltimore, Maryland EFPL-p861

16 FOUNTAIN ON EUTAW STREET

Courtesy of Baltimore Camera Club; Courtesy of Enoch Pratt Free Library, Central Library/State Library Resources Center, Baltimore, Maryland EPFL-h109

17 FIRST BAPTIST CHURCH Library of Congress

Library of Congress HABS MD,4-BALT,37-1

18 DISCARDED OYSTER SHELLS

Courtesy of Enoch Pratt Free Library, Central Library/State Library Resources Center, Baltimore, Maryland

19 SLIGHTLY ASKEW BUILDING

Courtesy of Baltimore Camera Club; Courtesy of Enoch Pratt Free Library, Central Library/State Library Resources Center, Baltimore, Maryland EPFL-h004

20 CENTER MARKET

Library of Congress LC-DIG-ppmsca-12326

21 THE RELAY HOUSE

Courtesy of Enoch Pratt Free Library, Central Library/State Library Resources Center, Baltimore, Maryland EFPL-p1041

22 PEABODY INSTITUTE

Library of Congress LC-DIG-det-4a09471

24 THOMAS WILDEY MONUMENT

Library of Congress LC-USZ6-1171

25 Washington Monument

Library of Congress LC-DIG-det-4a29716

26 BALTIMORE CITY COLLEGE

Courtesy of Enoch Pratt Free Library, Central Library/State Library Resources Center, Baltimore, Maryland EFPL-b274

27 FIRST METHODIST EPISCOPAL CHURCH

Courtesy of Enoch Pratt Free Library, Central Library/State Library Resources Center, Baltimore, Maryland EFPL-t202

28 LEXINGTON MARKET

Library of Congress LC-D4-43299

29 STEWART AND COMPANY DEPARTMENT STORE

Courtesy of Enoch Pratt Free Library, Central Library/State Library Resources Center, Baltimore, Maryland EFPL-h203

BOSTON STREET BRIDGE 30 Library of Congress

HAER MD,4-BALT,188-16

UNLOADING BANANAS 31

Library of Congress D4-18502

32 HOTEL KERNAN

Library of Congress D4-19127

33 JOHNS HOPKINS HOSPITAL

Library of Congress LC-USZ62-75217

34 HOME OF JAMES **GIBBONS**

Library of Congress LC-USZ62-48025

35 POLICE GUIDING CARTS AFTER FLOOD

Courtesy of Enoch Pratt Free Library, Central Library/State Library Resources Center, Baltimore, Maryland

36 LEXINGTON MARKET Library of Congress

LC-D401-16538

37 CANNERY WORKER INSPECTS KETTLE

Library of Congress LC-USZ6-1272

38 VIEW OF WOODBERRY FROM DRUID HILL PARK

Library of Congress LC-USZ6-1166

39 DRUID HILL PARK

Library of Congress LC-USZ62-46106

40 MOUNT ROYAL STATION

Courtesy of Enoch Pratt Free Library, Central Library/State Library Resources Center. Baltimore, Maryland EFPL-I4617

41 UNITED RAILWAYS AND ELECTRIC COMPANY

Library of Congress D4-10716L

42 GOUCHER HALL

Library of Congress D4-16527

44 GREAT FIRE OF BALTIMORE

Library of Congress LC-USZ62-45622

45 GREAT FIRE OF BALTIMORE

Library of Congress LC-USZ62-45623

46 GUGGENHEIMER AND WELLS BUILDING

Library of Congress LC-USZ62-45624

47 AFTERMATH OF THE GREAT FIRE

Library of Congress pan 6a05868

48 BALTIMORE STREET AFTER FIRE

Library of Congress LC-USZ62-96788

49 HANOVER STREET AFTER FIRE

Library of Congress pan 6a05843

50 BURNT RUBBLE

Library of Congress LC-USZ62-121248

51 BALTIMORE STREET IN RUINS

Library of Congress pan 6a05827

52 TROLLEY LORD BALTIMORE

Courtesy of Enoch Pratt Free Library, Central Library/State Library Resources Center, Baltimore, Maryland EPFL-h210

53 CONTINENTAL TRUST BUILDING

Library of Congress D4-19124

54 BALTIMORE FISH MARKET

Library of Congress LC-DIG-ppmsca-12678

55 OYSTER BOATS CROWD THE WHARF

Library of Congress LC-USZ6-1274

56 NORTH HOWARD STREET

Courtesy of Enoch Pratt Free Library, Central Library/State Library Resources Center, Baltimore, Maryland

57 LIGHT STREET

Courtesy of Enoch Pratt Free Library, Central Library/State Library Resources Center, Baltimore, Maryland

58 BROADWAY MARKET

Courtesy of Enoch Pratt Free Library, Central Library/State Library Resources Center, Baltimore, Maryland EFPL-X157

59 EUTAW PLACE

Courtesy of Enoch Pratt Free Library, Central Library/State Library Resources Center, Baltimore, Marvland EFPL-ba007

60 THE SUN NEWSPAPER BUILDING

Courtesy of Baltimore Camera Club: Courtesy of Enoch Pratt Free Library, Central Library/State Library Resources Center, Baltimore, Maryland EPFL-h137

61 STEAMERS LINE THE PIERS

Library of Congress LC-USZ62-127482

W. S. Powell 62 WAREHOUSE

Courtesy of Enoch Pratt Free Library, Central Library/State Library Resources Center, Baltimore, Maryland EFPL-p677

63 WORKERS LINING UP AT PAYMASTER'S POST

Library of Congress LC-USZ6-1287

64 SNOW ON HOWARD STREET

Courtesy of Enoch Pratt Free Library, Central Library/State Library Resources Center, Baltimore, Maryland

65 Young BALLPLAYERS

Courtesy of Baltimore Camera Club; Courtesy of Enoch Pratt Free Library, Central Library/State Library Resources Center, Baltimore, Maryland EPFL-h006

66 ORLEANS STREET

Courtesy of Enoch Pratt Free
Library, Central Library/State
Library Resources Center,
Baltimore, Maryland

Baltimore, Maryland EPFL-me005

67 POLICE FORCE

Courtesy of Enoch Pratt Free Library, Central Library/State Library Resources Center, Baltimore, Maryland EFPL-h264

68 COLLAPSED POLES
Courtesy of Enoch Pratt Free
Library, Central Library/State
Library Resources Center,
Baltimore, Maryland
EFPL-me076

69 Young Boy Carrying HEAVY LOADLibrary of Congress
LC-DIG-nclc-00753

70 Young Workers
Stringing Beans
Library of Congress
LC-DIG-nclc-00033

71 WAGON OF CHILDREN Library of Congress LC-DIG-nclc-00190

72 BALTIMORE IMMIGRANTS
ON WOLFE STREET
Library of Congress
LC-DIG-nclc-00193

73 BOTTOMLEY'S BERRY
FARM
Library of Congress

LC-DIG-nclc-00026

74 SAMUEL HECHT
FURNITURE STORE
Courtesy of Enoch Pratt Free
Library, Central Library/State
Library Resources Center,
Baltimore, Maryland
EFPL-me012

75 MOTORCYCLE POLICE
Courtesy of Enoch Pratt Free
Library, Central Library/State
Library Resources Center,
Baltimore, Maryland

76 LARRIMORE BUGGY TOP
COMPANY

77

Courtesy of Enoch Pratt Free Library, Central Library/State Library Resources Center, Baltimore, Maryland EFPL-me029

PATRIOTIC PARADE
Courtesy of Enoch Pratt Free
Library, Central Library/State
Library Resources Center,
Baltimore, Maryland
EPFL-me045

78 SOUTH BROADWAY
Courtesy of Enoch Pratt Free
Library, Central Library/State
Library Resources Center,
Baltimore, Maryland
EFPL-me014

79 BROADWAY MARKET
Courtesy of Enoch Pratt Free
Library, Central Library/State
Library Resources Center,
Baltimore, Maryland
EFPL-me011

80 GAS LANTERNS
Courtesy of Enoch Pratt Free
Library, Central Library/State
Library Resources Center,
Baltimore, Maryland
EPFL-L740

81 MOUNT VERNON PLACE
Courtesy of Baltimore
Camera Club;
Courtesy of Enoch Pratt Free
Library, Central Library/State
Library Resources Center,
Baltimore, Maryland
EPFL-h102

82 MOUNT VERNON PLACE METHODIST CHURCH Library of Congress LC-USZ62-95761 83 DEMOCRATIC
CONVENTION IN
BALTIMORE
Library of Congress
LC-DIG-ggbain-10618

84 DEMOCRATIC
CONVENTION
Library of Congress
LC-DIG-ggbain-10572

85 Inside the Convention Library of Congress LC-DIG-ggbain-10642

86 VIEW OF THE HARBOR FROM FEDERAL HILL Library of Congress pan 6a16328

87 LOMBARD STREET

Courtesy of Enoch Pratt Free
Library, Central Library/State
Library Resources Center,
Baltimore, Maryland
EFPL-e208

88 DIRT WAGON ROADS
Courtesy of Enoch Pratt Free
Library, Central Library/State
Library Resources Center,
Baltimore, Maryland
13822

89 BRICK PAVEMENT
Courtesy of Enoch Pratt Free
Library, Central Library/State
Library Resources Center,
Baltimore, Maryland
13824

90 Horse and Cart
Courtesy of Enoch Pratt Free
Library, Central Library/State
Library Resources Center,
Baltimore, Maryland
13808

91 MONTEBELLO FILTRATION PLANT Library of Congress LC-USZ62-109348

92 LOADED TRUCKS
Library of Congress
HAER MD,4-BALT,125-57

93 East Lexington
Street
Courtesy of Enoch Prair

Courtesy of Enoch Pratt Free Library, Central Library/State Library Resources Center, Baltimore, Maryland EFPL-L429

94 THE JAIL

Courtesy of Enoch Pratt Free
Library, Central Library/State
Library Resources Center,
Baltimore, Maryland
EPFL-b232

95 SURVIVING RESIDENTIAL
BUILDING
Courtesy of Enoch Pratt Free
Library, Central Library/State
Library Resources Center,
Baltimore, Maryland
EFPL-n125

96 AUTOMOBILE ACCIDENT
Courtesy of Enoch Pratt Free
Library, Central Library/State
Library Resources Center,
Baltimore, Maryland
19092

97 EMPLOYEES POSING IN
LITTERED ALLEY
Courtesy of Enoch Pratt Free
Library, Central Library/State
Library Resources Center,
Baltimore, Maryland

98 BALTIMORE ORIOLES
Library of Congress
LC-DIG-pan-6a29647

100 PAN AMERICAN
CONFERENCE OF WOMEN
Library of Congress
LC-USZ62-53814

101 CHANGING TIRE ON CAR
Courtesy of Enoch Pratt Free
Library, Central Library/State
Library Resources Center,
Baltimore, Maryland
EFPL-bev1932

102 WESTERN MARYLAND RAILROAD TERMINAL Library of Congress pan 6a05818

104 LEXINGTON MARKET

Courtesy of Enoch Pratt Free Library, Central Library/State Library Resources Center, Baltimore, Maryland

105 Inside Lexington Market

Courtesy of Enoch Pratt Free Library, Central Library/State Library Resources Center, Baltimore, Maryland EFPL-p043

106 PEALE'S BALTIMORE MUSEUM AND GALLERY OF FINE ARTS

Library of Congress HABS MD,4-BALT,55-1

107 SPECTATORS LINE THE B&O TRACKS

Library of Congress LC-USZ62-68495

108 LOCOMOTIVE WILLIAM MASON

Library of Congress LC-USZ62-1161

109 ROBERTS BROTHERS CANNERS

Courtesy of the BGE Photo Collection at the Baltimore Museum of Industry; Courtesy of Enoch Pratt Free Library, Central Library/State Library Resources Center, Baltimore, Maryland EPFL-038

110 PARK BANK BUILDING

Courtesy of the BGE Photo Collection at the Baltimore Museum of Industry; Courtesy of Enoch Pratt Free Library, Central Library/State Library Resources Center, Baltimore, Maryland EPFL-015

111 THE PLEASURE CAR OF THE 40s

Courtesy of Enoch Pratt Free Library, Central Library/State Library Resources Center, Baltimore, Maryland EPFL-b236

112 CONSOLIDATED GAS ELECTRIC LIGHT AND POWER COMPANY

Courtesy of the BGE Photo Collection at the Baltimore Museum of Industry; Courtesy of Enoch Pratt Free Library, Central Library/State Library Resources Center, Baltimore, Maryland EPFL014

113 BOWIE RACE TRACK

Courtesy of Enoch Pratt Free Library, Central Library/State Library Resources Center, Baltimore, Maryland EFPL-md2022

114 ORIOLE PARK

Courtesy of the BGE Photo Collection at the Baltimore Museum of Industry; Courtesy of Enoch Pratt Free Library, Central Library/State Library Resources Center, Baltimore, Maryland

116 ORIOLE CAFETERIA

Courtesy of the BGE Photo Collection at the Baltimore Museum of Industry; Courtesy of Enoch Pratt Free Library, Central Library/State Library Resources Center, Baltimore, Maryland

117 St. PAUL STREET BRIDGE

Courtesy of Enoch Pratt Free Library, Central Library/State Library Resources Center, Baltimore, Maryland EPFL-L808

118 LINOTYPE ROOM

Courtesy of the BGE Photo Collection at the Baltimore Museum of Industry; Courtesy of Enoch Pratt Free Library, Central Library/State Library Resources Center, Baltimore, Maryland

119 BALTIMORE COMMERCIAL BANK BUILDING

Courtesy of the BGE Photo Collection at the Baltimore Museum of Industry; Courtesy of Enoch Pratt Free Library, Central Library/State Library Resources Center, Baltimore, Maryland EPFL-md1119

120 MOUNT ROYAL STATION

Courtesy of Enoch Pratt Free Library, Central Library/State Library Resources Center, Baltimore, Maryland EFPL-m004

121 DOWNTOWN COMMERCIAL DISTRICT

Courtesy of Enoch Pratt Free Library, Central Library/State Library Resources Center, Baltimore, Maryland 48-418

122 STEAMBOATS LINE THE HARBOR PIER

Courtesy of Enoch Pratt Free Library, Central Library/State Library Resources Center, Baltimore, Maryland EFPL-f314

123 BALTIMORE TRANSIT

Courtesy of Enoch Pratt Free Library, Central Library/State Library Resources Center, Baltimore, Maryland EPFL-L497

124 BALTIMORE CITY HALL

Courtesy of Enoch Pratt Free Library, Central Library/State Library Resources Center, Baltimore, Maryland EFPL-m0003

125 NORTH HOWARD STREET

Courtesy of Enoch Pratt Free Library, Central Library/State Library Resources Center, Baltimore, Maryland EPFL-L4635

126 Mount Clare Station

Courtesy of Enoch Pratt Free Library, Central Library/State Library Resources Center, Baltimore, Maryland 33-7

127 BROADWAY PIER AT FELL'S POINT

Courtesy of Enoch Pratt Free Library, Central Library/State Library Resources Center, Baltimore, Maryland EFPL-a130

128 U.S. ROUTE 1

Courtesy of Enoch Pratt Free Library, Central Library/State Library Resources Center, Baltimore, Maryland 48-1104a

129 PASCAULT ROW

Courtesy of Enoch Pratt Free Library, Central Library/State Library Resources Center, Baltimore, Maryland EFPL-n097

130 BALTIMORE ROW Houses

Courtesy of Enoch Pratt Free Library, Central Library/State Library Resources Center, Baltimore, Maryland 33-8

131 BETHLEHEM STEEL

Courtesy of Enoch Pratt Free Library, Central Library/State Library Resources Center, Baltimore, Maryland

132 Lexington Street

Courtesy of Enoch Pratt Free Library, Central Library/State Library Resources Center, Baltimore, Maryland

133 CATHEDRAL OF THE ASSUMPTION OF THE BLESSED VIRGIN MARY

Courtesy of Enoch Pratt Free Library, Central Library/State Library Resources Center, Baltimore, Maryland EPFL-md1439

134 CATHEDRAL OF THE ASSUMPTION OF THE BLESSED VIRGIN MARY

Courtesy of Enoch Pratt Free Library, Central Library/State Library Resources Center, Baltimore, Maryland EPFL-h215

135 MOUNT VERNON PLACE METHODIST EPISCOPAL CHURCH

Courtesy of Enoch Pratt Free Library, Central Library/State Library Resources Center, Baltimore, Maryland EFPL-038

136 Shop on the Corner of South Broadway

Courtesy of Enoch Pratt Free Library, Central Library/State Library Resources Center, Baltimore, Maryland EFPL-n054

137 WATERLOO ROW

Library of Congress HABS MD,4-BALT,16-2

138 Washington Monument

Library of Congress HABS MD,4-BALT,33-2

139 Nurses Posing by Statue of Major George Armistead

Courtesy of Enoch Pratt Free Library, Central Library/State Library Resources Center, Baltimore, Maryland EPFL-L3149

140 FORT MCHENRY

Courtesy of Enoch Pratt Free Library, Central Library/State Library Resources Center, Baltimore, Maryland EPFL-L3196

141 FORT MCHENRY

Courtesy of Enoch Pratt Free Library, Central Library/State Library Resources Center, Baltimore, Maryland EPFL-b224

142 CAST-IRON WORK

Library of Congress HABS MD,4-BALT,71-1

143 PRESIDENT STREET STATION

Library of Congress HABS MD,4-BALT,25-1

144 Basilica of the Assumption

Library of Congress HABS MD,4-BALT,41-1

145 Snow Outside Basilica of the Assumption

Courtesy of Enoch Pratt Free Library, Central Library/State Library Resources Center, Baltimore, Maryland EPFL-L1152

146 JOHNS HOPKINS UNIVERSITY

Courtesy of Enoch Pratt Free Library, Central Library/State Library Resources Center, Baltimore, Maryland 42-60

147 LATROBE HALL

Courtesy of Enoch Pratt Free Library, Central Library/State Library Resources Center, Baltimore, Maryland 42-56

148 BALTIMORE CITY HOSPITAL

Courtesy of Enoch Pratt Free Library, Central Library/State Library Resources Center, Baltimore, Maryland EFPL-I1358

149 BALTIMORE CORRESPONDENT

Courtesy of Enoch Pratt Free Library, Central Library/State Library Resources Center, Baltimore, Maryland EPFL-md1122

150 Working on Floating Pipeline

Courtesy of the BGE Photo Collection at the Baltimore Museum of Industry; Courtesy of Enoch Pratt Free Library, Central Library/State Library Resources Center, Baltimore, Maryland EPFL-L2786

151 MOUNT VERNON PLACE

Courtesy of Enoch Pratt Free Library, Central Library/State Library Resources Center, Baltimore, Maryland EFPL-L3093

152 Howard Street Bridge

Courtesy of Enoch Pratt Free Library, Central Library/State Library Resources Center, Baltimore, Maryland EFPL-f658

153 E. H. Poole Machine

Courtesy of Enoch Pratt Free Library, Central Library/State Library Resources Center, Baltimore, Maryland EPFL-L3862

154 STATE-OF-THE-ART BAKERY

Library of Congress HAER MD-8012

155 MOUNT VERNON PLACE

Courtesy of Enoch Pratt Free Library, Central Library/State Library Resources Center, Baltimore, Maryland EFPL-13597

156 MUNICIPAL STADIUM

Courtesy of Enoch Pratt Free Library, Central Library/State Library Resources Center, Baltimore, Maryland EPFL-L4151

157 NORTH AVENUE

Courtesy of Enoch Pratt Free Library, Central Library/State Library Resources Center, Baltimore, Maryland 39-5100

158 EAST LOMBARD STREET

Courtesy of Enoch Pratt Free Library, Central Library/State Library Resources Center, Baltimore, Maryland EFPL-L3858

160 BALTIMORE ROW HOUSES

Library of Congress LC-DIG-fsa-8c02589

161 SCRUBBING WHITE STEPS

Library of Congress LC-USF346-8530D

162 A&P SUPER MARKET

Courtesy of Enoch Pratt Free Library, Central Library/State Library Resources Center, Baltimore, Maryland 48-409A

163 BALTIMORE COLLEGE OF DENTAL SURGERY

Courtesy of Enoch Pratt Free Library, Central Library/State Library Resources Center, Baltimore, Maryland EPFL-L4896

164 PREFABRICATING AND WELDING

Library of Congress LC-USE6-D-002420

- 165 SHIPYARD TRACK
 Library of Congress
 LC-USE6-D-002360
- 166 BETHLEHEM-FAIRFIELD SHIPYARD

Library of Congress LC-USW33-029959-C

- 167 LIBERTY SHIP READY FOR LAUNCHING Library of Congress LC-USW33-029963-C
- 168 COLONEL H. J. LAWES
 DEMONSTRATING THE
 JEEP
 Library of Congress

LC-USW33-027843-ZC

169 Women Heading to

Library of Congress LC-USW3-022019-E

- 170 GLENN L. MARTIN PLANT CARPOOL Library of Congress LC-USE6-D-005019
- **171 B-10 BOMBER**Library of Congress
 LC-USZ62-102979
- 172 AIR-RAID WARNING
 SIGN
 Library of Congress
 LC-USW3-022097-E
- 173 SIGN COMPANY
 Library of Congress
 LC-USW3-022081-E
- 174 QUIET STREETS
 Courtesy of Enoch Pratt Free
 Library, Central Library/State
 Library Resources Center,
 Baltimore, Maryland
 48-532
- 175 MEAT WAREHOUSE
 Library of Congress
 LC-USW3-022078-E

176 Two O'CLOCK CLUB

Courtesy of Enoch Pratt Free Library, Central Library/State Library Resources Center, Baltimore, Maryland 55-4276

177 FRED GROUER'S GROCERY STORE

Courtesy of Enoch Pratt Free Library, Central Library/State Library Resources Center, Baltimore, Maryland LC-H814-T01-1007

178 AERIAL VIEW OF BALTIMORE

Courtesy of Enoch Pratt Free Library, Central Library/State Library Resources Center, Baltimore, Maryland 938

180 TROLLEY HEADED
TOWARD BALTIC STREET

Courtesy of Enoch Pratt Free Library, Central Library/State Library Resources Center, Baltimore, Maryland 44-1903

181 POLICEMAN DIRECTING
TRAFFIC

Courtesy of Enoch Pratt Free Library, Central Library/State Library Resources Center, Baltimore, Maryland 48-425

182 BUILDING A BRIDGE

Courtesy of Enoch Pratt Free Library, Central Library/State Library Resources Center, Baltimore, Maryland 52-169

183 CHESAPEAKE BAY BRIDGE

Courtesy of Enoch Pratt Free Library, Central Library/State Library Resources Center, Baltimore, Maryland 52-524 184 COMMUTING DOWNTOWN
Courtesy of Enoch Pratt Free
Library Control Library (State

Courtesy of Enoch Pratt Free Library, Central Library/State Library Resources Center, Baltimore, Maryland 52-1242

185 AFTERNOON TRAFFIC

Courtesy of Enoch Pratt Free Library, Central Library/State Library Resources Center, Baltimore, Maryland 52-1239

186 Traffic on Orleans
Street Viaduct

Courtesy of Enoch Pratt Free Library, Central Library/State Library Resources Center, Baltimore, Maryland 52-1246

187 LIGHT STREET

Courtesy of Enoch Pratt Free Library, Central Library/State Library Resources Center, Baltimore, Maryland 53-2512

188 EAST PRATT

Courtesy of Enoch Pratt Free Library, Central Library/State Library Resources Center, Baltimore, Maryland 53-2515

189 EDMONDSON VILLAGE
SHOPPING CENTER

Courtesy of Enoch Pratt Free Library, Central Library/State Library Resources Center, Baltimore, Maryland 53-1100

190 MARYLAND
SHIPBUILDING AND
DRYDOCK COMPANY

Courtesy of Enoch Pratt Free Library, Central Library/State Library Resources Center, Baltimore, Maryland 55-19258 191 EUTAW PLACE BAPTIST CHURCH

Library of Congress HABS MD,4-BALT,120-1

- 192 COURTHOUSE
 Library of Congress
 HABS MD,4-BALT,113-1
- 193 CITY JAIL
 Library of Congress
 HABS MD,4-BALT,114-1
- 194 FRANKLIN STREET
 PRESBYTERIAN CHURCH
 Library of Congress
 HABS MD.4-BALT.112A-3
- 195 LLOYD STREET
 SYNAGOGUE
 Library of Congress
 HABS MD.4-BALT.117-1
- 196 SNOWFALL AT MOUNT ROYAL STATION Library of Congress HABS MD,4-BALT,119-1
- **197** Baltimore Lighthouse Library of Congress LC-DIG-ppmsca-09099
- 198 WIESSNER BREWERY
 Library of Congress
 HABS MD.4-BALT,146-13
- 199 300 BLOCK OF WEST LEXINGTON STREET Library of Congress HABS MD.4-BALT.178-1
- 200 CITY HALL RENOVATION Library of Congress HABS MD,4-BALT,123-22